★
ICONS

THE AMERICAN INDIAN

DIE INDIANER AMERIKAS
LES INDIENS D'AMÉRIQUE

Karl Bodmer
Maximilian Prinz zu Wied

TASCHEN

KÖLN LONDON LOS ANGELES MADRID PARIS TOKYO

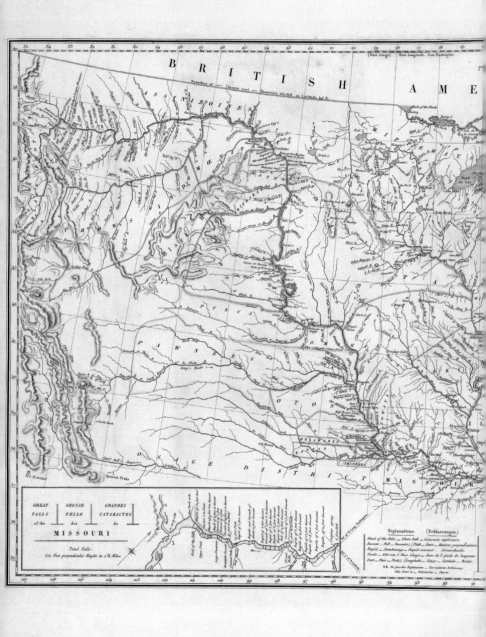

GREAT
FALLS
of the
MISSOURI

GROSSE
FÄLLE
des

GRANDES
CATARACTES
du

Total Falls:
359 Feet perpendicular Height, in 2⅝ Miles.

Explanations. (Erklärungen.)

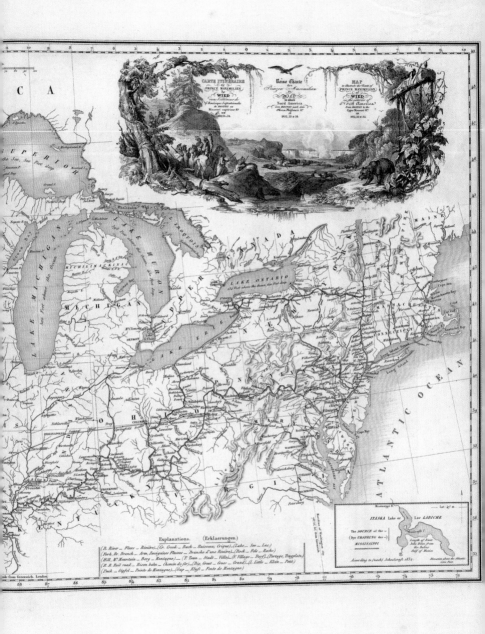

The reproductions of the illustrations in the present book are taken from the hand-coloured copy of *Die Reise in das innere Nord-America in den Jahren 1832–34* by Prince Maximilian of Wied (1782–1867) that has remained to this day in the keeping of the royal family Wied-Neuwied.

Der Druck der vorliegenden Abbildungen erfolgte nach dem handkolorierten Exemplar *Die Reise in das innere Nord-America in den Jahren 1832–34* des Prinzen Maximilian zu Wied (1782–1867), das sich bis heute im Besitz der Fürstlichen Familie zu Wied-Neuwied befindet.

L'impression des présentes illustrations a été réalisée d'après l'exemplaire, colorié à la main, du *Die Reise in das innere Nord-America in den Jahren 1832–1834* (*Voyage dans l'Intérieur de l'Amérique du Nord …*) du prince Maximilien de Wied-Neuwied (1782–1867). L'ouvrage se trouve encore à ce jour en possession de la famille princière de Wied-Neuwied.

CONTENT · INHALT · SOMMAIRE

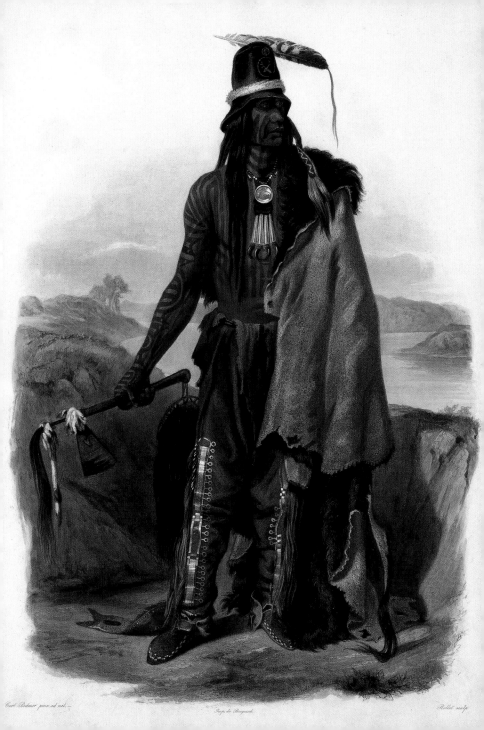

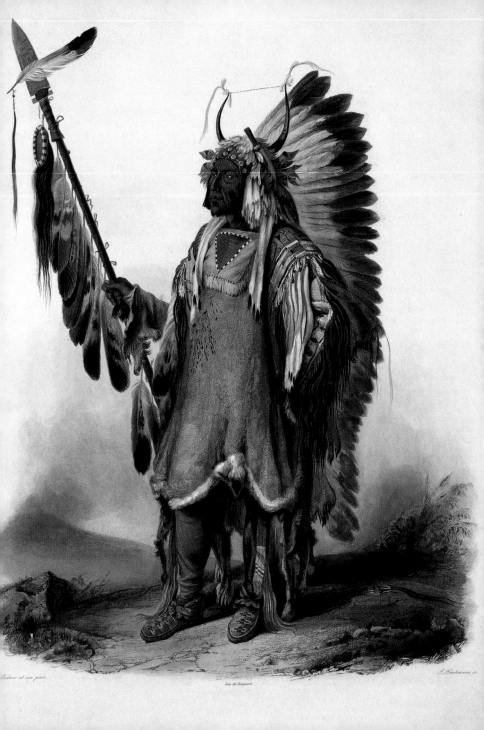

TRAVELS IN THE INTERIOR OF NORTH AMERICA

The fascination and reality of Native American cultures

DIE REISE IN DAS INNERE NORD-AMERICA

Faszination und Realität indianischer Kulturen

VOYAGE DANS L'INTÉRIEUR DE L'AMÉRIQUE DU NORD

Fascination et réalité des cultures indiennes

The news that the S.S. Yellow Stone was taking travellers to the Upper Missouri was received with great interest in Europe. From 1832 onwards the Yellow Stone was the first steamboat of the American Fur Company that sailed as far as Fort Union in the north-eastern corner of the present state of Montana, where the Missouri and Yellowstone Rivers meet. In 1833 the German Baron von Braunsberg was to travel with two companions in this self-same ship, the S.S. Yellow Stone, up the Missouri to the interior of North America. Who were these three men who deliberately faced great trials and dangers in order to discover and document life worlds previously unknown to them?

Concealed behind the pseudonym Baron von Braunsberg was the naturalist Maximilian Prince of Wied. Like many of his contemporaries, he had followed the researches of the geographer and natural scientist Alexander von Humboldt (1769–1859) with keen interest. The return of the great Prussian scholar from his five-year expedition to South America (1799–1804), and more particularly the presentation of the first results, awoke the desire in Prince Maximilian to learn more about the New World, which was still largely unexplored. A personal meeting with Alexander von Humboldt in 1804 further prompted the Prince to embark on his own expedition, which took him from 1815 to 1817 to Brazil and to the isolated region between Rio de Janeiro and Bahia. During his journey, Prince Maximilian meticulously studied the distinctive geographical, geological, botanical, zoological and above all cultural features of that distant continent.

Die Nachricht, dass die »Yellow Stone« Reisende an den Oberen Missouri brachte, wurde in Europa mit großem Interesse aufgenommen. Ab 1832 fuhr die »Yellow Stone« als erstes Dampfschiff der Amerikanischen Pelzhandelsgesellschaft bis nach Fort Union, das im Nordosten des heutigen Bundesstaates Montana liegt, dort wo die beiden Flüsse Missouri und Yellowstone ineinander fließen. 1833 sollten der deutsche Baron von Braunsberg und zwei Begleiter mit der »Yellow Stone« den Missouri aufwärts in das Innere Nordamerikas reisen. Wer waren diese drei Männer, die Strapazen und Gefahren auf sich nahmen, um fremde Lebenswelten kennen zu lernen und diese zu dokumentieren?

Hinter dem Pseudonym Baron von Braunsberg verbarg sich der Naturforscher Maximilian Prinz zu Wied. Wie viele seiner Zeitgenossen verfolgte auch er aufmerksam die Forschungen des Geographen und Naturhistorikers Alexander von Humboldt (1769–1859). Als der berühmte preußische Gelehrte nach der Rückkehr von seiner fünfjährigen Südamerikareise (1799–1804) erste Forschungsergebnisse präsentierte, weckte er auch bei Prinz Maximilian die Neugierde, mehr über die noch weitgehend unbekannte Neue Welt zu erfahren. Durch ein persönliches Treffen mit Alexander von Humboldt im Jahr 1804 wurde er angeregt, eine eigene Forschungsreise zu unternehmen, die ihn von 1815 bis 1817 nach Brasilien in das abgelegene Gebiet zwischen Rio de Janeiro und Bahia führte. Auf dieser Reise stu-

La nouvelle que le « Yellow Stone » acheminait des voyageurs jusque dans les régions longeant le cours supérieur du Missouri fut accueillie en Europe avec un très grand intérêt. Ce bateau à vapeur de la Société Américaine de Pelleterie était le premier, à partir de 1832, à aller jusqu'à Fort-Union, situé au nord-est de l'État actuel du Montana, plus exactement au confluent du Missouri et de la Yellowstone River. En 1833, le baron allemand von Braunsberg et deux accompagnateurs devaient, à bord de ce même « Yellow Stone », remonter le Missouri et s'enfoncer à l'intérieur du continent américain. Mais qui étaient ces trois hommes qui ne craignaient pas d'affronter l'extrême fatigue et les dangers pour apprendre à connaître des mondes étrangers et les documenter ?

Derrière le pseudonyme du baron von Braunsberg se dissimulait un naturaliste, le prince Maximilien de Wied-Neuwied. Comme beaucoup de ses contemporains, il suivit lui aussi très attentivement les expéditions du géographe et naturaliste Alexandre von Humboldt (1769–1859). Lorsqu'à son retour de cinq années de voyage en Amérique du Sud (1799–1804), le célèbre savant prussien présenta les premiers résultats de son expédition, il éveilla chez le prince Maximilien le désir d'en savoir plus sur ce Nouveau Monde qui était encore en grande partie inconnu. Sa rencontre personnelle avec Alexandre von Humboldt en 1804 le détermina à entreprendre son propre voyage d'exploration, lequel le conduisit, entre 1815 et 1817, dans la région reculée du

Whilst previously the people of Europe had scarcely occupied themselves with the strange "wild men" of America, numerous researchers in the early 19th century became increasingly intrigued by them, for they seemed to embody man in his "natural state". Maximilian Prince of Wied was similarly in search of the "natural countenance of North America" as he prepared for his second expedition to the New World.

THE NATURALIST MAXIMILIAN PRINCE OF WIED

Prince Maximilian (1782–1867) devoted his life to the study of the natural sciences. Initially he was a self-taught scholar, who deepened the knowledge gained from his observations by reading a wide variety of scientific publications. Simultaneously, during his army days he had already made contact with leading zoologists, anthropologists, botanists, mineralogists, geographers and other natural scientists. From April 1811 to Easter 1812 he studied at the Georgia Augusta University in Göttingen in order to place his natural history research on an even firmer basis. One of his fellow students was William Backhouse Astor, son of the owner of the American trading company that was later to back Prince Maximilian's expedition to the remote American Indian settlements on the banks of the Upper Missouri. Already during his travels in Europe Maximilian had documented and sketched the animals, plants, minerals and even national costumes he en-

dierte Prinz Maximilian akribisch die geographischen, geologischen, botanischen, zoologischen und vor allem auch kulturellen Besonderheiten des fremden Kontinents.

Hatte man sich in Europa bislang kaum mit den wunderlichen »Waldmenschen« Amerikas befasst, so galt ihnen zu Beginn des 19. Jahrhunderts zunehmend die Aufmerksamkeit vieler Forscher, die sie den »natürlichen Zustand« der Menschheit zu verkörpern schienen. Auch Maximilian Prinz zu Wied war auf der Suche nach dem »natürlichen Gesicht Nordamerikas«, als er seine zweite Expedition in die Neue Welt vorbereitete.

DER NATURFORSCHER
MAXIMILIAN PRINZ ZU WIED

Prinz Maximilian (1782–1867) widmete sein Leben dem Studium der Natur, zunächst als Autodidakt, der seine aus Beobachtungen gewonnenen Kenntnisse durch die Lektüre zahlreicher wissenschaftlicher Publikationen vertiefte. Zugleich pflegte er bereits während seiner Militärzeit Kontakt zu führenden Zoologen, Anthropologen, Botanikern, Mineralogen, Geographen und anderen Naturforschern. Von April 1811 bis Ostern 1812 war er an der Georgia-Augusta-Universität zu Göttingen immatrikuliert, um seine naturkundlichen Forschungen zu vertiefen. Einer seiner Kommilitonen war William Backhouse Astor, dessen Vater Eigentümer jener Amerikanischen Pelzhandelsgesellschaft war, die

Brésil comprise entre Rio de Janeiro et Bahia. Au cours de ce voyage, le prince Maximilien se livra à l'étude scrupuleuse des particularités géographiques, géologiques, botaniques, zoologiques et surtout culturelles de ce continent inconnu.

Si en Europe on ne s'était jusqu'ici guère préoccupé de ces étranges «hommes des bois» d'Amérique, voici qu'à présent, en ce début du 19e siècle, on voyait de plus en plus d'explorateurs s'intéresser à eux dans la mesure où ils semblaient incarner «l'état naturel de l'humanité». Le prince Maximilien de Wied-Neuwied était lui aussi à la recherche du «visage naturel de l'Amérique du Nord» lorsqu'il prépara sa seconde expédition dans le Nouveau Monde.

LE NATURALISTE
MAXIMILIEN DE WIED-NEUWIED

Le prince Maximilien (1782–1867) consacra son existence à l'étude de la nature. D'abord autodidacte, il approfondit par la lecture de multiples publications scientifiques les connaissances qu'il avait acquises par l'observation. En même temps, il noua des contacts, alors qu'il était encore dans l'armée, avec des zoologistes, des anthropologues, des botanistes, des minéralogistes, des géographes et autres naturalistes de renom. D'avril 1811 à Pâques 1812, il s'inscrivit à l'université Georgia Augusta de Göttingen pour approfondir ses recherches dans le domaine des sciences naturelles. Un de ses camarades

countered. His researches led to pathbreaking scientific insights. The Prince discovered hitherto unknown species of plants and animals, and described the cultural life of the indigenous population of Brazil with great precision. Simultaneously the account he wrote and the artefacts he collected enabled the general public to gain a fascinating picture of previously alien life worlds.

DOCUMENTATION OF THE JOURNEY

The Prince was accompanied on his journey to North America by David Dreidoppel, a retainer at the royal court at Neuwied who had already accompanied him on his expedition to Brazil as a seasoned hunter taxidermist and plant preparator. During his Brazil expedition, Maximilian had done his own sketches and paintings in the field, but this time he looked for an artist who would document the American expedition for him. He had felt dissatisfied with the quality of his own work. His choice was the young artist Karl Bodmer of Zurich. Since the 23-year-old had already made a name for himself as a landscape painter and had published numerous engravings of landscapes along the Rhine, Maximilian was confident that he would depict the indigenous plants, animals and peoples in a faithful manner.

A contract was drawn up, in which Maximilian Prince of Wied secured the right of possession of all the pictures produced during the journey, while undertaking to cover the artist's

später die Expedition Prinz Maximilians in abgelegene indianische Siedlungen entlang des Oberen Missouri unterstützen sollte. Bereits auf seinen Reisen innerhalb Europas dokumentierte und skizzierte Maximilian Tiere, Pflanzen, Mineralien und Volkstrachten. Seine Forschungen in Brasilien brachten bereits wegweisende wissenschaftliche Erkenntnisse zu Tage. Der Prinz entdeckte dort bislang unbekannte Pflanzen- und Tierarten und beschrieb das kulturelle Leben der indigenen Bevölkerung mit großer Exaktheit. Seine schriftlichen Aufzeichnungen und die Artefakte, die er sammelte, vermittelten zugleich einer breiten Öffentlichkeit ein Bild von zuvor fremden, faszinierenden Lebenswelten.

DIE DOKUMENTATION DER REISE
Begleitet wurde der Prinz auf seiner Reise nach Nordamerika von David Dreidoppel, einem Bediensteten des fürstlichen Hofes in Neuwied, der ihm bereits während der Brasilienreise als geübter Jäger und Präparator zur Seite gestanden hatte. Hatte der Prinz während seiner Brasilienreise selbst vor Ort Skizzen und Bildwerke angefertigt, war er jetzt auf der Suche nach einem Künstler, der die Amerikareise bildlich dokumentieren sollte, denn die Qualität seiner eigenen Werke hatte ihn nicht zufrieden gestellt. Die Wahl fiel auf den jungen Landschaftsmaler Karl Bodmer aus Zürich. Der 23-Jährige hatte sich bereits einen Namen als Landschaftsmaler gemacht und zahlreiche Stiche von Rheinlandschaften

d'études était William Backhouse Astor, dont le père faisait partie de cette Société Américaine de Pelleterie qui plus tard, devait soutenir l'expédition du prince Maximilien dans des colonies indiennes reculées installées le long du cours supérieur du Missouri. Maximilien avait déjà documenté et dessiné des animaux, des végétaux, des minéraux et des costumes nationaux ou régionaux au cours de ses voyages en Europe. Ses recherches avaient abouti à des résultats qui ouvraient de nouvelles perspectives du point de vue scientifique. Le prince avait découvert des espèces animales et végétales jusqu'ici inconnues et donné une description très précise de la vie culturelle de la population autochtone du Brésil. Ses notes et les spécimens qu'il avait collectés permirent d'autre part au grand public de se faire une image de ces mondes fascinants et jusqu'alors inconnus.

LA DOCUMENTATION DU VOYAGE
Le prince était accompagné dans son voyage en Amérique du Nord par David Dreidoppel, un domestique de la cour princière de Neuwied qui avait déjà participé au voyage au Brésil où il avait apporté son expérience de chasseur et de taxidermiste. Si pendant son séjour au Brésil, le prince avait réalisé lui-même des dessins et des croquis, il recherchait à présent un artiste pour faire une documentation illustrée du voyage en Amérique, la qualité de ses propres œuvres ne l'ayant pas satisfait. Son choix se porta sur le jeune peintre paysagiste Karl Bodmer

travel and living expenses during the journey and to pay him a modest wage. During the expedition, the Prince repeatedly stressed that the Native people, in particular, should be depicted with the greatest possible accuracy. Visually documenting the people they encountered was of no less importance to him than finding new botanical and zoological specimens to add to his extensive collection.

Like Alexander von Humboldt and other scholars of the period, Maximilian Prince of Wied subscribed to the ideals of the Enlightenment. For him this meant first and foremost showing respect towards indigenous peoples and their cultures. Thus it was his avowed intention to document the life world of the North American Indian population in good time, before their unique culture was lost forever – as had already happened in the eastern states of America.

A SUCCESSFUL JOURNEY

On May 7, 1832, Maximilian Prince of Wied, Karl Bodmer and David Dreidoppel left the castle at Neuwied for Coblenz, from whence they travelled to Rotterdam, where the American sailing ship Janus took them to North America.

Their journey over the next 28 months was to take them from the east coast, along the courses of the Ohio, Mississippi and Missouri Rivers, to the remote Indian territories in the northern part of present-day Montana. On their return journey, they reached Fort Clark in the

veröffentlicht, und Maximilian versprach sich von ihm eine wirklichkeitsgetreue Darstellung der Tiere, Pflanzen und Menschen.

Mit einem Vertrag sicherte sich Maximilian Prinz zu Wied die Besitzrechte an den während der Reise gefertigten Bildwerken und verpflichtete sich, dem Künstler Fahrt und Aufenthalt sowie einen bescheidenen Lohn zu zahlen. Während der Expedition legte er immer wieder größten Wert darauf, dass der Künstler vor allem die indianischen Menschen in seinen Darstellungen mit größtmöglicher Genauigkeit abbildete. Die bildhafte Dokumentation der indigenen Bevölkerung war ihm mindestens ebenso wichtig wie das Aufspüren botanischer und zoologischer Belegstücke für seine umfangreiche Sammlung.

Wie Alexander von Humboldt und andere Gelehrte seiner Zeit sah sich Maximilian Prinz zu Wied den Idealen der Aufklärung verpflichtet. Dies bedeutete für ihn vor allem, indigene Menschen und ihre Kultur zu achten. Seine erklärte Absicht war es, die Lebenswelt der indianischen Bevölkerung in Nordamerika zu dokumentieren, bevor ihre einzigartige Kultur für immer verloren ging, wie dies in den amerikanischen Oststaaten bereits zu beobachten war.

de Zurich. Ce jeune homme de 23 ans s'était déjà fait un nom en tant que peintre paysagiste et avait publié de nombreuses gravures de paysages rhénans. Aussi Maximilien attendait-il de lui une représentation fidèle des animaux, des végétaux et des gens.

Le prince Maximilien de Wied-Neuwied s'assura par contrat les droits des œuvres réalisées pendant le voyage et, tout en prenant en charge le voyage et l'hébergement de l'artiste, s'engagea à lui verser un modeste salaire. Au fur et à mesure de l'expédition, il accorda de plus en plus d'importance à la fidélité des illustrations, surtout en ce qui concernait la représentation des Indiens. La documentation iconographique de la population autochtone lui tenait pour le moins autant à cœur que la découverte de spécimens botaniques et zoologiques destinés à venir enrichir sa collection.

Comme Alexandre von Humboldt et d'autres savants de son époque, le prince Maximilien de Wied-Neuwied se réclamait des idéaux des Lumières, ce qui pour lui signifiait surtout le respect des Indiens et de leur culture. Son intention déclarée était de documenter à temps ce qu'était la réalité de la population indienne d'Amérique du Nord, avant que cette civilisation unique ne disparaisse à jamais, comme on l'observait déjà dans les États américains de l'Est.

autumn of 1833, where they spent the winter and developed friendly relations with the neighbouring Mandan and Hidatsa tribes. In April 1834 they recommenced their return journey, again following the rivers, and after making a detour to the famous Niagara Falls, finally reached New York. They then set out across the Atlantic in mid-June, arriving in their homeland one month later. Once there, they had to work through the various impressions, experiences and written accounts with which they had returned, to catalogue the wealth of fascinating objects they had brought with them from the realms of the natural sciences and anthropology, and to reproduce Bodmer's paintings as prints.

For the Europeans, who had only just developed an interest in distant worlds, this journey to the North American interior was a curious undertaking, for the explorers were unable to predict what awaited them there. And even from an American point of view, this carefully documented expedition, guided solely by scientific interest, was something quite new. Meriwether Lewis (1774–1809) and William Clark (1770–1838) had also kept close records and collected specimens during their earlier exploration of the land route to the Pacific in 1803–1806. But this strategically motivated expedition failed to produce the detailed written and pictorial documentation of Native cultures that Prince of Wied and Karl Bodmer were to amass.

The American painter George Catlin (1796–1872) had travelled one year ahead of Prince Maximilian and Karl Bodmer up the Missouri, and returned with 135 paintings done in a

EINE ERTRAGREICHE EXPEDITION

Am 7. Mai 1832 verließen Maximilian Prinz zu Wied, Karl Bodmer und David Dreidoppel das Schloss in Neuwied, um sich von Koblenz aus auf den Weg nach Rotterdam zu machen. Von dort sollte sie das amerikanische Segelschiff »Janus« nach Nordamerika bringen.

Die Reise führte sie in den kommenden 28 Monaten von der Ostküste entlang der Wasserwege des Ohio, Mississippi und Missouri bis in die abgelegenen Indianergebiete im Norden des heutigen Montana. Auf ihrer Rückreise erreichten sie im Herbst 1833 Fort Clark, wo sie überwinterten und freundschaftliche Beziehungen zu den benachbarten Mandan und Hidatsa aufbauten. Im April 1834 folgten sie auf ihrer Rückreise wiederum den Flussläufen, machten einen Abstecher an die berühmten Niagarafälle, um schließlich nach New York zu gelangen. Mitte Juli überquerten sie dann den Atlantik, und einen Monat später waren sie wieder in heimischen Gefilden. Dort galt es, die zahlreichen Eindrücke, Erfahrungen und Berichte aufzuarbeiten, die Vielzahl mitgebrachter natur- und kulturwissenschaftlich interessanter Sammlungsobjekte zu katalogisieren und die Gemälde Bodmers in Form von Drucken zu reproduzieren.

Aus der Sicht der Europäer, die gerade ihr Interesse an fernen Welten entdeckten, war diese Reise in das Innere Nordamerikas ein ungewöhnliches Unterfangen, konnten die Reisenden doch nicht abschätzen, was sie erwartete und in welche gefährlichen Situationen sie

UNE EXPÉDITION FRUCTUEUSE

Le 7 mai 1832, le prince Maximilien de Wied-Neuwied, Karl Bodmer et David Dreidoppel quittaient le château de Neuwied et, depuis Coblence, se mettaient en route pour Rotterdam. De là, le voilier le « Janus » devait les emmener en Amérique du Nord.

Dans les 28 mois à venir, ce voyage devait les conduire, en longeant les voies navigables de l'Ohio, du Mississipi et du Missouri, de la côte est aux territoires indiens reculés du nord de l'actuel Montana. Au retour, ils atteignirent, à l'automne 1833, Fort-Clark où ils passèrent l'hiver et nouèrent des relations d'amitié avec leurs voisins mandan et hidatsa. Ils se remirent en route en avril 1834, suivant de nouveau le cours des fleuves et faisant un crochet par les célèbres chutes du Niagara avant de gagner enfin New York. Ils traversèrent l'Atlantique à la mi-juillet et un mois plus tard, ils étaient de retour dans leurs foyers. Il s'agissait à présent de mettre à jour la masse de leurs impressions, expériences et de leurs comptes rendus, de cataloguer, en fonction de leur intérêt scientifique et anthropologique, les nombreux objets de collection qu'ils avaient rapportés et de reproduire les aquarelles de Bodmer sous forme d'estampes.

Du point de vue des Européens, qui découvraient justement leur intérêt pour les contrées lointaines, ce voyage à l'intérieur de l'Amérique du Nord était une entreprise extraordinaire, les voyageurs ne pouvant pré-

mere 86 days. Another German naturalist, Duke Paul Wilhelm of Württemberg (1797–1860), had traced the Missouri from New Orleans to its source in the 1820s. His detailed records were, however, largely destroyed during the Second World War, so that since then Maximilian of Wied's copious diary entries and Karl Bodmer's accompanying visual documentation have proved to be of inestimable value, especially given the devastating smallpox epidemic of 1837, which killed countless people along the Missouri and brought profound changes to the cultural life of the area.

Today, the precise documentation of this expedition and Bodmer's highly expressive pictures serve as an important source – not least for the indigenous American peoples wishing to learn more about the life world of their forebears, which has long since disappeared.

Maximilian made a selection of Bodmer's numerous watercolours from the expedition for publication in his travel book. It is these pictures that were to colour the image of the American Indian in Europe, and that influence our understanding of Native Americans to this day.

geraten würden. Und selbst aus amerikanischer Perspektive war diese sorgfältig dokumentierte und wissenschaftlichen Interessen folgende Expedition ein Novum. Zwar hatten auch Meriwether Lewis (1774–1809) und William Clark (1770–1838) auf ihrer Suche nach dem Landweg zum Pazifik genau Buch geführt und Sammlungen von Belegstücken angelegt, jedoch ließ ihre strategisch motivierte Expedition (1803–1806) die detaillierte schriftliche und bildliche Dokumentation der indianischen Kulturen vermissen, wie sie Prinz zu Wied und Karl Bodmer erreichten.

Der amerikanische Maler George Catlin (1796–1872) reiste ein Jahr vor Prinz Maximilian und Karl Bodmer den Missouri hinauf und kehrte mit 135 Bildern zurück, die er innerhalb von nur 86 Tagen angefertigt hatte. Ein weiterer deutscher Naturforscher, Herzog Paul Wilhelm von Württemberg (1797–1860), hatte bereits in den 1820er Jahren von New Orleans kommend mehrfach den Missouri bereist und bis zum Ursprung erkundet, doch sind seine detaillierten Aufzeichnungen zum größten Teil im Zweiten Weltkrieg vernichtet worden.

Die ausführlichen Tagebuchaufzeichnungen von Maximilian zu Wied und die auf sie abgestimmte visuelle Dokumentation durch Karl Bodmer sind vor diesem Hintergrund von unschätzbarem Wert, zumal verheerende Pockenepidemien 1837 unzähligen Menschen entlang des Missouri den Tod brachten und das kultu-

voir ce qui les attendait ni se douter des situations périlleuses auxquelles ils devraient faire face. Et même de celui des Américains, ce voyage qui avait été soigneusement préparé et poursuivait des objectifs scientifiques, était quelque chose de tout à fait nouveau. Certes, Meriwether Lewis (1774–1809) et William Clark (1770–1838), en cherchant une voie de terre pour atteindre le Pacifique, avaient eux aussi tenu un compte très précis de leur voyage et constitué des collections d'objets, mais leur expédition, qui obéissait à des motifs stratégiques (1803–1806), restait très discrète sur les civilisations indiennes, et il manquait à leur documentation ces détails dont faisaient preuve les textes et les images du prince de Wied-Neuwied et de Karl Bodmer.

Un an avant l'expédition du prince Maximilien et de Karl Bodmer, le peintre américain George Catlin (1796–1872) avait remonté le Missouri et rapporté de son voyage 135 peintures, réalisées en l'espace de seulement 86 jours. Partant de la Nouvelle-Orléans, un autre naturaliste allemand, le duc Paul Wilhelm von Württemberg (1797–1860), avait déjà exploré le Missouri et était remonté jusqu'à sa source. Mais ses notes, très concises, ont été en grande partie détruites pendant le Seconde Guerre mondiale.

Aussi, étant donné le contexte, la correspondance harmonieuse des notes détaillées du journal de Maximilien de Wied-Neuwied et de la documentation visuelle de Karl Bodmer est-elle d'une valeur inestimable, d'autant

The comprehensive descriptions that Prince Maximilian wrote on his travels continue to be an important source. Whilst the original publication, which appeared in the years 1839–1841, gave the text and pictures in separate volumes, the present book has chosen to link selected texts from the Prince's extensive descriptions of his travels with Karl Bodmer's pictures. In this way the illustrations, with their exceptional artistry, are complemented by the important background information and atmospheric descriptions of the journey that are contained in the texts.

The lengthy quotations are based on Evans Lloyd's English translation of the first edition of the diary, which appeared in 1843. However, the Prince's notes were greatly abridged for Lloyd's translation and the passages that we selected therefore needed revision and completion. The captions to the illustrations have been taken, unaltered, from Karl Bodmer's original engravings.

relle Leben tiefgreifend veränderten. Heute bieten die genaue Dokumentation der Reise und die ausdrucksstarken Bilder Bodmers eine wichtige Quelle nicht zuletzt für die Indianer selbst, die mehr über die untergegangene Lebenswelt ihrer Vorfahren erfahren möchten.

Für die Publikation seines Reisewerks traf Maximilian eine Auswahl unter den zahlreichen Aquarellen, die Bodmer während der Reise geschaffen hatte. Diese Bildwerke waren es, die das Indianerbild in Europa prägen sollten und unsere Vorstellung von den Indianern bis heute beeinflussen.

ZUM VORLIEGENDEN REPRINT

Bis heute gelten die ausführlichen Reisebeschreibungen des Prinzen Maximilian zu Wied als bedeutende Quelle. Hatte die ursprüngliche Publikation, veröffentlicht in den Jahren 1839–1941, Bild und Text getrennt wiedergegeben, verknüpft der vorliegende Band ausgewählte Texte der umfangreichen Reisebeschreibungen Maximilians mit den Bildern Karl Bodmers. Über die besondere künstlerische Qualität der Abbildungen hinaus vermitteln so die Texte wichtige Hintergrundinformationen und Stimmungsbilder der Reise. Die ausführlichen Zitate stammen aus der Originalausgabe, deren Orthographie und Interpunktion übernommen wurde. Die Bildlegenden folgen den Angaben auf Karl Bodmers Stichen.

qu'en 1837, des épidémies de variole décimèrent une grande partie de la population des rives du Missouri et apportèrent de profonds bouleversements culturels. La documentation précise du voyage et les images très expressives de Bodmer représentent aujourd'hui une source importante d'informations, aussi et surtout pour les Indiens désireux d'en savoir davantage sur le mode de vie, depuis longtemps disparu, de leurs ancêtres.

Maximilien sélectionna, en vue de la publication, de nombreuses aquarelles peintes par Bodmer pendant le voyage. Ce sont ces œuvres qui devaient façonner l'image que l'Europe se fit des Indiens, image dont l'influence est du reste toujours sensible aujourd'hui.

À PROPOS DE LA PRÉSENTE ÉDITION

Les récits de voyage détaillés du prince Maximilien sont encore considérés aujourd'hui comme une source précieuse. Tandis que dans leur édition originale, publiée dans les années 1839–1941, le texte et les images étaient séparés, cet ouvrage se propose de réunir des extraits du texte considérable de Maximilien et les images de Karl Bodmer. Outre la qualité artistique des illustrations, les textes donnent des informations sur les détails cachés de ce voyage et permettent d'en reconstituer l'atmosphère.

Les citations proviennent de la traduction française de l'édition originale de 1841–1843, dont l'orthographe a été respectée. Les légendes des illustrations suivent les indications données par les gravures de Karl Bodmer.

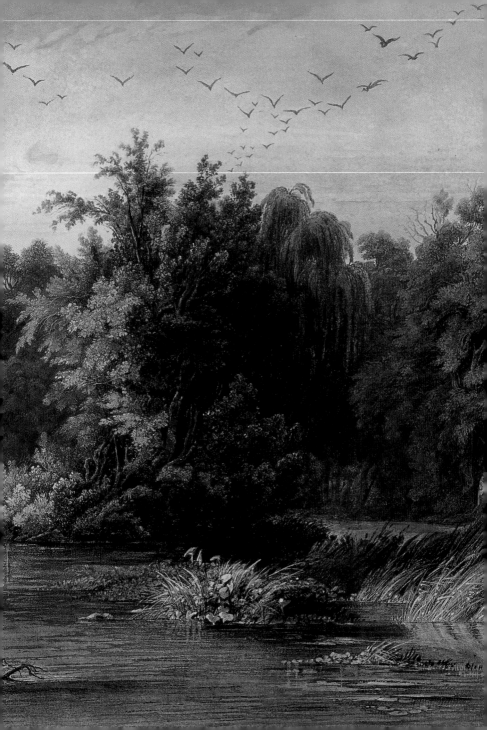

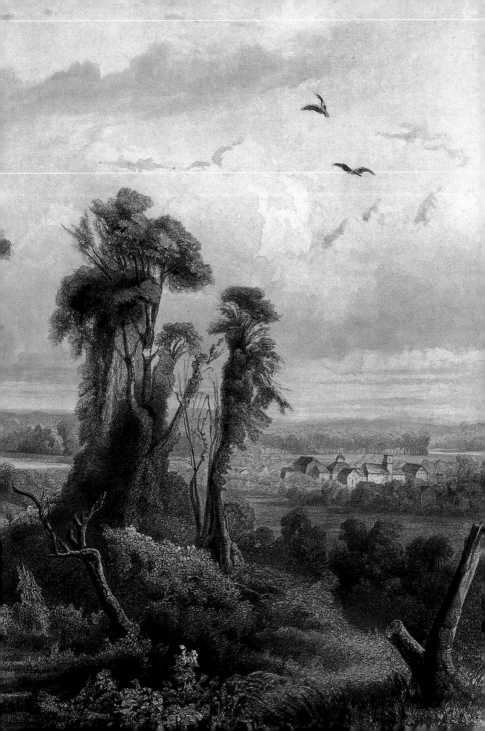

FOREST SCENE ON THE LEHIGH
(PENNSYLVANIA)

The road through the Lehigh Valley, which we took on the evening of the 31st of August [1833], was agreeable and diversified. A violent thunderstorm had passed over the valley, and had poured down torrents of rain, traces of which were everywhere visible. We proceeded along the right bank of the river, on a rather sandy road, shaded by old trees. On our right hand we had at first steep wooded mountains, where Rubus odoratus and other beautiful plants grew amongst rude rocks. The mountains then receded and gave way to fields, meadows, and detached dwellings as we approached Lehighton, where the sign of the inn was visible from afar off.

WALD-ANSICHT AM LECHA
(PENSYLVANIEN)

Der Weg durch das Lecha-Thal, welchem wir am 31. August [1833] Abends folgten, ist angenehm und abwechselnd. Ein heftiges Gewitter war über dem Thale herauf gezogen und hatte besonders mehr abwärts Regenfluthen herab gesendet, wovon wir überall die Spuren bemerkten. Man folgt dem rechten Flussufer auf etwas sandigem Wege, der von alten Bäumen beschattet ist. Zur Rechten hatten wir anfänglich den steilen bewaldeten Berg, wo Rubus odoratus u. a. schöne Pflanzen in wilden Felsen wachsen. Die Berge ziehen sich dann zurück und Felder, Wiesen und einzelne Wohnungen treten zur Rechten an die Stelle des Waldberges. Man erreicht das Dorf Lehighton, wo der hohe Schild des Gasthofes sich von ferne zeigt.

FORÊT SUR LE LEHIGH
(PENSYLVANIE)

Le chemin qui, en partant de Mauch – Chunk, suit la vallée du Lehigh, et que nous parcourûmes dans la soirée du 31 août [1833], est agréable et varié. Un orage terrible grondait sur la vallée qu'avaient inondée des torrents de pluie, dont nous retrouvâmes partout la trace. La route, le long de la rive droite de la rivière, est un peu sablonneuse et ombragée par de grands arbres. Dans les commencements nous eûmes, sur notre droite, une montagne escarpée et boisée où le Rubus odoratus et d'autres belles plantes croissaient dans les fentes des rochers. Un peu plus avant, les montagnes s'éloignent et sont remplacées par des champs, des prairies et des habitations éparses. Bientôt nous arrivâmes au village de Lehighton, dont l'auberge se reconnaît de loin à son enseigne.

NEW HARMONY ON THE WABASH

At Harmony the Wabash divides, the easterly arm becoming Cut-off River, while further down it breaks up into several branches, forming many wooded islands, the largest of which are inhabited. From the wooded ridge bordering the lowland one has a most delightful view of the town and the region, and it was from here that Herr Bodmer painted his excellent view of New Harmony.

New Harmony is surrounded on all sides by fields, which are from 600 to 800 paces wide; all around are lofty forests, where settlers have cultivated detached patches. These people are generally called backwoodsmen, and they live like half savages, without any education or religious instruction. The forests which they inhabit are extensive, and the soil extremely fertile: vegetation is much more luxuriant than to the east of the Alleghanys.

NEW-HARMONY AM WABASH

Der Wabash theilt sich bei Harmony in zwei Arme, wovon man den östlichen Cutoff-River nennt, weiter hin aber in mehrere, und bildet viele waldige Inseln, von welchen die grösseren bewohnt sind. Auf der die Niederung begrenzenden bewaldeten Hügelkette hat man eine hübsche Ansicht der Gegend und des Ortes, und hier hat Herr Bodmer auch die sehr treue Ansicht von New-Harmony aufgenommen.

New-Harmony ist überall von seinen Feldern umgeben, die etwa 6[00] bis 800 Schritte im Durchmesser halten, alsdann erheben sich rundum hohe Waldungen, in welchen überall einzeln vertheilt die Ansiedler ihre Feldchen angelegt haben. Man kennt diese Leute gewöhnlich unter dem Namen der Backwoodsmen, da sie wie halbe Wilde, zum Theil ohne Schulunterricht und ohne Geistliche aufwachsen. Die Wälder, welche sie bewohnen, sind höchst ausgedehnt, ihr Boden höchst fruchtbar. Die Natur ist hier weit kräftiger und üppiger als östlich von den Alleghanys.

NEW-HARMONY SUR LE WABASH

Le Wabash se divise, près d'Harmony, en deux bras, dont le plus oriental s'appelle Cutoff-River. Plus loin ces deux bras se subdivisent en plusieurs autres et forment un grand nombre d'îles boisées dont les plus considérables sont habitées. Du haut des collines qui bordent la vallée on jouit d'un beau point de vue sur le village et ses environs; M. Bodmer a dessiné de ce site une vue de New-Harmony.

New-Harmony est entouré de tous les côtés de champs cultivés qui peuvent avoir de six à huit cents pas de diamètre; par derrière s'élèvent partout de hautes forêts, au milieu desquelles des colons isolés ont défriché et ensemencé de petits carrés de terre. Ces hommes sont généralement connus sous le nom de backwoodsmen; ils mènent une vie à demi sauvage, ne reçoivent presque aucune instruction et sont entièrement privés des secours de la religion. Les bois qu'ils habitent sont d'une vaste étendue et extrêmement fertiles. La nature y est beaucoup plus vigoureuse et plus riche que sur le versant oriental des Alleghanys.

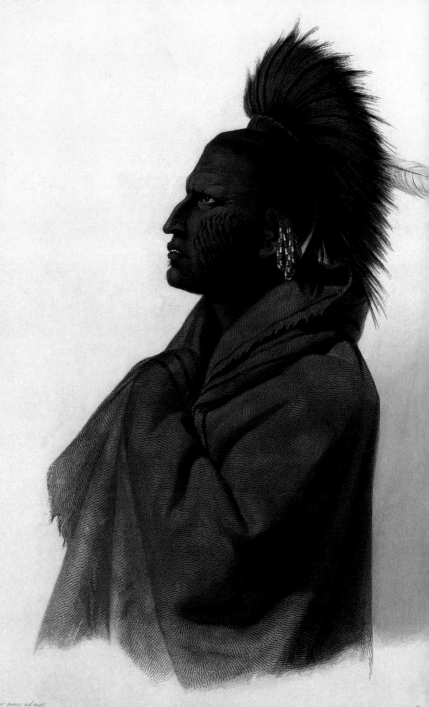

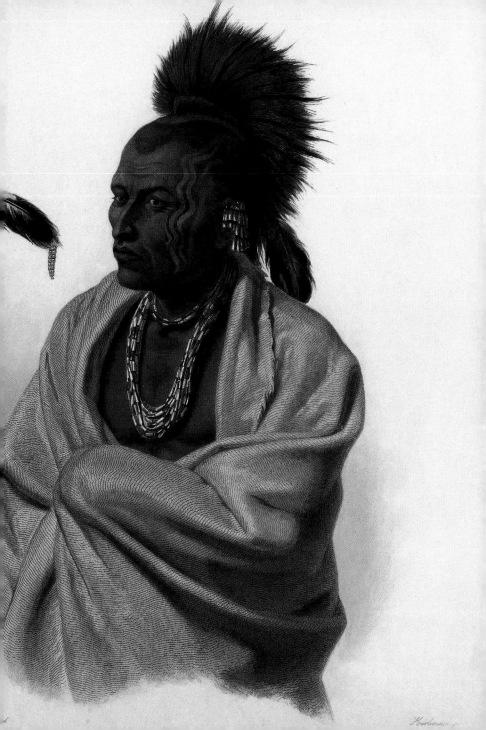

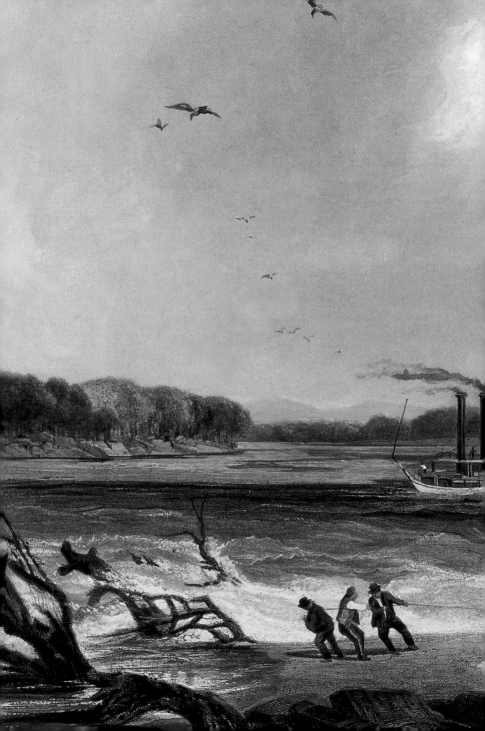

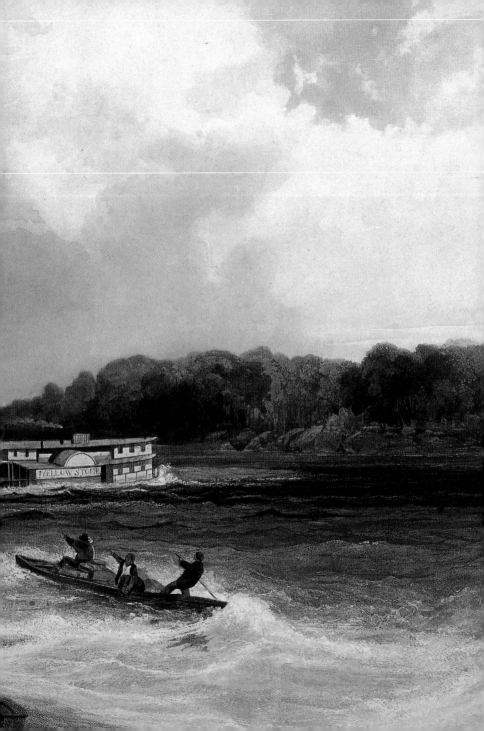

MÁSSIKA – SAKI INDIAN
WAKUSÁSSE – MUSQUAKE INDIAN

A tall, handsome Sauk Indian, called Mássika (the tortoise), had a bold, fierce countenance, and an aquiline nose; his cordiality was very striking; his brown eyes sparkled, and his white teeth looked quite dazzling, in contrast with the dark brown face, which had a good deal of red paint on it. The Sauk and Fox Indians shave all the hair off their heads except for a small tuft behind. The chief ornament of the head is the deer's tail, a tuft of hair from the tail of the Virginian stag. This is mainly white, with black streaks, the white part being dyed red with vermilion.

MÁSSIKA – SÁKI INDIANER
WAKUSÁSSE – MUSQUAKE INDIANER

Ein grosser schöner Sáki Indianer, Mássika (die Schildkröte), von 5 Fuss 10 Zoll Höhe, hatte ein kühnes, wildes Gesicht und eine Adlernase. Seine Freundlichkeit war besonders ausdrucksvoll, die schwarzbraunen Augen funkelten alsdann, und die schneeweissen Zähne glänzten in dem dunkelbraunen, gewöhnlich zinnoberroth angestrichenen Gesichte.

Ihre Haare trugen die Sákis und Foxes über den ganzen Kopf abrasirt, mit Ausnahme eines schmalen Haarbusches oder Streifens am Hinterkopfe, welchen sie meistens gleich einer Bürste kurz geschnitten hatten, und der in einen dünnen Haarzopf sich verlor, welcher geflochten wurde, um daran die Haupt-Kopfzierrath, den sogenannten Hirschschwanz (Deerstial) zu befestigen, einen Busch der Schwanzhaare des virginischen Hirsches, weiss mit einigen schwarzen Haaren, dessen weisser Theil mit Zinnober roth gefärbt wird.

MÁSSIKA – INDIEN SAKI
WAKUSÁSSE – INDIEN MUSQUAKE (RENARD)

Un grand et bel Indien Saki, Mássika (la Tortue), de cinq pieds dix pouces, avait les traits hardis et sauvages, et le nez aquilin. Quand il voulait être aimable, ses manières étaient singulièrement expressives; ses yeux noirs étincelaient, et ses dents, blanches comme la neige, brillaient dans son visage cuivré et ordinairement peint en rouge.

Les Sacs [Sauks] et les Renards [Fox] portaient les cheveux rasés sur toute la tête, à l'exception d'une petite touffe ou mèche par derrière, que la plupart d'entre eux avaient coupée courte comme une brosse, et qui aboutissait en une étroite queue tressée, à laquelle ils attachaient la coiffure appelée queue de cerf et qui se compose effectivement d'une touffe de poils de la queue du cerf de Virginie; ces poils sont blancs, mêlés de quelques poils noirs, mais la partie blanche est teinte en rouge avec du cinabre yeux.

Mouth of Fox River · Mündung des Fox-Rivers · Embouchure du Fox-River

THE STEAMER

Yellow Stone on the 19th April 1833

On the following morning the air was murky; no doubt from the smoke of a prairie fire. At nine o'clock it was already 65 degrees Fahrenheit. The ship was lying stranded on a sand bank about 3½ miles from Fort Osage. However, since it was moving slightly, they tried to lighten it by unloading some of the cargo. A flat boat was procured and sent several times, fully loaded, to the river bank, where the goods were piled up in the wood and covered with cloths. During these manoeuvres, the hunters went out and spotted some venison but came back with no more than a few squirrels. By midday it was 70½ degrees Fahrenheit. Herr Bodmer made a faithful record of the scene of the steamer's cargo being shifted onto the flat boat.

Around four o'clock in the afternoon, through the combined efforts of the whole crew, the Yellow Stone was finally pulled off the sand bank into deeper water on the right-hand bank of the river just below the mouth of Fishing Creek.

DAS DAMPFBOOT

Yellow-Stone am 19ten April 1833

Am folgenden Morgen (19. April) war die Atmosphäre trübe, ohne Zweifel durch einen Prairie-Brand; um 9 Uhr 65° Fahr[enheit]. Das Schiff lag noch immer 3½ Meilen von Fort-Osage auf der Sandbank, bewegte sich jedoch ein wenig, und man versuchte dasselbe durch Ausladen zu erleichtern. Ein Flatboat (flaches Fahrzeug oder eine flache viereckige Fähre) wurde aus der Nähe herbei geschafft, mit einem Theile der Waaren beladen, und auf diese Art mehrmals an das Land gesendet, wo man die Güter am Ufer im Walde aufschichtete und mit Tüchern bedeckte. Während dessen waren die Jäger ausgegangen, welche zwar ein Rudel Wildpret sahen, aber nichts erlegten, als einige Eichhörnchen. Um 12 Uhr am Mittage 70½° Fahr[enheit]. Herr Bodmer hatte die Scene sehr treu gezeichnet, wo das Dampfschiff durch das platte Fahrzeug erleichtert ward.

Um 4 Uhr nach Mittag war es endlich den vereinten Anstrengungen der Mannschaft gelungen, die Yellow-Stone von der Sandbank zu ziehen, und etwas unterhalb des einfallenden Fishing-Creek an das rechte Ufer in tieferes Wasser zu bringen.

LE BATEAU À VAPEUR

Yellow-Stone, le 19 april 1833

Le lendemain matin, 19 avril, le ciel était couvert d'une espèce de brume, provenant sans doute de l'incendie d'une prairie; à 9 heures, 65° Fahr. (14°7 Réaum.). Le bâtiment était toujours échoué sur un banc de sable, à 3½ milles du Fort-Osage. Il remuait pourtant un peu, et l'on essaya de l'alléger en le déchargeant. On se procura du voisinage un bateau plat, sur lequel on plaça une partie de la cargaison que l'on débarqua ainsi, en plusieurs voyages, sur la rive où l'on empila les marchandises que l'on couvrit de toiles. Pendant ce temps, les chasseurs étaient sortis. Ils rencontrèrent à la vérité du gibier, mais ne tuèrent qu'un écureuil. À midi, 70½° Fahrenheit M. Bodmer avait dessiné très fidèlement le lieu où le pyroscaphe fut allégé par le bateau plat.

À quatre heures de l'après-midi, on était enfin parvenu à tirer le Yellow-Stone du banc de sable, et à l'amener dans une eau plus profonde sur la rive droite, un peu au-dessous du confluent du Fishing-Creek.

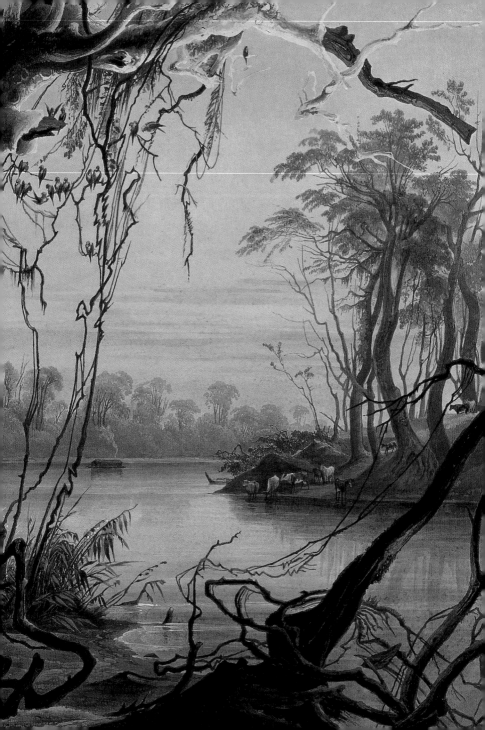

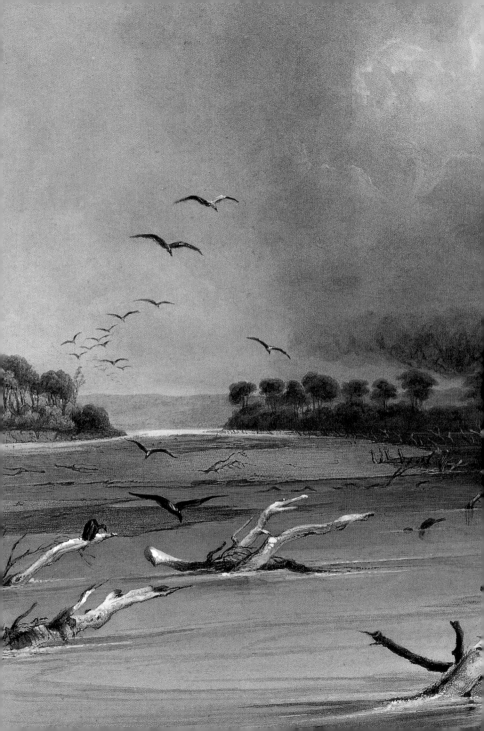

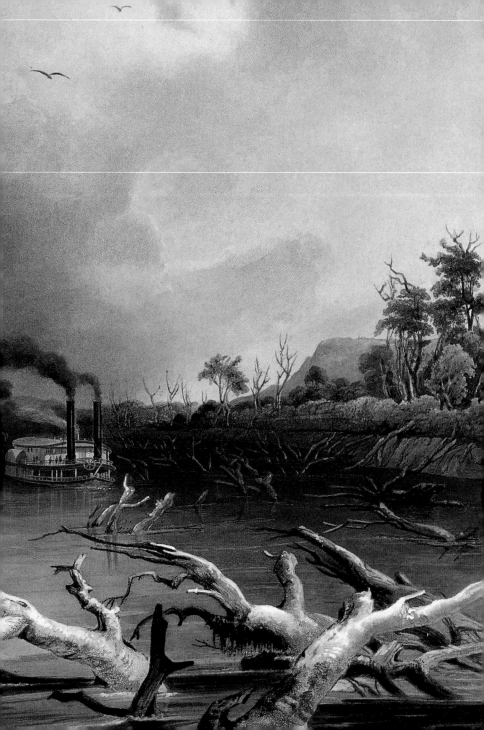

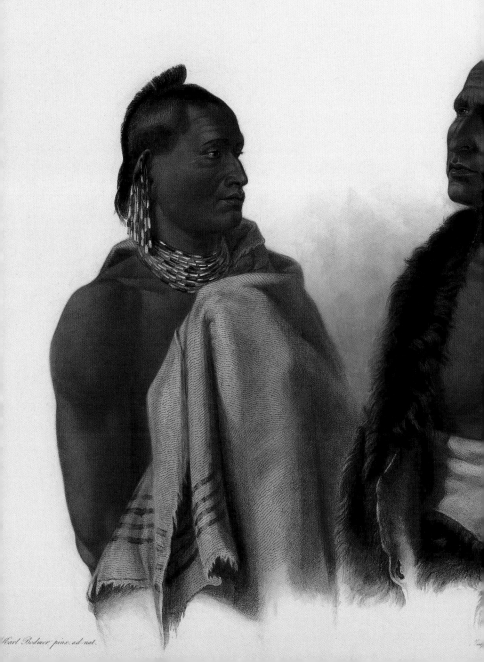

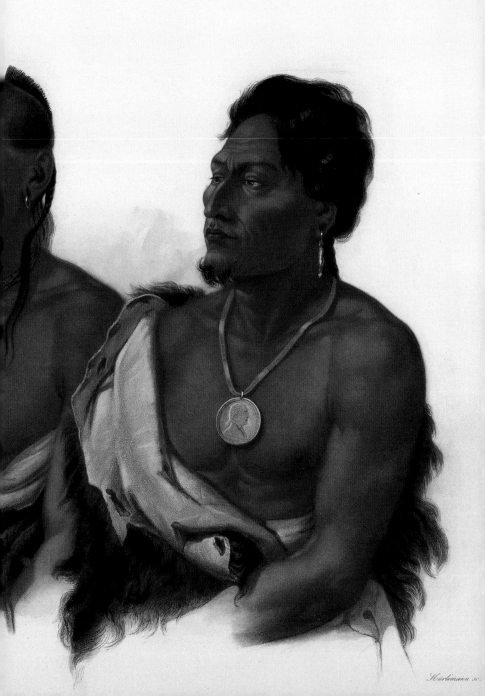

SNAGS
(SUNKEN TREES ON THE MISSOURI)

On the morning of the 17th [April 1833] we saw only an uninterrupted forest, and in the course of the day we again encountered much danger from the quantity of snags, which, in some places, scarcely left a channel of 10 feet in breadth; but our pilot steered with great dexterity between all these danger spots, where many a smaller vessel had been wrecked.

During this hazardous navigation, we were all on deck, anxiously watching the boat's progress as she wove her way through the tree trunks and other obstacles, but everything went off well and we observed several highly interesting scenes.

SNAGS
(IM MISSOURI VERSUNKENE BAUMSTÄMME)

Am 17. [April 1833] früh, bei einer Temperatur von +5°, erblickten wir nun ununterbrochenen Wald. In der Nähe von Tabeau's-River lief die Yellow-Stone über einige dicke, auf dem Grund liegende Stämme, zerquetschte und zerbrach sie zum Theil, wobei ein grosser Baum mit seinen Wurzeln herauf kam und, sich wie eine colossale Schlange wand. Man fand nun mehr Tiefe am rechten Ufer, welches dergestalt weggerissen war, dass ein daselbst stehendes kleines Gebäude halb frei in der Luft hieng. Eine gefährliche Stelle mit sehr vielen Treibholzstämmen, welche das Schiff auf die Seite neigten und eine Radschaufel zerbrachen, wurde glücklich zurück gelegt.

Da das Wetter heute wärmer war, als zuvor, so konnte man den ganzen Tag auf der Galle-rie des Schiffes zubringen, und dasselbe über die Baumstämme und andere Hindernisse hinauf laufen sehen, wo es öfters höchst interessante Scenen zu beobachten gab.

SNAGS (TRONCS D'ARBRES OBSTRUANT
LE COURS DU MISSOURI)

Le 17 au matin, la température était de 5°; nous ne vîmes de tous côtés qu'une forêt non inter-rompue. Dans les environs de Tabeau's-River, notre bâtiment passa par-dessus quelques gros troncs, les brisa et les écrasa en partie; sur quoi un grand arbre s'éleva sur l'eau avec ses racines, en se tortillant comme un serpent colossal. Sur la rive droite, l'eau fut après cela plus profonde; elle l'avait tellement creusée, qu'une petite maison qui y avait été construite se montrait en quelque façon suspendue dans l'air. Nous dépassâmes heureusement un endroit dangereux par la quantité de bois flotté, qui fit pencher notre bâtiment et cassa une des rames de nos roues.

Le temps était plus chaud qu'il n'avait encore été; nous pûmes rester toute la journée sur le pont, d'où nous voyions le bâtiment franchir les troncs d'arbres et les autres obstacles, ce qui nous fournissait souvent les scènes les plus intéressantes.

MISSOURI INDIAN, OTO INDIAN, CHIEF OF THE PUNCAS [SCHU·DE·GA·CHEH]

They [the Ponca] are all robust, good-looking men, tall, and well-proportioned, with strongly-marked features, high cheek-bones, aquiline noses, and animated dark hazel eyes. Their hair hangs down as far as the shoulders, and parts of it lower; that of the chief was shorter, and fastened together in a plait. The upper part of the body of these Indians is naked except for an ornamental band worn around the neck. They have large slits in their ears, and from those of the chief an ornament of shell work is suspended. His beard below the chin consists of scanty hairs, which have been allowed to grow very long.

MISSOURI INDIANER, OTO INDIANER, CHEF DER PUNCAS [SCHU·DE·GAH·CHEH]

Sie [die Punca Indianer] waren sämmtlich ansehnliche, starke Männer, gross und wohl gebildet, mit stark ausgewirkten Zügen, hohen Backenknochen, stark gebogenen Nasen und feurigen, dunkel schwarzbraunen Augen. Ihre Haare hingen zum Theil bis gegen, auch wohl über die Schultern hinab, bei dem Chef [Schu-de-gah-cheh, der welcher raucht] waren sie kürzer gehalten und hinten in eine Flechte zusammen gedreht. Am Oberleibe waren diese Indianer nackt, nur um den Hals trugen sie ein verziertes Band, in den Ohrläppchen eine grosse Oeffnung, bei dem Chef mit einem Zierrathe von Muscheln behängt. Seinen Bart unter dem Kinne, der nur aus langen, sparsamen Haaren bestand, hatte er lang wachsen lassen.

INDIEN MISSOURI, INDIEN OTO, CHEF DES PUNCAS [CHOUDEGACHÉH]

Ils étaient tous trois distingués et forts, grands et bien bâtis, avec des traits fort marqués, les os des joues proéminents, le nez très aquilin et les yeux expressifs et noirs. Leur chevelures pendaient jusque sur leurs épaules et même plus bas; les cheveux du chef étaient un peu plus courts et rassemblés par derrière en une tresse. Ces Indiens étaient nus jusqu'à la ceinture et portaient seulement autour du cou un ruban orné. Leurs oreilles étaient percées de grands trous auxquels pendait, chez le chef, un ornement de coquillages. Il avait laissé croître sa barbe sous son menton, laquelle du reste ne se composait que de quelques poils longs et épars.

A SIOUX WARRIOR

Mr. Bodmer having expressed a wish, to paint a full-length portrait immediately, the Big Soldier [Wahktägeli] arrived in his complete state dress. His face was painted vermilion red with short, black, parallel stripes across his cheeks. On his head he wore long feathers of birds of prey, as tokens of his warlike exploits, particularly of the enemies he had slain. They were fastened in a horizontal position with strips of red cloth. In his ears he wore long strings of blue glass beads, and on his breast, suspended from his neck, the great silver medal of the United States. His leather leggins, painted with dark crosses and stripes, were very neatly ornamented with a broad band of yellow, red, and sky-blue figures, embroidered in dyed porcupine quills, and his shoes were adorned in the same manner. His buffalo robe was tanned white, and he held his toma-hawk or battle-axe in his hand.

DACOTA KRIEGER

Da Herr Bodmer sogleich bei seiner Ankunft, den Big-Soldier [Wahk-tä-g-eli, großer Soldat] in ganzer Figur malen wollte, so erschien dieser in seinem ganzen Staat, das Gesicht mit Zinnober roth angestrichen, und mit kurzen schwarzen parallelen Querstreifen auf den Backen. Auf dem Kopfe trug er lange Raubvogelfedern kreuz und quer durch einander, Zeichen seiner Helden-thaten, besonders der erlegten Feinde. Sie waren in horizontaler Lage mit rothen Tuchstreifen befestigt. In den Ohren trug er lange Schnüre von blauen Glasperlen, und um den Hals auf der Brust hängend die grosse Silber-Medaille der Vereinten Staaten. Seine Beinkleider oder Leggings von Leder mit dunklen Kreuzen und Streifen bemalt, waren an der Aussenseite höchst nett mit einem breiten gestickten Streifen von gelben, rothen und himmelblauen Figuren von gefärbten Stachelschweinstacheln, und die Schuhe auf eben diese Art verziert. Seine Bisonrobe war weiss gegerbt, und in der Hand trug er seinen Tomahack oder Streitaxt.

GUERRIER DACOTA

M. Bodmer voulant, dès son arrivée, peindre le Big-Soldier [Wahk-Tä-Ge-Li, Guerrier – Valeu-reux] en pied, celui-ci se présenta en grande toilette, le visage peint en rouge avec du cinabre, et de courtes raies noires parallèles sur les joues. Sur la tête, il portait des plumes d'oiseaux de proie, placées sans ordre ; c'étaient des trophées de ses exploits, et notamment des ennemis qu'il avait tués. Elles étaient attachées horizontalement par des bandes de drap rouge. Ses oreilles étaient parées de longs cordons de grains de verre bleus, et sur sa poitrine pendait, à un cordon passé au-tour du cou, la grande médaille d'argent des États-Unis. Sa culotte, ou ses leggings de cuir, peinte avec des croix et des raies de couleur sombre, était ornée extérieurement, avec beaucoup de goût, d'une large bande brodée avec des piquants de porc-épic en figures jaunes, rouges et bleues. Ses souliers étaient ornés de la même manière. Sa robe de bison était blanche par le bas, et à la main il tenait son tomahawk ou hache d'armes.

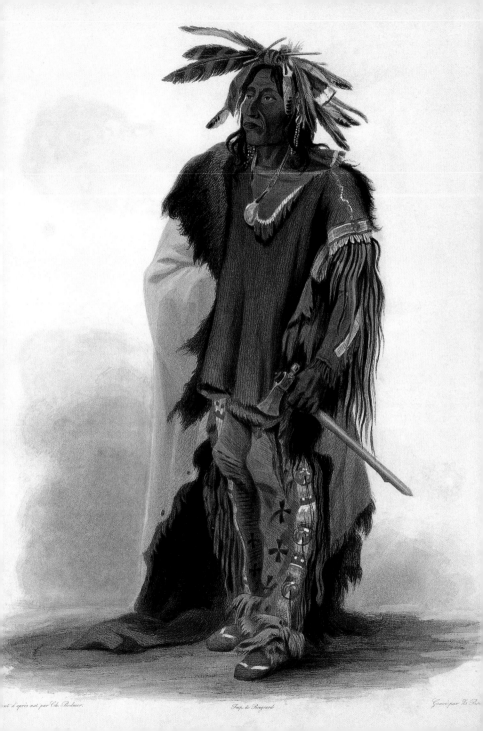

nt d'après nat. par Ch. Bodmer. Imp. de Bougeard. Gravé par Th. Bo...

DACOTA WOMAN
AND ASSINIBOIN GIRL

The women wear their hair hanging down, naturally parted down the middle of the head, with the parting painted red. Their robes are coloured red and black, as the portrait of Chan-Chä-Uiá-Te-Üinn (a woman of the Crow nation) shows. Various figures are neatly embroidered with dyed porcupine quills on their shoes.

DACOTA INDIANERIN
UND ASSINIBOIN MÄDCHEN

Die Weiber tragen die Haare natürlich herabhängend, auf der Mitte des Kopfes gescheitelt und die Scheitellinie roth angestrichen. Ihre Roben waren roth und schwarz bemalt, wie die Abbildung der Chan-Chä-Uiá-Te-Üinn (Weib von der Crow-Nation) zeigt, die Schuhe mit allerhand Figuren von gefärbten Stachelschweinstacheln nett verziert.

INDIENNE DACOTA
ET JEUNE FILLE ASSINIBOINE

Les femmes portent leurs cheveux retombant naturellement, séparés au milieu de la tête, et la ligne de séparation peinte en rouge. Leurs robes étaient peintes en rouge et noir, ainsi qu'on peut le voir au portrait de Chan-Ché-Ouié-Te-Üinn (le ch guttural, l'an nasal, ainsi que les autres syllabes. Ce nom signifie : Femme de la nation des Corbeaux). Leurs souliers étaient ornés avec goût de piquants de porc-épic, coloriés et disposés en toutes sortes de figures.

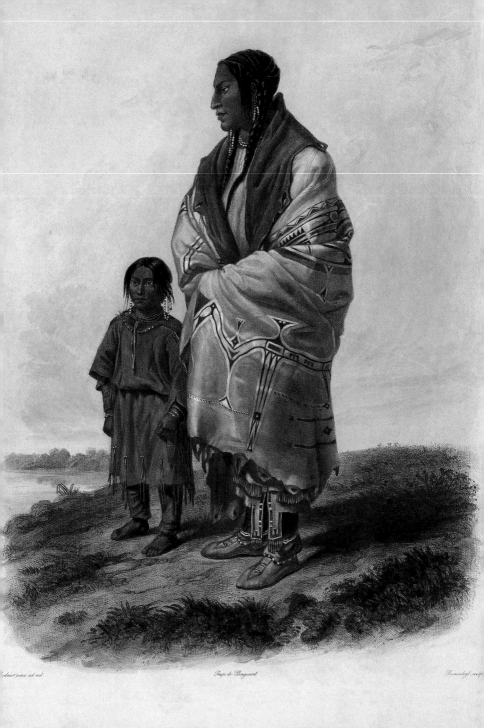

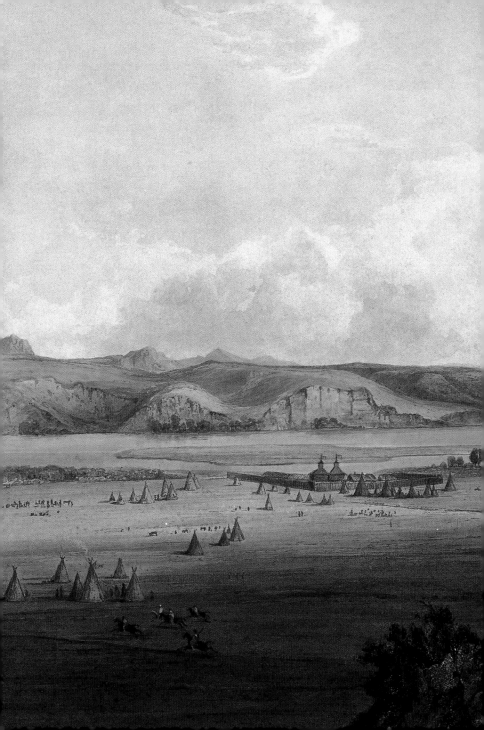

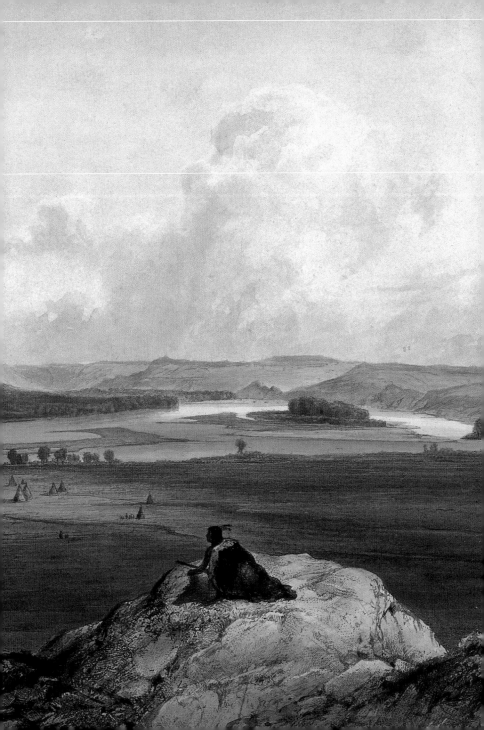

ONWARD TO FORT PIERRE

The steamer had proceeded a little further, when we came in sight of the fort, to the great joy of all on board: the colours were hoisted, both on the steamer and on the fort, which produced a very good effect between the trees on the bank. A small village, consisting of 13 Sioux tents, lay on the left hand side. Fort Pierre is one of the most considerable settlements of the Fur Company on the Missouri, and forms a large quadrangle, surrounded by high pickets.

WEITERREISE BIS FORT PIERRE

Nachdem das Dampfschiff etwas vorgerückt war, erblickten wir das Fort, und Freude äusserte sich allgemein! Man zog gegenseitig die Flagge auf. Das Fort, welches aus den Bäumen am Ufer hervorblickte, nahm sich nett aus; ein Dörfchen von 13 Dacota-Zelten lag links daneben und gewährte mit seinen Kegelgestalten einen eigenthümlichen Anblick. Fort Pierre ist eine der ansehnlichsten Niederlassungen der Fur-Company am Missouri und bildet ein grosses, von hohen Pickets umgebenes Quadrat.

POURSUITE DU VOYAGE À FORT-PIERRE

Après que le bateau à vapeur eut avancé un peu, nous aperçûmes le fort, et la joie à cet aspect fut générale ; de part et d'autre on hissa le pavillon. Le fort, que l'on distinguait à travers les arbres de la rive, faisait un très joli effet ; à gauche, il y avait un petit village de treize tentes de Dakotas, dont le sommet conique offrait un aspect original. Le Fort-Pierre est un des établissements les plus importants de la Compagnie des Pelleteries sur le Missouri. Il forme un grand carré entouré de piquets élevés.

FUNERAL SCAFFOLD OF A SIOUX CHIEF
NEAR FORT PIERRE

Among the peculiar customs of the Dakota [Sioux] is their treatment of the dead. Those who die at home are sewed up in blankets and skins, in their complete dress, painted, and laid with their arms and other effects on a high stage, supported by four poles, till they have decomposed, when they are sometimes buried. Those who have been killed in battle are immediately interred on the spot. Sometimes, too, in times of peace, they bury their dead in the ground, and protect them against the wolves by a fence of wood and thorns. Very often, however, they lay their dead in trees.

Before their death, they usually state whether they wish to be buried, or to be placed on a stage or in a tree.

TODTENGERÜSTE EINES SIOUX CHEFS
BEI FORT PIERRE

Zu den charakteristischen Zügen der Dacota's [Sioux] gehört ihre Art die Todten zu behandeln. Die zu Hause Verstorbenen pflegen sie in Decken und Felle eingeschnürt, in ihrem ganzen Anzuge, bemalt und mit ihren Waffen und anderen Geräthschaften auf einem hohen auf vier Pfählen ruhenden Gerüste nieder zu legen, bis sie verwest sind, wo man sie zuweilen begräbt. Gewaltsam vor dem Feinde Gebliebene begräbt man auf der Stelle in der Erde. Auch in der Ruhe begraben sie ihre Leichen zuweilen in die Erde und schützen sie durch Holz und Dornen vor den Wölfen. Sehr oft aber legen sie ihre Todten auch in ästige Bäume.

Sie bestimmen gewöhnlich vor ihrem Tode, wie sie beigesetzt seyn wollen, ob in der Erde, auf einem Gerüste oder auf einem Baume.

ÉCHAFAUDAGE FUNÉRAIRE D'UN CHEF SIOUX
PRÈS DU FORT PIERRE

Un des traits les plus caractéristiques des Dakotas [Sioux] est la manière dont ils traitent leurs morts. Ceux qui meurent chez eux sont, comme je l'ai déjà dit, enveloppés de couvertures et de peaux, et placés tout habillés, peints, et avec leurs armes et autres ustensiles, sur un échafaud soutenu par quatre piliers, où ils restent jusqu'à ce qu'ils soient décomposés, après quoi on les enterre quelquefois. Ceux qui sont tués en combattant sont enterrés sur le champ de bataille. Même en temps de paix, ils déposent leurs morts dans la terre, et les protègent contre les loups par du bois et des épines. Souvent ils déposent leurs morts dans les branches des arbres.

Avant leur mort, ils ont coutume de fixer la manière dont ils veulent être ensevelis ; dans la terre, sur un échafaudage ou dans un arbre.

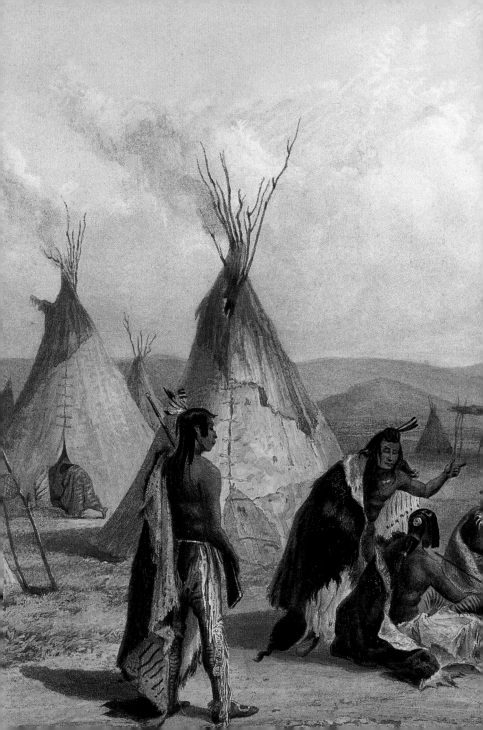

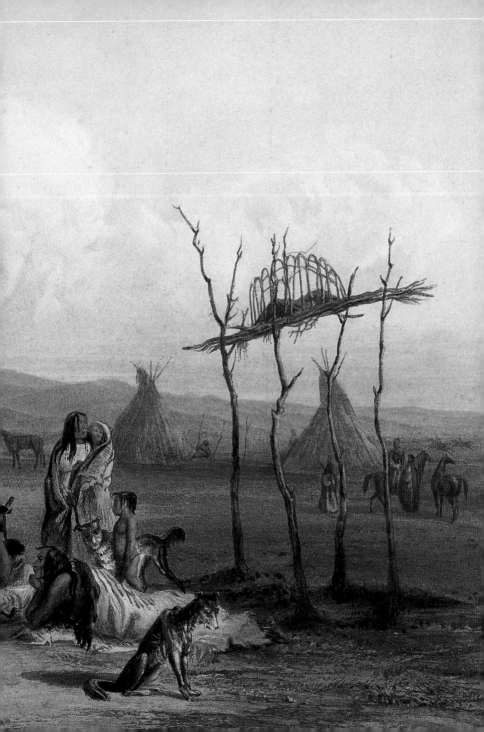

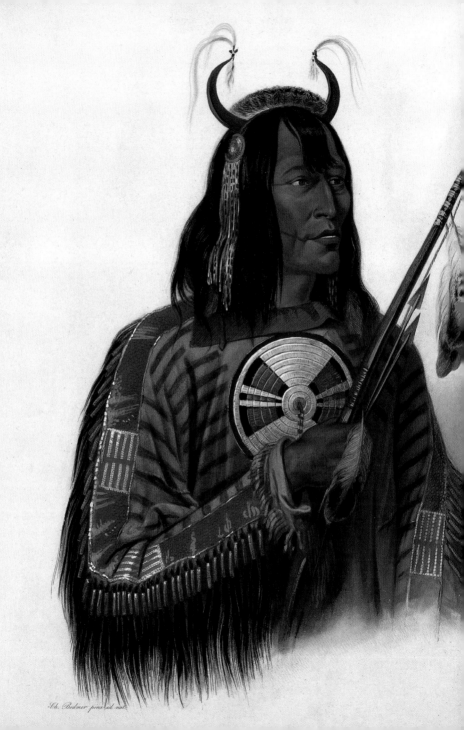

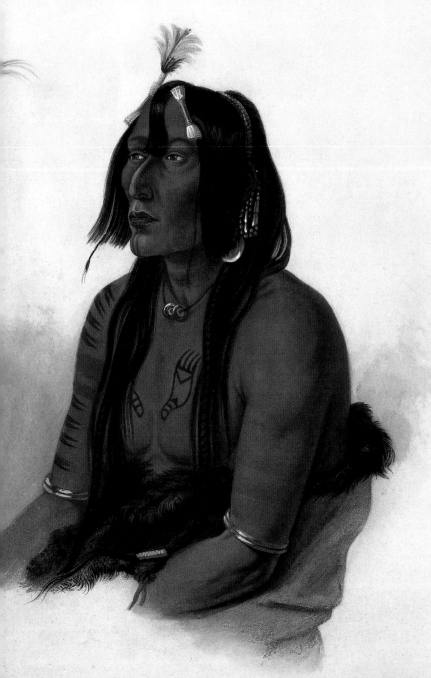

A MANDAN CHIEF

Mr. Bodmer painted the chief, Mató-Tópe, at full length, in his grandest dress. The vanity which is characteristic of the Indians induced this chief to stand stock-still for several days, so that his portrait succeeded admirably. He wore on this occasion a handsome new shirt of bighorn leather, the large feather cap, and held in his hand a long lance with scalps and feathers. The large horned feather cap (Máhchsi-Akub-Háschka) is a cap consisting of strips of white ermine, with pieces of red cloth hanging down behind as far as the calves of the legs, to which is attached an upright row of black-and-white eagle's feathers, beginning at the head and reaching to the whole length. Only distinguished warriors, who have performed many exploits, may wear this headdress.

MANDAN CHEF

Herr Bodmer hatte auch den Chef Mató-Tópe in ganzer Figur in seinem schönsten Anzuge gemalt. Eitel wie alle Indianer sind, hatte dieser Mann mehre Tage unbeweglich gestanden; sein Bild ist deshalb aber auch vortrefflich gelungen. Er trug bei dieser Gelegenheit ein schönes neues Hemde von Bighorn-Leder, auf dem Kopfe die grosse Federmütze Máhchsi-Akub-Háschka, und in der Hand eine lange mit Scalpen und Federn behangene Lanze.

Die grosse gehörnte Federhaube (Máhchsi-Akub-Háschka) [ist] eine Kopfmütze von weissen Hermelinfell-Streifen, hinten mit breitem bis zur halben Wade herabhängendem rothem Tuchstreifen, auf welchem ein aufrechter Kamm von weiss und schwarzen Kriegsadlerfedern befestigt ist, der oben am Kopfe anfängt, und in gedrängter Reihe bis zum Ende hinabreicht. Nur ausgezeichnete Krieger, die schon viele Coups gemacht, oder Feinde erlegt haben, dürfen diesen Kopfputz tragen.

CHEF MANDAN

M. Bodmer avait peint aussi le portrait en pied du chef Mató-Tópe, dans son plus beau costume. Vain, comme le sont tous les Indiens, cet homme était resté pendant plusieurs jours parfaitement immobile; aussi son portrait est-il on ne saurait plus ressemblant.

Ces Indiens portent aussi le grand bonnet de plumes cornu (Mahchsi-Akoub-Hachka); il est fait de bandes blanches d'hermine, ayant par derrière une large bande de drap rouge retombant jusqu'au mollet, sur laquelle est attachée une crête droite de plumes d'aigle, blanches et noires, qui commence à la tête et se prolonge en rang serré jusqu'au bout. Il n'y a que les guerriers distingués qui ont tué beaucoup d'ennemis à qui il soit permis de porter ce bonnet.

PAGE/SEITE 46/47

Noápeh
An Assiniboin Indian · Assiniboin Indianer · Indien Assiniboin

Psíhdjä-Sáhpa
A Yanktonan Indian · Yanktonan Indianer · Indien Yanktonan

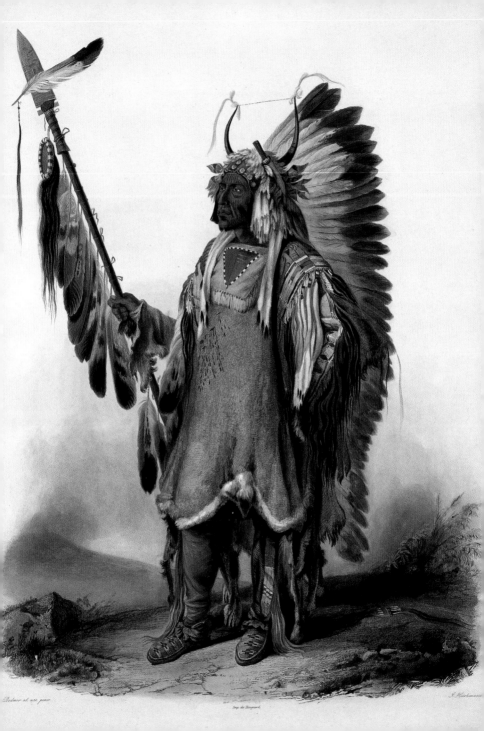

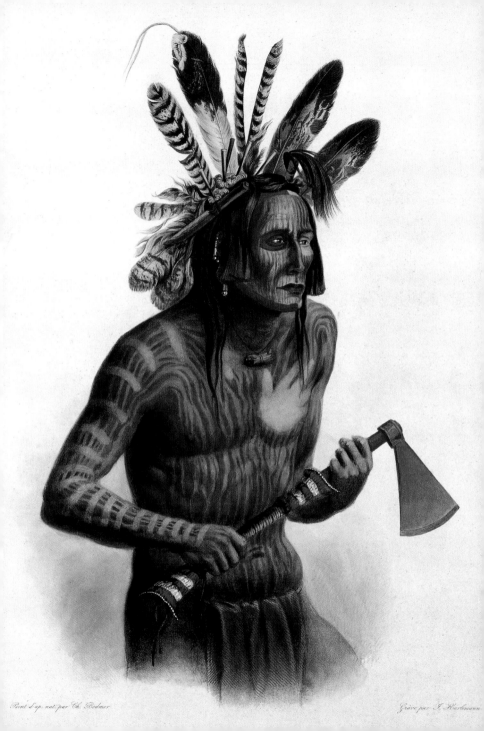

Peint d'ap. nat. par Ch. Bodmer Gravé par I. Hürlimann

ADORNED WITH THE INSIGNIA
OF HIS WARLIKE DEEDS

Very celebrated and eminent warriors, when most highly decorated, wear in their hair various pieces of wood, as tokens of their wounds and heroic deeds. Thus Mató-Tópe had fastened transversely in his hair a wooden knife, painted red, and about the length of a hand, because he had killed a Cheyenne chief with his knife; then six wooden sticks, painted red, blue, and yellow, with a brass nail at one end, indicating so many musket wounds which he had received. For an arrow wound, he fastened in his hair the wing feather of a wild turkey; at the back of his head he wore a large bunch of owl's feathers, dyed yellow, with red tips, as the badge of the Meniss-Ochata (the "Dogs"). One half of his face was painted red, and the other yellow; his body was painted reddish-brown, with narrow stripes, which were produced by wiping off the colour with the wetted tip of a finger.

GESCHMÜCKT MIT DEN ZEICHEN
SEINER KRIEGSTHATEN

Berühmte ausgezeichnete Krieger tragen im höchsten Prunke in den Haaren allerhand Zeichen von Holz für ihre Wunden und Heldenthaten; so trug z. B. Mató-Tópe ein aus Holz geschnitztes, roth angemaltes, etwa handlanges Messer quer in den Haaren befestigt, weil er einen Chayenne-Chef mit dem Messer erstochen hatte, ferner sechs hölzerne, roth, blau oder gelb gefärbte Stäbchen, die auf dem oberen Ende mit einem gelben Nagel beschlagen waren, und eben so viele Kugelwunden bedeuteten, als er erhalten hatte. Für eine Pfeilwunde befestigte er die gespaltene Schwungfeder eines wilden Truthahns in seinen Haaren, auf dem Hinterkopfe trug er einen grossen Bündel von gelb und an der Spitze roth gefärbten Uhufedern, als Zeichen der Meniss-Ochatä (der Bande der Hunde). Sein Gesicht war halb roth, halb gelb bemalt, der Körper rothbraun angestrichen, darauf schmale ungefärbte Streifen, die durch das Wegstreichen der Farbe mit dem benetzten Finger hervorgebracht werden.

PARÉ DES EMBLEMES
DE SES FAITS D'ARMES

Les guerriers particulièrement distingués, quand ils sont dans la plus haute tenue, portent dans leurs cheveux toutes sortes de marques en bois, pour indiquer leurs blessures et leurs exploits. C'est ainsi que Mató-Tópe avait attaché en travers, dans sa chevelure, un couteau fait de bois, peint en rouge et long à peu près comme la main : c'était l'emblème du couteau avec lequel il avait tué un chef Cheyenne ; il portait en outre six petites brochettes en bois peintes en rouge, en bleu ou en jaune, et garnies, à l'extrémité supérieure, d'un clou doré, pour indiquer le nombre de coups de feu dont il avait été blessé. Pour marquer la blessure d'une flèche, il attachait dans ses cheveux une plume de coq d'Inde fendue ; sur le derrière de la tête, il portait une grosse touffe de plumes jaunes de hibou et peintes en rouge à leur extrémité, comme signe de ralliement des Meniss-Ochaté (bande des chiens). Son visage était peint moitié en rouge et moitié en jaune, et son corps en rouge brun, avec des raies d'où la couleur avait été enlevée au moyen d'un doigt mouillé.

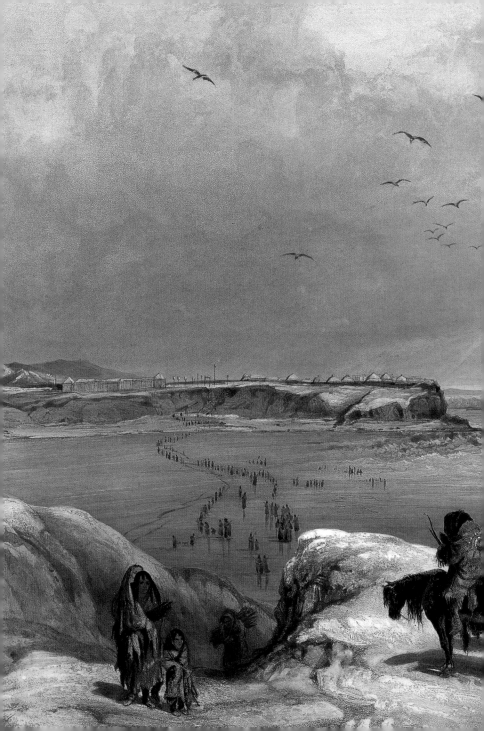

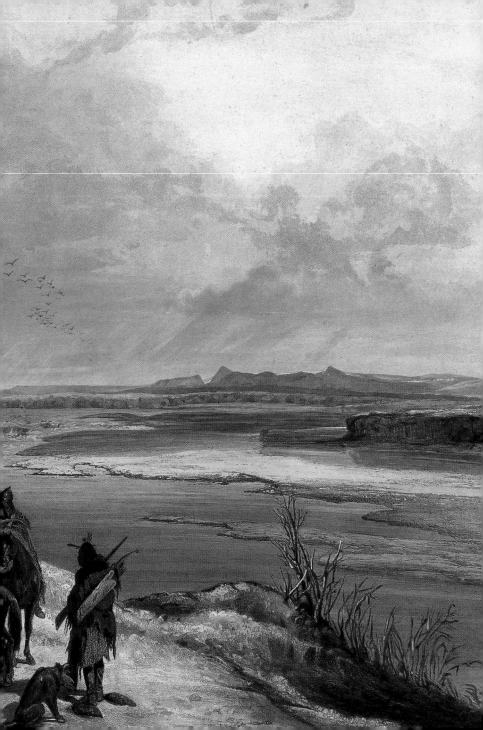

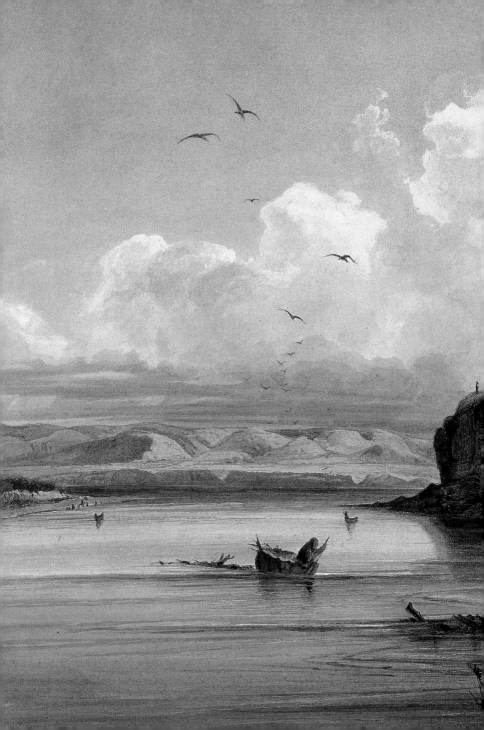

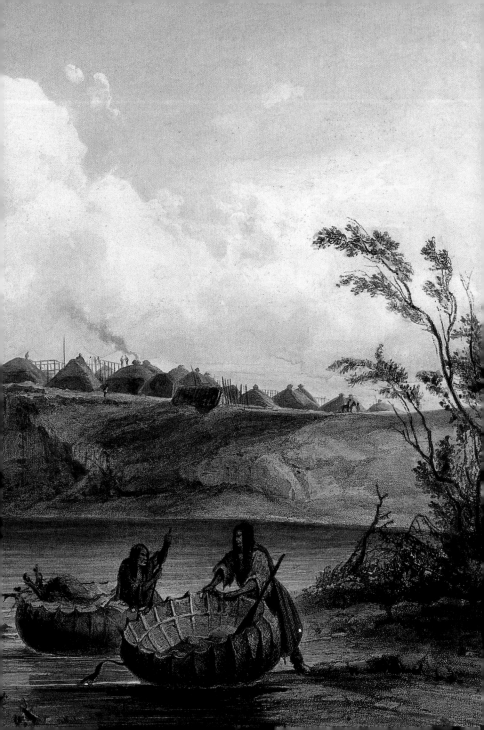

FORT CLARK ON THE MISSOURI
(FEBRUARY 1834)

The winter [in the area near Fort Clark] is long, and generally severe, causing most animals to migrate, so that the winter fauna has but a few species whereof to boast. We were told that, around New Year, there is usually an intensely cold interval of about a week, which was the case during our visit; and the Indians have, on account of this, called one of their months "the moon of the seven cold days." The winter of 1833–34 is considered to have been one of the most severe. The mercury in the thermometer was frozen for several days, and, at Fort Union, the cold is said to have reached 47 degrees Fahrenheit below zero. The snow is seldom more than two feet deep, but it remains a long time, often unchanged till the month of March – a proof of the dryness of the climate.

FORT CLARK AM MISSOURI
(FEBRUAR 1834)

Der Winter [in der Gegend von Fort Clark] ist lang und gewöhnlich streng; die meisten Thierarten ziehen alsdann fort und daher ist die Fauna des Winters nicht zahlreich an Arten. Gewöhnlich soll um Neujahr eine sehr kalte Periode von etwa einer Woche eintreten, welches auch während unserer Anwesenheit eintraf, und die Indianer haben deshalb einen ihrer Monate, den Mond der sieben kalten Tage benannt. Der Winter 1833 und 1834 wird als einer der strengsten betrachtet. Das Quecksilber war mehrere Tage gefroren, zu Fort Union soll man 47° Fahrenh. unter 0 [-44°C] gehabt haben. Der Schnee fällt selten über zwei Fuss tief, bleibt alsdann aber lange Zeit, oft unverändert bis in den März liegen, ein Beweis für die Trockenheit des Climas.

FORT CLARK SUR LE MISSOURI
(FEVRIER 1834)

L'hiver est long et communément rigoureux; la plupart des animaux s'éloignent alors et la faune de l'hiver n'est pas très nombreuse en espèces. Vers le nouvel an, il y a ordinairement une semaine pendant laquelle le froid est particulièrement rigoureux, et nous l'éprouvâmes; c'est aussi pour cela que les Indiens ont nommé un de leurs mois, la lune aux sept jours froids. L'hiver de 1833 à 1834 passe pour l'un des plus froids que l'on ait eus; le mercure y gela pendant plusieurs jours, et le thermomètre de Fahrenheit descendit au Fort-Union à 47° au-dessous de zéro (-35,4 R.). La neige s'élève rarement à plus de deux pieds, mais elle reste longtemps sur la terre et souvent jusqu'au mois de mars, ce qui démontre combien l'air y est sec.

A MANDAN VILLAGE

The Mandans were formerly a numerous people, who, according to the narrative of an aged man lately deceased, inhabited 13, and perhaps more villages. The smallpox and the assaults of their enemies have reduced this people to such small numbers that the whole tribe now resides in two villages, in the vicinity of Fort Clarke. These two villages are Mih-Tutta-Hang-Kusch (the southern village), about 300 paces above Fort Clarke, and on the same side of the river, and Ruhp-ta-re, about three miles higher up, likewise on the same bank.

This village consisted of about 60 large hemispherical clay huts, and was surrounded with a fence of stakes, at the four corners of which conical mounds were thrown up, covered with a facing of wicker-work, and embrasures, which served as defence and commanded a view of the river and the plain. We were told that these cones or block-houses were not erected by the Indians themselves, but by the Whites.

MANDAN DORF

Die Mandans bildeten ehemals ein zahlreiches Volk, welches nach der Erzählung eines alten, kürzlich verstorbenen Mannes, 13 und vielleicht mehr Dörfer bewohnte. Blattern und Feinde hatten dieses Volk so sehr vermindert, dass seine Gesamtzahl auf zwei Dörfer reducirt worden war, die jetzt noch in der Nähe von Fort-Clarke bestehen. Diese beiden Dörfer sind Mih-Tutta-Hangkusch (das südliche Dorf), etwa 300 Schritte oberhalb Fort-Clarke an demselben Flussufer, und Ruhptare (die sich umwenden), etwa 3 Meilen höher am Flusse aufwärts, ebenfalls an demselben Ufer.

Dieses Dorf bestand aus etwa 60 grossen, halbkugelförmigen Erdhütten, und war mit einem Zaune von Pfählen umgeben, an welchem man an den vier Hauptecken fleschenartige Aufwürfe mit einer Verkleidung von Weiden-Flechtwerk und Schiesslöchern angelegt hatte, welche zur Vertheidigung dienen und den Fluss und die Ebene bestrichen. Diese Fleschen oder Blockhäuser sollen nicht von den Indianern selbst, sondern von Weissen erbaut worden seyn.

VILLAGE MANDAN

Les Mandans formaient autrefois un peuple nombreux, lequel, d'après le récit d'un vieillard qui vient de mourir depuis peu, habitait treize villages ou même davantage. La petite vérole et les ennemis ont si fort diminué le nombre des Mandans qu'ils sont réduits aux deux villages qui se trouvent aujourd'hui auprès du Fort-Clark. Ce sont ceux de Mih-Tutta-Hangkusch (le village du midi), à trois cents pas environ du fort et sur la même rive ; et Rouhptare (ceux qui se retournent), à trois milles plus haut et aussi sur la même rive.

Ce village, qui se compose d'à peu près soixante grandes cabanes de terre de forme hémisphérique, est entouré d'une clôture de palissades, aux quatre coins de laquelle on a élevé des retranchements en forme de flèches, recouverts de treillages en osier et munis de meurtrières ; ils devaient servir à la défense du village et dominaient la rivière et la plaine. Ces flèches ou blockhaus n'ont point, dit-on, été construites par les Indiens eux-mêmes, mais par des blancs.

A MINATARRE OR BIG-BELLIED INDIAN

The costume of the Mandans is rather simple, by far the greatest attention being paid to the headdress. Their hair is parted transversely across the middle of the head, while the front hair is combed smoothly down, and generally divided into three flat bands, two of which hang down over the temples, and are generally plaited. To these plaits they attach the ornament already mentioned, which consists of two strips of leather or cloth closely embroidered with white or azure glass beads, and intertwined with brass wire, as represented in the portrait of Pehriska-Ruhpa [the two ravens].

EIN MÖNNITARRI INDIANER

Der Anzug der Mandans ist ziemlich einfach. Unter allen Theilen des Körpers verlangt der Kopf bei weitem die meiste Sorgfalt. Sie tragen die Haare auf der Mitte quer über gescheitelt, die vorderen sind glatt herunter gestrichen, meist in drei platte Stränge getheilt, von welchen zwei an den Seiten vor den Schläfen oder hinter den Augen herabhängen und gewöhnlich in eine Flechte gebracht worden sind. An diesem Zopfe tragen sie den schon erwähnten, aus zwei Leder- oder Tuchstücken bestehenden, mit weissen oder hellblauen Glasperlen dicht besetzten, und in der Mitte mit Messingdrahth-Gewinde verbundenen Zierrath, welchen man an Péhriska-Rúhpa [die beiden Raben] findet.

INDIEN MEUNITARRI OU GROS VENTRE

Il est digne de remarque que la vanité des hommes est bien plus grande que celle des femmes, et que celles-ci leur cèdent en tous points sous le rapport de l'élégance de la mise. Du reste, celle des Mandans est assez simple. De toutes les parties du corps, c'est la tête dont ils s'occupent le plus ; ils portent les cheveux partagés en travers au milieu ; ceux de devant sont lissés et ordinairement partagés en trois tresses plates, deux desquelles retombent des deux côtés des tempes ou derrière les yeux, et sont en général entrelacés. C'est à cette queue qu'ils portent l'ornement que j'ai déjà décrit et qui se compose de deux morceaux de cuir ou de drap, garnis de grains de verre blancs ou bleu clair, et noués au milieu avec du fil de laiton ; cet ornement s'appelle Pehriska-Ruhpa.

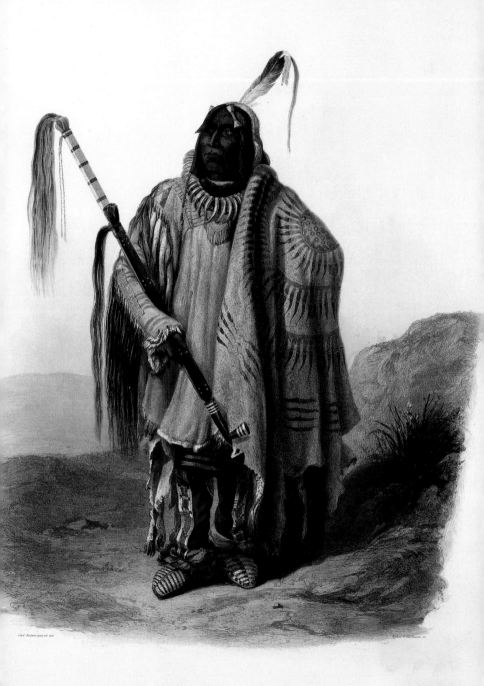

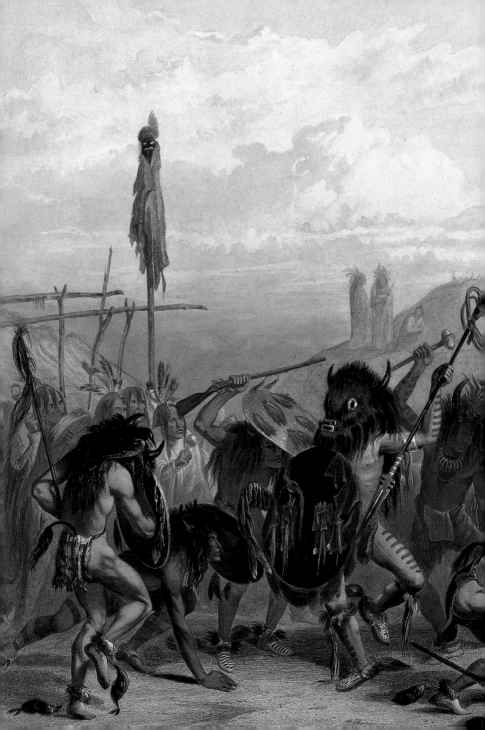

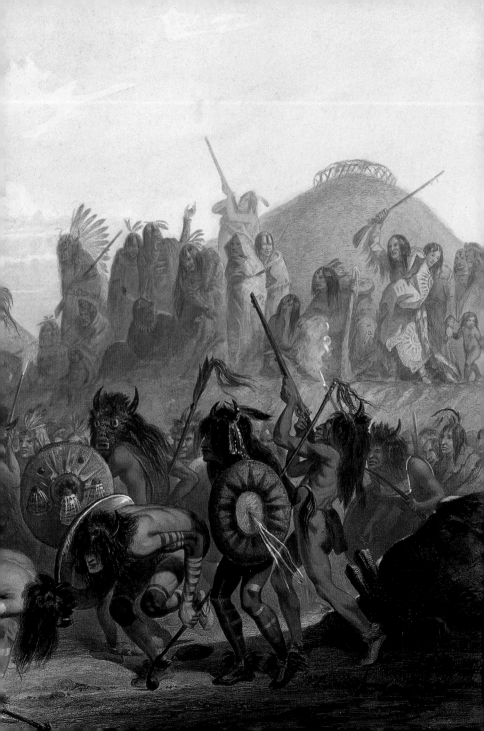

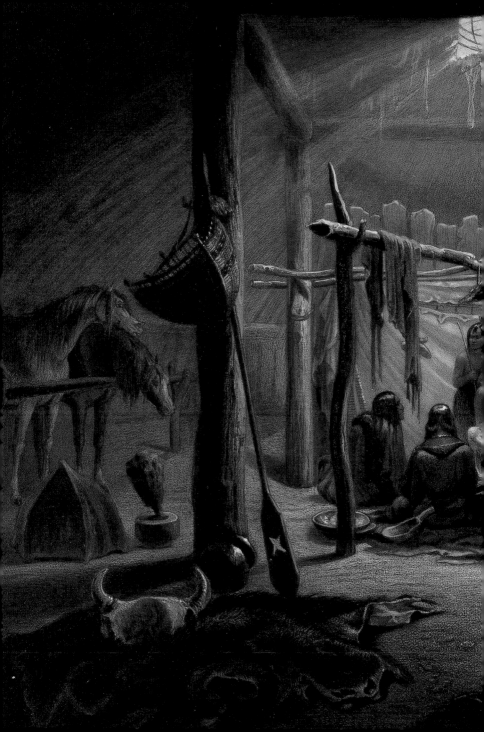

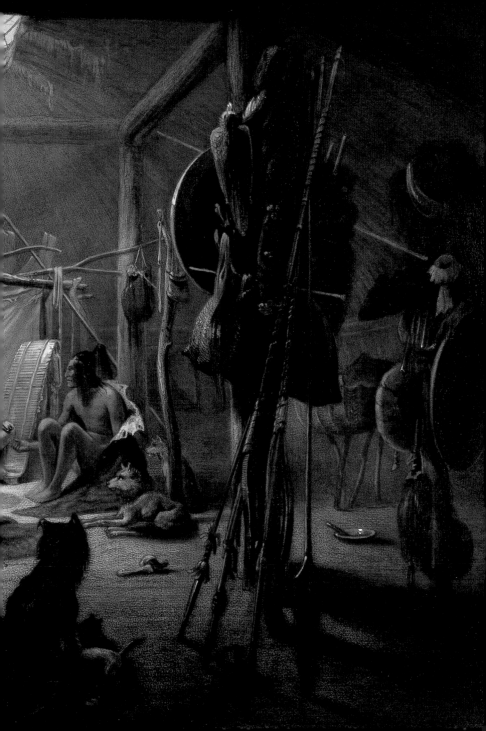

BISON-DANCE OF THE MANDAN INDIANS
IN FRONT OF THEIR MEDICINE LODGE
IN MIH-TUTTA-HANGKUSCH

In their dance they [the Beróck-Óchatä or "Buffalo" society] wear the skin of the upper part of the head and the mane of the buffalo, with its horns, on their heads; but two select individuals, the bravest of all, who thenceforward never dare to flee from the enemy, wear a perfect imitation of the buffalo's head, with the horns, which they set on their heads, and in which there are holes left for the eyes, which are surrounded with an iron or tin ring.

The men with the buffalo heads always keep to the outside of the dancing group, imitating all the motions and the voice of this animal, as it timidly and cautiously retreats while looking around in all directions.

BISONTANZ DER MANDAN INDIANER
VOR DER MEDEZIN HÜTTE
IN MIH-TUTTA-HANGKUSCH

Sie [die Beróck-Óchatä, die Bisontiere] tragen bei dem Tanze die obere Kopfhaut und die langen Nackenhaare des Bisonstieres mit dessen Hörnern auf dem Kopfe; zwei Auserwählte unter ihnen aber, die Tapfersten unter ihnen allen, die alsdann nie mehr vor dem Feinde fliehen dürfen, tragen einen ganzen, völlig nachgebildeten Bisonkopf mit den Hörnern, welchen sie über ihren Kopf setzen, durch dessen künstliche, mit einem eisernen oder blechernen Ringe umlegte Augen sie hindurch blicken.

Die Männer mit den Bisonköpfen halten sich beim Tanze immer an der Aussenseite der Gruppe, ahmen alle Bewegungen und Stimmen dieses Thieres nach, wie es schüchtern und scheu auf die Seite fährt, sich nach allen Richtungen umsieht.

DANSE DU BISON DES INDIENS MANDANS
DEVANT LA LOGE DE MEDECINE
À MIH-TUTTA-HANGKOUCHE

Ils [Les Berach-Ochaté, les bisons] portent en dansant la peau de la tête d'un bison, avec sa longue crinière et ses cornes; mais les deux plus vaillants d'entre eux, choisis parmi tous, et à qui après cela il n'est plus jamais permis de fuir devant l'ennemi, portent sur la tête une imitation complète d'une tête de bison tout entière avec les cornes, et regardent à travers les yeux artificiels, entourés d'un cercle de fer ou de fer-blanc.

Les hommes à la tête de bison se tiennent toujours, pendant la danse, en dehors du groupe, imitant les mouvements et le beuglement de cet animal, quand il court de côté et d'autre, inquiet et timide, regarde autour de lui dans tous les sens.

THE INTERIOR OF THE HUT
OF A MANDAN CHIEF

The huts (Oti) themselves are of a circular form, slightly vaulted, having a sort of portico entrance. In the centre of the roof is a square opening for the smoke to find vent, over which is a circular sort of screen made of twigs, as a protection against the wind and rain, and when necessary this is covered with skins. The interior of the hut is spacious, tolerably light and clean. Four strong pillars towards the middle, with several cross beams, support the roof.

In the centre of the hut a circular place is dug for the fire. The inmates sit around it, on low seats, made of stripped osiers, covered with buffalo or bear skin.

DAS INNERE DER HÜTTE
EINES MANDAN HÄUPTLINGS

Die Hütten (Oti) selbst sind von runder Gestalt, oben sanft rundlich gewölbt, mit einem Eingange, an welchem von oben und von beiden Seiten Schirmwände vortreten. Oben in ihrer Mitte hat die Hütte eine viereckige Öffnung als Rauchfang, über welcher man von Stangen und Zweigen in rundlich gewölbter Gestalt eine Art von Schirm gegen den Regen und Wind anbringt, den man, wenn es nöthig ist, noch mit Fellen behängt. Das Innere der Hütte ist geräumig, ziemlich hell und reinlich. Vier starke Pfeiler in der Mitte tragen die Decke mit mehren Querbalken. In dem Mittelpuncte der Hütten ist ein flach ausgegrabener runder Platz angebracht, in welchem man das Feuer anzündet.

Die Hausgenossen sitzen um dasselbe herum, auf niederen Sitzen, welche von geschälten Weidenruthen gemacht, und mit Bison- und Bärenfellen belegt werden.

INTERIEUR DE LA CABANE
D'UN CHEF MANDAN

Les cabanes (Oti) sont rondes, légèrement voûtées par le haut, avec une entrée défendue par une avance en forme de porche. Quand les habitants sont absents, cette entrée est bouchée par des branchages et des ronces. Pour fermer l'ouverture elle-même, on suspend au devant une peau séchée et fortement tendue sur des bâtons, et que l'on pousse de côté quand on entre. Au milieu du toit de la cabane, il y a une ouverture pour donner issue à la fumée, et qui est défendue contre le vent et la pluie par une espèce de cage arrondie, faite de bâtons et de rameaux qu'en cas de besoin on peut encore recouvrir de peaux. L'intérieur de la cabane est vaste, propre et assez claire. Quatre gros pieux, placés au centre, supportent le toit avec des poutres de traverse. Au milieu de la cabane il y a un trou rond dans lequel on allume le feu, et au-dessus duquel on suspend la marmite.

La famille s'assied autour du foyer, sur des sièges bas, faits d'osier pelé et recouverts de peaux de bisons ou d'ours.

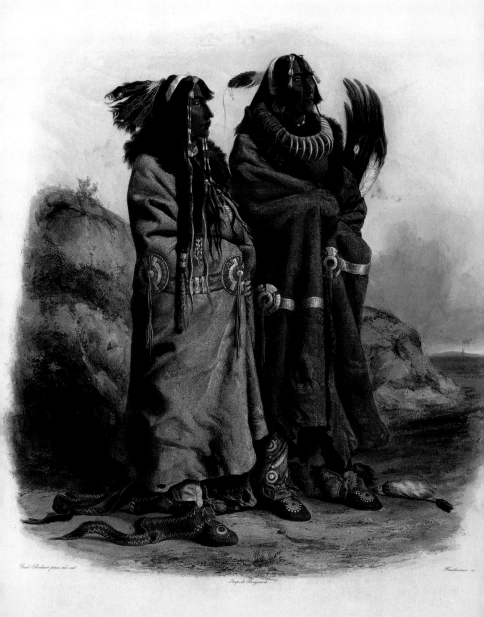

Carl Bodmer pinx. ad nat.

Imp. de Bougeard

Hürlimann sc.

MANDAN INDIANS

Sih-Chidä and Mahchsi-Karehde (the flying eagle), also visited us [on the 4th of December 1833]; the latter was the tallest man among the Mandans, and belonged to the society of the "Soldiers".

Sih-Chidä [the yellow feather], a tall, stout young man, the son of a celebrated chief now dead, was an Indian who might be depended on, who became one of our best friends, and visited us almost daily. He was very polished in his manners, and possessed more delicacy of feeling than most of his countrymen.

MANDAN INDIANER

Sih-Chidä und Máhsich-Karéhde, der fliegende Kriegsadler, befanden sich [am 4.12.1833] ebenfalls bei uns, der letztere der grösste Mann von Gestalt unter den Mandans.

Sih-Chidä, ein grosser, starker junger Mann, der Sohn eines berühmten, jetzt verstorbenen Chefs, Tóhpka-Singkä (die vier Männer) genannt, war ein zuverlässiger Indianer, von sehr gutem Character, der einer unserer besten Freunde wurde und uns beinahe alle Tage besuchte.

INDIENS MANDANS

Sih-Chida et Mahchsi-Karehde, l'aigle volant, se trouvaient également chez nous [le 4.12.1833]. Ce dernier était le plus grand de tous les Mandans.

Sih-Chida, jeune homme grand et fort, fils d'un célèbre chef défunt, Tohpka-Singké (les quatre hommes), était un Indien digne de confiance, d'un très bon caractère, qui devint un de nos meilleurs amis et qui nous visitait tous les jours.

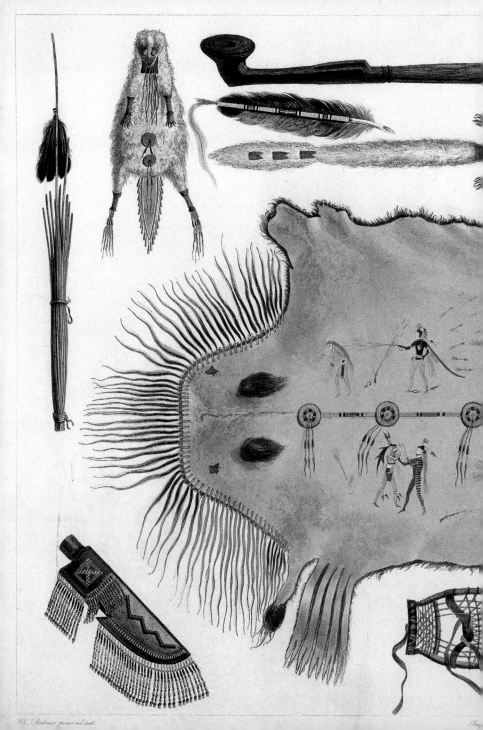

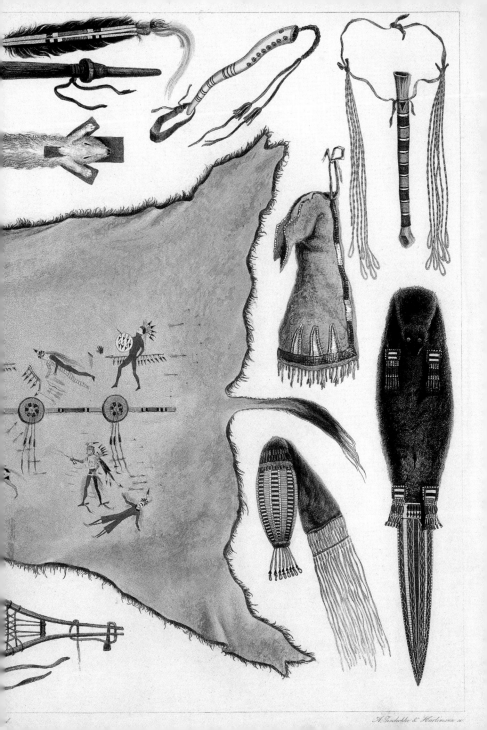

A. Tischbein & Hartmann sc.

BUFFALO ROBE

The chief article of their [Mandan] dress, the large buffalo robe, is, for the most part, painted on the tanned side, but less skilfully than among the other nations. In general, there are black parallel lines mixed with a few figures, often with arrow heads, or other arabesques; others, again, are painted with representations of their warlike exploits, in black, red, green, and yellow. The figures represent the taking of prisoners, dead or wounded enemies, captured arms and horses, blood flowing, balls flying through the air, and so forth. Such robes are embroidered with transverse bands of porcupine quills of the most brilliant colours, divided into two equal parts by a round rosette of the same. On the underside the hide is often reddish-brown, and the figures on it black. All the Missouri Indians wear these robes, and it is well known that those of the Minitari and the Crow are the most beautifully worked and painted.

BUFFALOE-ROBE

Das Hauptstück des Anzuges, die große Bisonhaut (Buffaloe-Robe) ist meist auf der gegerbten Seite bemalt, jedoch weniger künstlich als bei anderen Nationen. Gewöhnlich bemerkt man darauf schwarze Parallellinien mit einigen wenigen abwechselnden Figuren, oft mit Pfeilspitzen, oder anderen Arabesken, wieder andere sind mit den Kriegsthaten schwarz, roth, grün und gelb bemalt. Die Figuren stellen die Erbeutung von Gefangenen, Getödtete, Verwundete, genommene Waffen und Pferde, fliessendes Blut, in der Luft umher fliegende Kugeln und alle dergleichen Gegenstände vor. Solche Roben sind mit einer Querbinde von Stachelschweinstacheln in den lebhaftesten Farben gestickt, welche durch eine ähnliche runde Rosette in zwei gleiche Theile getheilt ist. Oft ist der Grund des Felles rotbraun und die Figuren darauf schwarz. Alle Missouri Indianer tragen diese Roben und es ist bekannt, dass sie von den Mönnitarris und Crows am schönsten gearbeitet und gemalt werden.

BUFFALOE-ROBE

La principale pièce de leur costume, la peau de bison (Buffaloe-Robe), est généralement peinte du côté tanné. On y remarque ordinairement des lignes noires parallèles, avec un petit nombre de figures variées, telles que des pointes de flèches ou d'autres mauvaises arabesques; il y en a qui représentent les exploits de guerre en noir, en rouge, en vert et en jaune. Ces figures peignent la prise de prisonniers, des morts, des blessés, des armes et des chevaux enlevés, du sang qui coule, des balles traversant les airs et autres objets semblables. Ces robes sont brodées des plus vives couleurs et ornées d'une bande transversale de piquants de porc-épic, partagée en deux parties égales par une rosette semblable. Le fond de la peau est souvent rouge brun avec des figures noires. Tous les Indiens du Missouri portent de ces robes, et l'on sait que ce sont les Meunitarris et les Corbeaux qui les travaillent avec le plus de soin.

THE HEROIC LIFE OF MATÓ-TÓPE

He [Mató-Tópe] had killed many enemies, among them five chiefs. The illustration gives a fac-simile of a representation of one of his exploits, painted by himself, of which he frequently gave me an account. He was, on that occasion, on foot with a few Mandans on a military expedition when they encountered four Cheyennes, their most virulent foes, on horseback. The chief of the latter, seeing that their enemies were on foot, and that the combat would thereby be un-equal, dismounted, and the two parties attacked each other. The two chiefs fired, missed, threw away their guns, and, seized their naked weapons; the Cheyenne, a tall, powerful man, drew his knife, while Mató-Tópe, who was lighter and more agile, took his battle-axe. The former at-tempted to stop Mató-Tópe, who laid hold of the blade of the knife, by which he, indeed, wounded his hand, but wrested the weapon from the enemy, and stabbed him with it, on which the Cheyenne took flight.

HELDENTATEN DES MATÓ-TÓPE

Er [Mató-Tópe] hatte viele Feinde erlegt, unter denen fünf Chefs sich befanden. Die Abbildung gibt ein fac simile einer dieser von ihm selbst abgebildeten Heldenthaten, deren Erzählung er mir mehrmals mittheilte. Er befand sich damals mit einigen wenigen Mandans zu Fusse auf einem Kriegs-Streifzuge, als sie vier berittene Chayennes, ihren erbittertsten Feinden begegne-ten. Da der Chef der letzteren sah, dass die Feinde zu Fusse waren, das Gefecht daher ungleich gewesen seyn würde, so stiegen sie ab, und beide Partheien giengen aufeinander los. Die beiden Chefs schossen nach einander, fehlten, warfen die Gewehre weg und griffen schnell zu der blan-ken Waffe. Der Chayenne, ein grosser starker Mann, zog sein Messer, der leichtere, sehr ge-wandte Mató-Tópe führte die Streitaxt. Eben wollte der erstere den letzteren erstechen, als ihm dieser in das Messer griff, sich zwar stark an der Hand verwundete, aber dem Feinde die Waffe aus der Hand drehte, und ihn damit erstach, worauf die Chayennes die Flucht ergriffen.

EXPLOITS DE MATÓ-TÓPE

Dans les combats, il [Mató-Tópe] avait tué de sa main plusieurs ennemis, dont cinq chefs. L'illustration offre le fac-simile d'un de ses exploits, dessiné par lui-même, et dont il m'avait fait plusieurs fois le récit. Il se trouvait, avec un petit nombre de Mandans à pied, dans une expédi-tion de guerre, quand ils aperçurent quatre Cheyennes, qui sont leurs ennemis les plus invétérés. Ceux-ci étaient à cheval, et leur chef voyant que ses adversaires étaient à pied, ce qui aurait rendu le combat inégal, les fit descendre, et le combat commença. Les deux chefs tirèrent l'un sur l'autre, et, s'étant manqués, ils jetèrent leurs fusils et prirent en main l'arme blanche. Le Cheyenne, qui était un homme grand et fort, tira son coutelas ; Mató-Tópe, plus léger et très adroit, tenait un casse-tête. Comme le premier allait percer celui-ci, Mató-Tópe saisit le coutelas dans la main, à laquelle il se fit à la vérité une forte blessure, mais il parvint néanmoins à le lui ar-racher et lui plongea dans la poitrine, sur quoi les Cheyennes prirent la fuite.

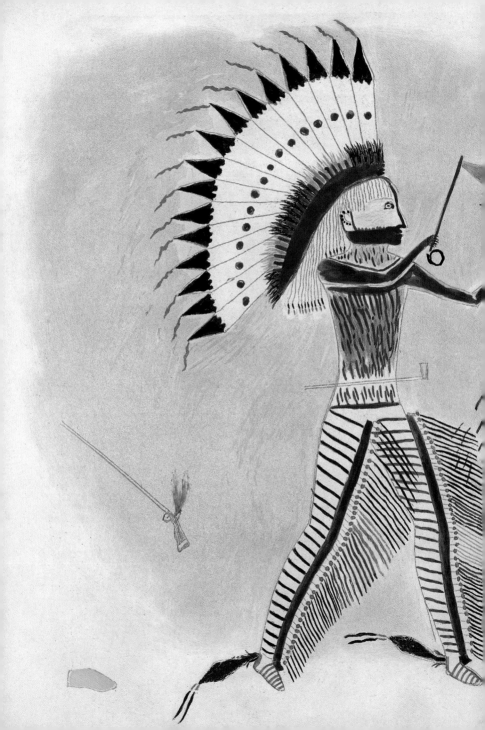

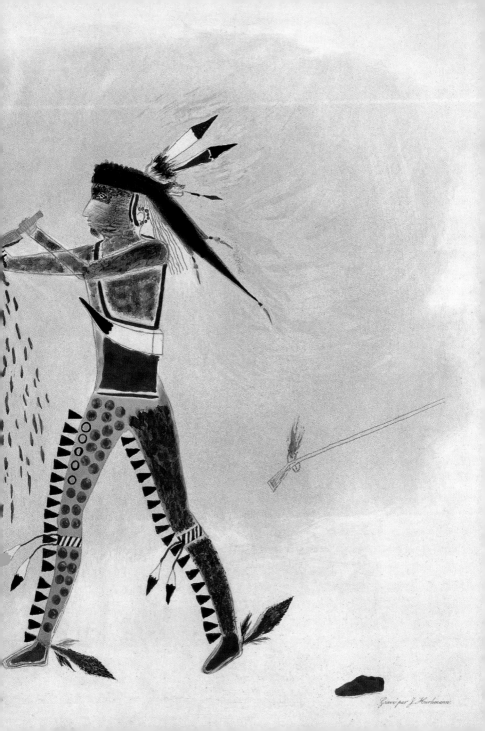

MINATARRE WARRIOR IN THE COSTUME
OF THE DOG DANCE

The fourth society, that of the "Dogs", wear in their dance a large cap of coloured cloth, to which a great number of ravens', magpies', and owls' feathers are fastened, adorned with dyed horse-hair and strips of ermine; they have a large war pipe made from the wing bone of a swan. The costume of these dogs is shown in the portrait of Pehriska-Ruhpa.

The principal weapon of the Mandan and the Minitari is the bow and arrow. The bows are made of elm or ash, there being no other suitable kind of wood in their country. In form and size they resemble those of the other nations; the string is made of the twisted sinews of animals. They are frequently ornamented. A piece of red cloth, four or five inches long, is wound round each end of the bow, and adorned with glass beads, dyed porcupine quills, and strips of white ermine.

MÖNNITARRI KRIEGER IM ANZUGE
DES HUNDETANZES

Die 4. Bande oder Klasse, Meniss-Óchatä, die Hunde, trägt beim Tanze eine grosse Mütze aus buntem Tuche, auf welcher eine grosse Menge von Raben-, Elstern- und Uhufedern befestigt ist, mit bunten Pferdshaaren und Hermelinschnüren verziert, dabei eine große Kriegspfeife aus dem Flügelknochen des Schwanes. Den Anzug der Hunde zeigt die Abbildung des Périska-Rúhpa.

Die Waffen der Mandans und Mönnitarris sind nachfolgende. Zuerst der Bogen, Woraërúhpa, und die Pfeile, Manna-Máhhä. Der erstere wird von Ulmen oder Eschenholz gemacht, da man hier keine andere gute Holzarten hat. Gestalt und Grösse sind wie bei den übrigen Nationen, die Schnur besteht aus gedrehten Thiersehnen. Häufig ist der Bogen an seiner Vorderseite mit einer breiten Thiersehne beleimt, und die innere Seite deckt eine Schiene aus den Hörnern des Bighorn oder Elkhirsches in ihrer ganzen Länge. Solche sehr elastische und starke Bogen werden oft verziert. Man bringt alsdann an jedem Ende ein etwa 4 bis 5 Zoll langes Stück rothes Tuch an, womit man den Bogen umwickelt, und welches mit weissen Glasperlen oder Schnüren von bunten Stachelschweinstacheln, auch mit Streifchen von weissem Hermelinfelle verziert wird.

GUERRIER MEUNNITARRI COSTUMÉ
POUR LA DANSE DU CHIEN

La quatrième bande ou classe, qui est celle des Meniss-Ochaté (ch guttural) ou des Chiens, porte, en dansant, un grand bonnet de drap bigarré, auquel est attachée une grande quantité de plumes de corbeau, de pie et de hibou, et qui est orné de crins de diverses couleurs et de bandes d'hermine ; elle a aussi un grand sifflet de guerre, fait de l'aileron d'un cygne. Le portrait de Pehriska-Ruhpa, sur le tableau, indique le costume des trois Chiens.

Voici quelles sont les armes des Mandans et des Meunitarris. D'abord l'arc (Woraéruhpa) et la flèche (Manna-Mahhé). Le premier se fait de bois d'orme ou de frêne, car on n'a pas, dans ces contrées, de bois de bonne qualité, et il est souvent couvert d'ornements. Dans ce cas, on attache à chaque extrémité un morceau de drap rouge de quatre à cinq pouces de long, dont on entoure l'arc, qui est orné de grains de verre blancs ou de rangées de piquants porc-épic teints, ou bien encore de petites bandes d'hermine.

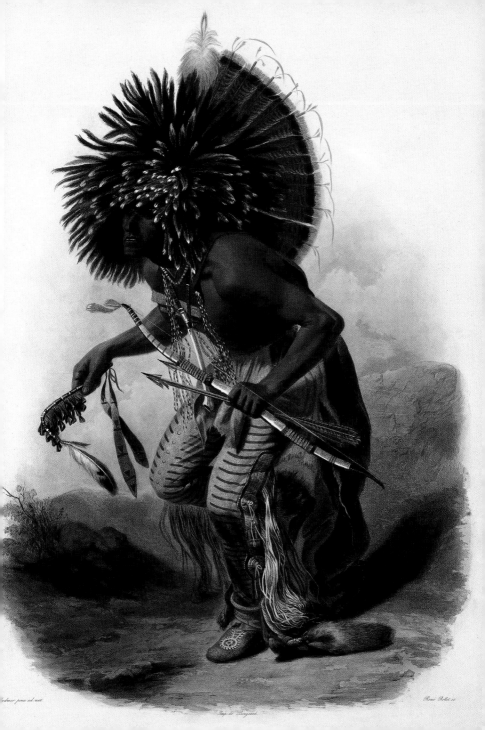

Gedruer pinx ad nat. René Roller sc.

Imp. de Langmet.

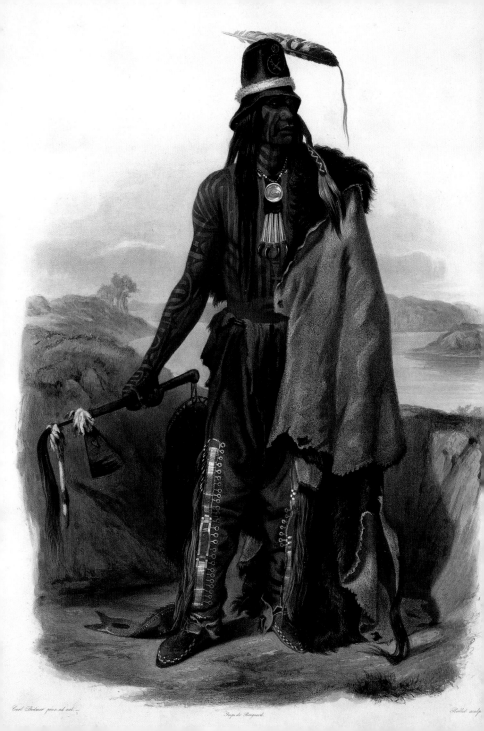

A MINATARRE CHIEF

Many of the men [of the Minitari tribe] are tattooed, usually on one side of the body only, for instance, the right half of the breast, and the right arm, sometimes down to the wrist; nay, the old chief, Addih-Hiddish, had the whole of his right hand tattooed in stripes.

Tattooing is customary among these tribes. They dye the needles with the dark blue extract of willow bark crushed in water.

MÖNNITARRI CHEF

Viele Männer unter den Mönnitarris sind tattowirt, besonders nur an einer Seite des Körpers, z. B. an der rechten Hälfte der Brust und dem rechten Arme mit mancherlei Streifen, zum Theil bis auf die Hand hinab, ja der alte Chef Addíh-Híddisch hatte die ganze rechte Hand gestreift.

Tattowierung ist im Gebrauche unter diesem Volke. Man färbt die Nadelstiche mit in Wasser gequetschter Weidenrinde schwarzblau.

CHEF MEUNITARRI

Beaucoup d'hommes, parmi les Meunitarris, sont tatoués sur un côté du corps, par exemple, au bras droit et au côté droit de la poitrine ; ce tatouage se compose de raies de différentes espèces qui descendent jusque sur les mains ; le vieux chef Addih-Hiddisch avait même tatoué sa main tout entière.

Le tatouage est utilisé par ce peuple. Sa couleur bleu foncé est obtenue à partir d'écorce de saule pilée dans de l'eau.

IDOLS OF THE MANDAN INDIANS

Besides the white buffalo skins which are offered in sacrifice and hung on poles, other strange figures on high poles are seen in the vicinity of the Mandan and the Minitari villages. These figures are composed of skin, grass and twigs, which appear to represent the sun and moon and perhaps also the lord of life and the first man. The Indians turn to them when they wish to petition for anything, and sometimes howl and lament for days and weeks together.

GÖTZENBILDER DER MANDAN INDIANER

Ausser den an Stangen aufgehängten und geopferten weissen Bisonfellen, beobachtet man in der Nähe der Dörfer der Mandans und Mönnitarris noch andere sonderbare Figuren auf hohen Stangen. Hier sind Figuren von Fell, Gras und Reisern zusammen gesetzt, welche, wie es scheint, Sonne und Mond vorstellen sollen, vielleicht auch den Herrn des Lebens und den ersten Menschen. Zu ihnen gehen die Indianer, wenn sie etwas erbitten wollen, heulen und klagen Tage- und Wochen lang.

IDOLES DES INDIENS MANDANES

Indépendamment des peaux de vache blanches, suspendues en offrande à des perches, on remarque encore dans les environs des villages des Mandans et des Meunitarris, d'autres figures singulières sur de grandes perches, ainsi qu'on peut le voir sur le tableau de l'atlas. Ce sont des figures composées de peau, de gazon et de branchages, qui doivent représenter, à ce qu'il paraît, le seigneur de la Vie et le premier homme. Quand les Indiens ont quelque chose à demander, ils vont là, et pleurent et gémissent pendant des journées et des semaines entières.

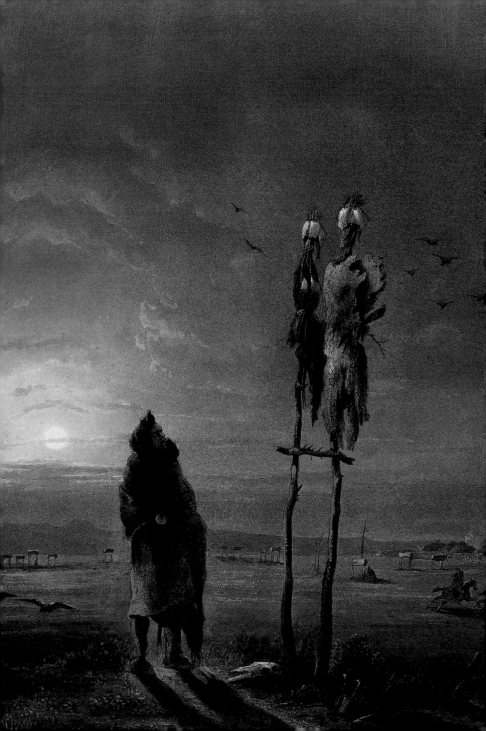

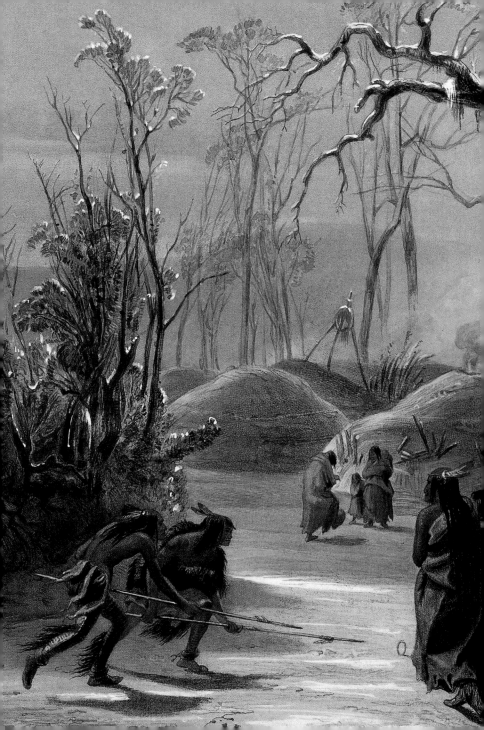

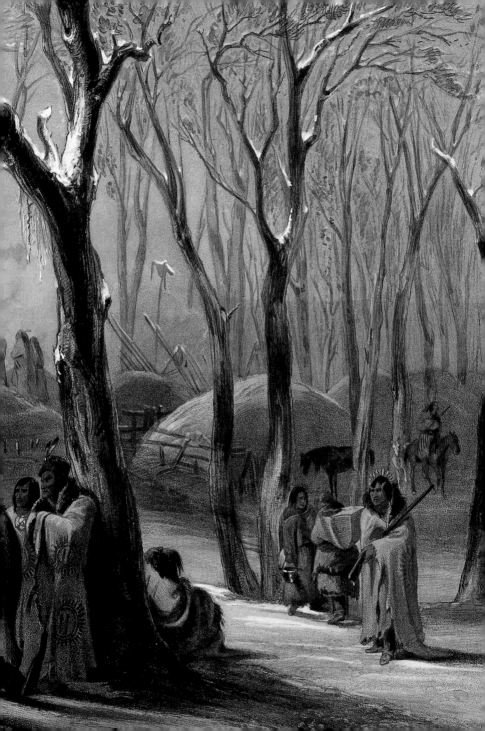

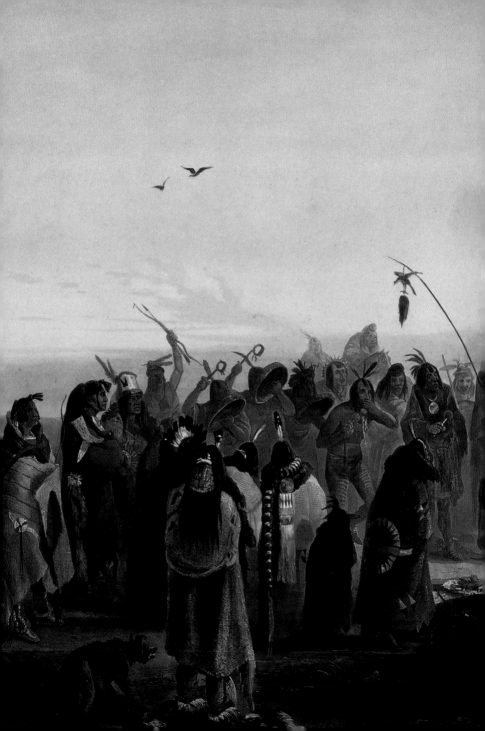

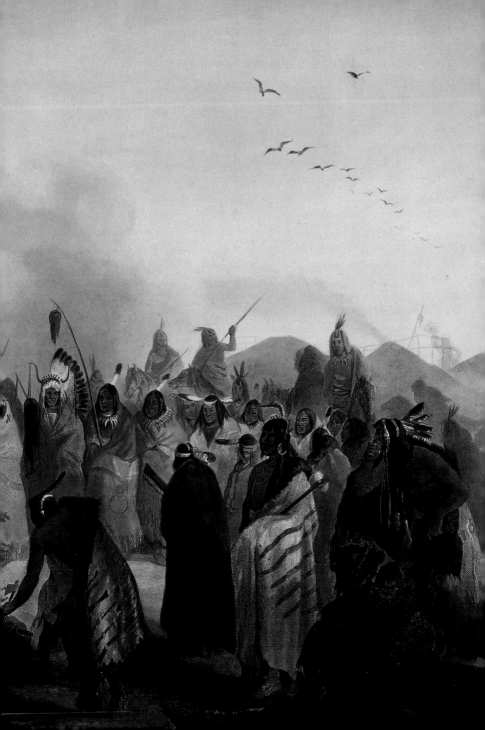

WINTER VILLAGE OF THE MINATARRES

Like the Mandan, the Minitari go into the forest on either side of the Missouri in winter, where they find fuel, and protection against the inclement weather. Their winter villages are in the thickest parts of the forest, and the huts are built near to each other, promiscuously, and without any attempt at order or regularity.

At that season there is generally more life on the frozen river, as the Indians travel continually backwards and forwards from their winter to their summer villages, and to the fort [Fort Clark]. Men, women, children, and dogs, drawing little sledges, are seen on it all day long.

WINTERDORF DER MÖNNITARRIS

Im Winter ziehen die Mönnitarris wie die Mandans an beiden Ufern des Missouri in die Wälder, wo sie Holz und Schutz vor der Witterung finden. Ihre Winterdörfer liegen daselbst im dichten Walde und die Hütten sind ohne alle Ordnung nahe an einander erbaut.

Auf dem Eis des Flusses ist alsdann gewöhnlich mehr Leben, da die Indianer von ihren Winterdörfern nach den Sommerdörfern und dem Fort [Clark] beständig ab- und zugehen. Weiber, Kinder, Männer, Hunde, welche kleine Schlitten ziehen, werden während des ganzen Tages gesehen.

VILLAGE D'HIVER DES MEUNITARRIS

En hiver, les Meunitarris, de même que les Mandans, vont dans les bois qui bordent les deux rives du Missouri, où ils trouvent à la fois un abri et du combustible. Leurs villages d'hiver sont situés dans la partie la plus épaisse du bois, et les cabanes y sont construites sans aucun ordre.

Sur le fleuve glacé il y a ordinairement de l'animation puisque les Indiens vont continuellement de leurs villages d'hiver aux villages d'été et au fort [Clark]. Toute la journée, on y voit des femmes, des enfants, des hommes et des chiens, lesquels tirent de petits traîneaux.

SCALP DANCE OF THE MINATARRES

Eighteen women, marching two-by-two in a close column, entered the courtyard of the fort at a short-measured, slow pace. Seven men of the band of the "Dogs", with faces painted black, or black striped with red, acted as musicians, three of them having drums, and four the schischikué [rattles]. The faces of some of the women were painted black, others red, while some were striped black and red. They wore buffalo dresses, or blankets, and the two principal dancers were enveloped in the white buffalo robe. Most of them had the upright eagle feather of war, but one only wore the large handsome feather cap. In their arms they carried battle-axes or guns, ornamented with red cloth and short black feathers, which, during the dance, they placed with the butt-end on the ground; in short, while performing this dance, the women were accoutred in the military dress and weapons of warriors.

SCALPTANZ DER MÖNNITARRIS

Achtzehn Weiber zogen gepaart in gedrängter Colonne in den Hofraum des Fortes ein. Ihr Schritt war kurz und langsam. Sieben Männer von der Bande der Hunde bildeten die Musik. Sie waren im Gesichte schwarz bemalt, einige roth und schwarz gestreift, drei von ihnen führten Trommeln, vier andere die Schischikués [Rasseln]. Die Weiber hatten das Gesicht theils schwarz, theils roth bemalt, einige roth und schwarz gestreift, sie trugen Bisonroben oder bunte wollene Decken, ein paar von ihnen weisse Bisonfelle. Auf dem Kopfe trugen die meisten eine aufgerichtete Kriegsadlerfeder und nur eine unter ihnen die grosse Federhaube (Máhchsi-Akub-Háschka bei den Mandans). Im Arme hielten sie Streitäxte oder eine mit rothem Tuche und kurzgeschnittenen schwarzen Federn verzierte Flinte, die sie während des Tanzes mit dem Kolben auf die Erde setzten; kurz bei diesem Scalptanze, oder dem Zúhdi-Arischi der Mönnitarris, sind die Weiber mit allen Waffen und dem Kriegsanzuge der Männer ausgerüstet.

DANSE DU SCALP DES INDIENS MEUNITARRIS

D'autres femmes entrèrent deux à deux, en colonne serrée, et occupèrent la cour du fort. Leurs pas était court et lent. Sept hommes de la bande des chiens formaient la musique ; eux aussi s'étaient peint le visage en noir, quelques-uns l'avaient rayé en rouge et noir ; trois d'entre eux portaient des tambours, les quatre autres des chichikoués. Le visage des femmes était peint chez les unes en noir, chez les autres en rouge, et chez d'autres encore en rouge et noir ; elles portaient des robes de bison ou des couvertures de laine de différentes couleurs ; une ou deux avaient des peaux de bisons blancs. La plupart portaient sur la tête une plume d'aigle posée perpendiculairement ; une seule avait le grand bonnet de plumes, le Mahchsi-Akoub-Hacheka des Mandans. Elles avaient au bras des casse-têtes ou des fusils, ornés de drap rouge et de petites plumes noires, et dont elles posaient la crosse par terre en dansant ; en un mot, dans cette danse du scalp, que les Meunitarris appellent Zuhdi-Arichi, les femmes portent les armes et tout le costume de guerre des hommes.

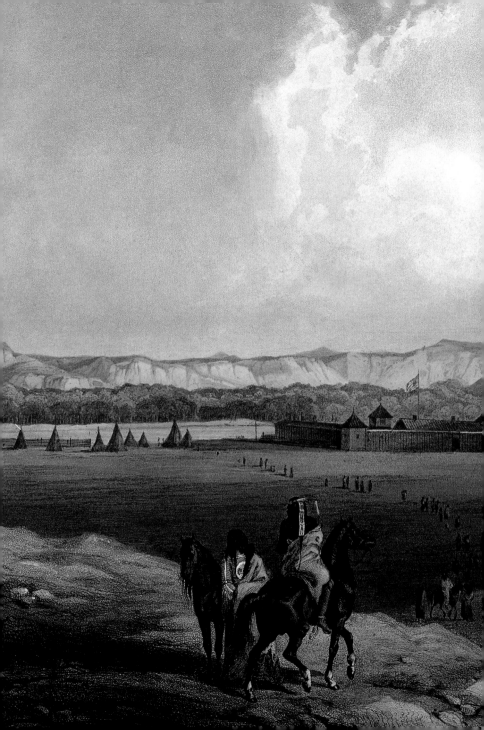

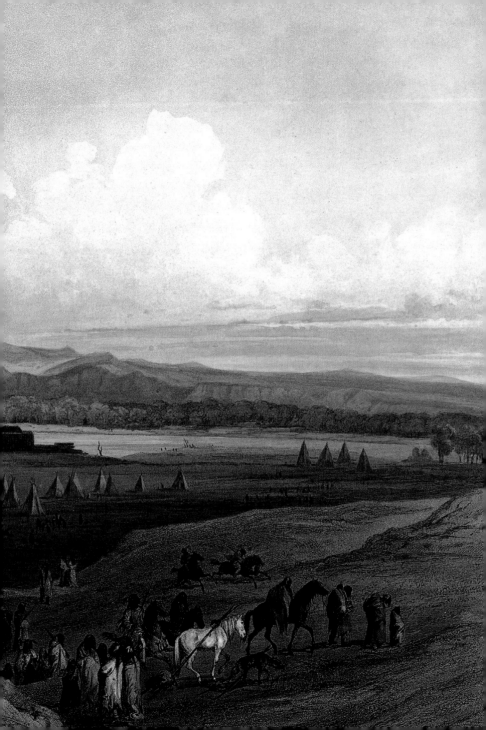

TOMBS OF ASSINIBOIN INDIANS ON TREES

In the wood below the fort [Fort Union] we found a tree, on which the corpses of several Assiniboins had been deposited; one of them had fallen down, and been torn and devoured by the wolves. The blankets which covered the bodies were new, and partly bedaubed with red paint, and some of the branches and the trunk of the tree were coloured in the same manner. Dreidoppel [the Prince's hunter], who discovered this tree, took up the skull of a young Assiniboin, in which a mouse had made a nest for its young; and Mr. Bodmer made an accurate drawing of the tree, under which there was a close thicket of roses in full blossom. The fragrant flowers seemed predestined to veil this melancholy scene of human frailty and folly.

ASSINIBOIN BAUMGRÄBER

In dem Walde unterhalb des Fortes [Union] fanden wir einen Baum, auf welchem mehrere Assiniboin-Leichname deponirt waren. Einer derselben war herab gefallen und von den Wölfen zerissen und verzehrt worden, eine eben nicht sehr einladende Scene! Die wollenen Decken, welche die Leichen einhüllten, waren neu und zum Theil mit rother Farbe beschmutzt, auch die Aeste und der Stamm des Baumes zum Theil mit dieser Farbe angerieben. Dreidoppel [der Jäger des Prinzen], welcher dieses Baumgrab zuerst entdeckte, hob daselbst einen jungen Assiniboin-Schädel auf, in welchem eine Maus das Nest für ihre Jungen angelegt hatte, und Herr Bodmer nahm eine genaue Zeichnung jenes Baumes auf, unter welchem sich ein dichtes Gebüsch von jetzt blühenden Rosen befand, ein wahrer Rosengarten, dessen wohlriechendende Blüthen bestimmt schienen, diese traurige Scene menschlicher Vergänglichkeit und Thorheit zu verschleiern.

TOMBEAUX DES ASSINIBOINS DANS DES ARBRES

Nous profitâmes des derniers moments de notre séjour pour faire des excursions dans les forêts de la rive et dans la prairie. Dans les premières nous trouvâmes un arbre où l'on avait déposé plusieurs corps d'Assiniboins. L'un de ces corps étant tombé, avait été déchiré et dévoré par les loups, spectacle fort peu attrayant! Les couvertures de laine qui enveloppaient le corps, étaient neuves, et peintes en partie d'une couleur rouge, ainsi que le tronc de l'arbre. Dreidoppel, le chasseur du prince, qui le premier découvrit ce tombeau sylvain, y ramassa un crâne d'Assiniboin, dans lequel une souris avait fait son nid, et M. Bodmer dessina fort exactement cet arbre, sous lequel croissaient d'épais buissons de roses, dont les fleurs, en parfumant l'air, semblaient destinées à répandre quelque charme sur cette scène de fragilité et de folie humaines.

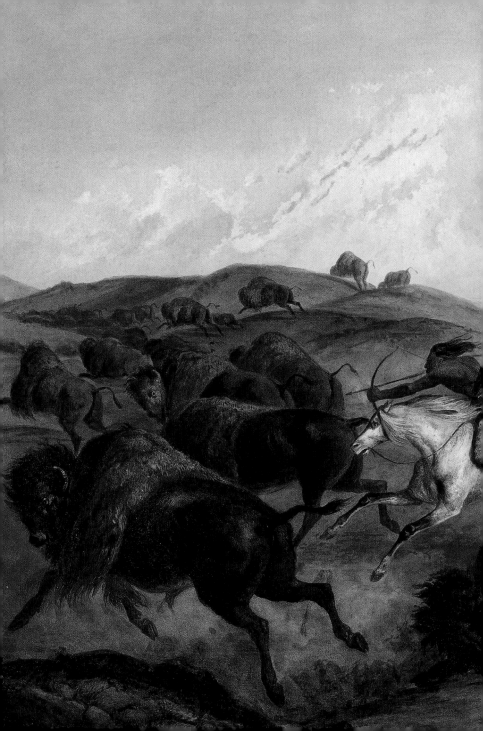

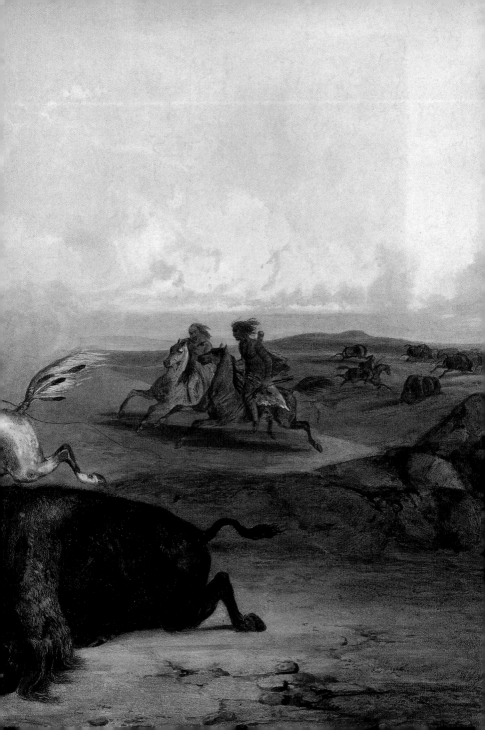

ASSINIBOIN INDIANS

Later on, another interesting young man named Pitatapiu, of the latópabine or Stone Indians, had his portrait taken. His hair hung down like a lion's mane, especially over his eyes, so that they could scarcely be seen; over each of them a small white sea shell was fastened with a hair string; in his hand he carried a long lance, used only for show, to which a number of slips of the entrails of a bear were fastened, and smeared with red paint. This slender young man had his painted leather shield on his back, to which a small, well-wrapped package was fastened, containing his medicine or horse-stealing amulet, which he greatly prized. These people will not part with such things on any terms. The handle of his whip was of wood, with holes in it like a flute.

ASSINIBOIN INDIANER

Ein anderer interessanter junger Mann vom Stamme der Iatópabine oder Stone-Indians, dessen Name Pitätapiú war, diente später als Modell. Seine Haare hiengen gleich Löwenmähnen herab, besonders über die Augen, so dass man diese kaum sehen konnte. Ueber einem jeden derselben befand sich an einem Haarstrange eine kleine weisse Seemuschel befestigt. In der Hand trug er eine lange Bogenlanze, dergleichen sie nur zum Staate führen, an welcher eine Menge Bänder oder Streifen von den Därmen des Bären befestigt und mit röthlicher Farbe bestrichen waren. Auf dem Rücken trug dieser schlanke junge Mensch seinen ledernen, bunt bemalten Schild (Pare-flèche der Canadier), auf welchem ein kleines, wohl eingewickeltes Päckchen, seine Medecine oder Schutzapparat beim Pferdestehlen, befestigt war, die er sehr hoch hielt. Solche Dinge würden diese Menschen um keinen Preis hergebe

INDIENS ASSINIBOINS

Un autre jeune homme intéressant, de la tribu des Iatopabines ou Gens des Roches, qui s'appelait Pitétapiou, nous servit plus tard de modèle. Ses cheveux retombaient comme la crinière d'un lion, et cachaient surtout ses yeux, au point qu'on pouvait à peine les apercevoir. Au-dessus de chacun d'eux était attachée, à une mèche de cheveux, une petite coquille marine blanche. Il tenait à la main une de ces longues lances qu'ils ne portent que pour la montre, à laquelle pendaient une quantité de rubans ou de cordons faits de boyaux d'ours et peints d'une couleur rougeâtre. Sur le dos, ce jeune homme efflanqué portait son bouclier de cuir peint de diverses couleurs, et que les Canadiens appellent un pare-flèche. À ce bouclier était attaché un petit paquet bien enveloppé, contenant sa médecine, c'est-à-dire, le talisman qui devait le protéger quand il allait voler des chevaux, et auquel il attachait une grande valeur. Ces hommes ne vendraient des objets de ce genre pour aucun prix. Le manche de son fouet était de bois et percé de trous comme une flûte.

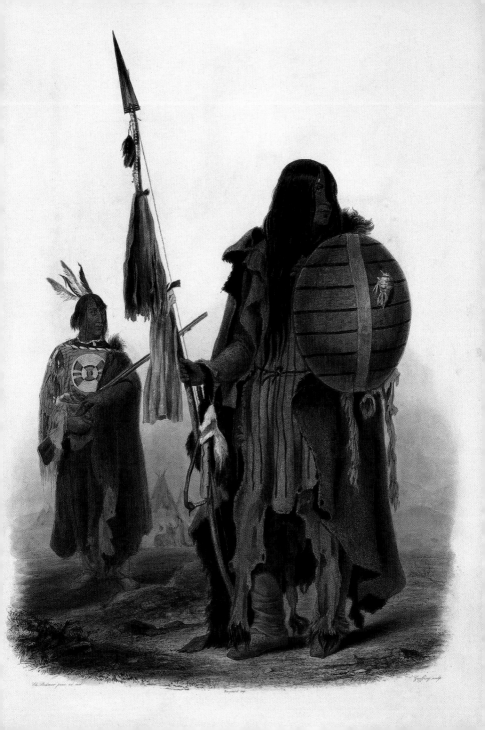

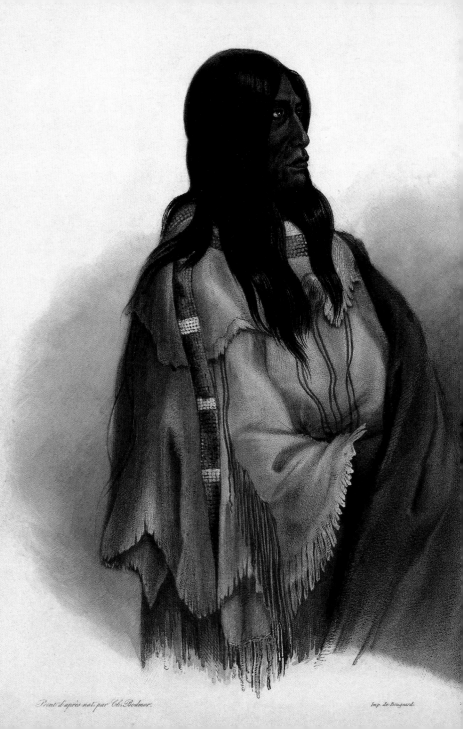

Imp. de Bougeard.

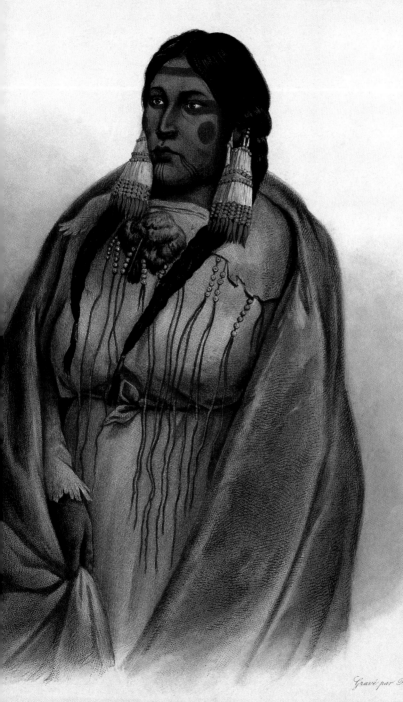

Gravé par P. Legrand.

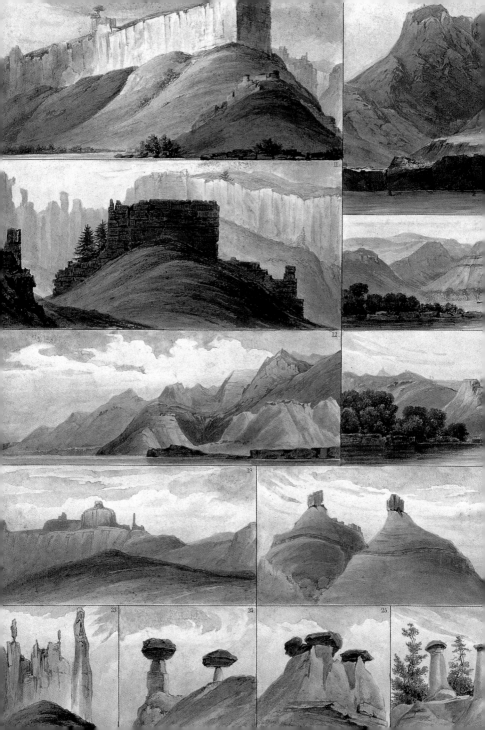

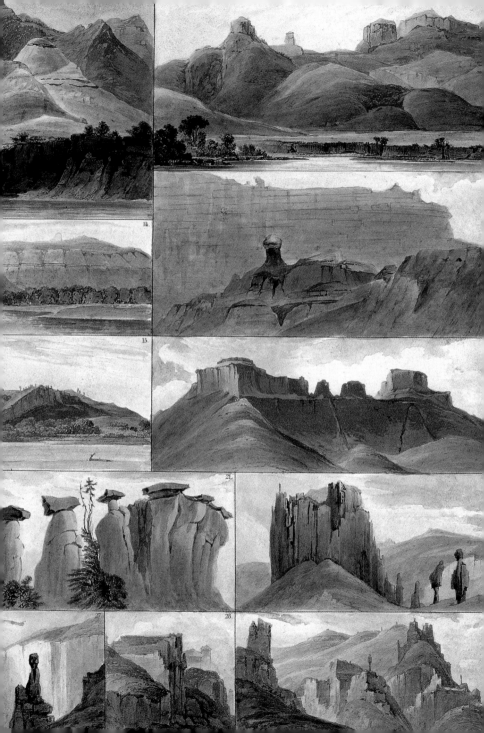

REMARKABLE HILLS ON THE UPPER MISSOURI

Near Bighorn Island, we again saw most singular summits on the hills. Entire rows of extraordinary forms joined each other, and in the lateral valleys we had interesting glimpses of this remarkable scenery, as we were now approaching the most interesting part of the Mauvaises Terres ["Badlands"]. I described these mountains earlier when speaking of the White Castles, but here they began to be more continuous, with rough tops and isolated pillars, bearing flat slabs, or boulders, resembling mountain-castles, fortresses, and the like, and they became steeper and more barren at every step. Often one could plainly perceive hills or mountains that had sunk into the marshy valley.

MERKWÜRDIGE HÜGEL AM OBERN MISSOURI

In der Gegend [des] Bighorn-Island zeigten sich wieder höchst originelle Kuppen an den Höhen. Reihen sonderbarer Gestalten schliessen sich aneinander und in den Seitenthälern hatte man schöne Blicke in diese merkwürdige Natur, da wir uns jetzt dem interessantesten Puncte der Mauvaises-Terres näherten. Schon in der Gegend der sogenannten White-Castles (der weissen Bergschlösser) habe ich diese originellen Berge beschrieben, sie beginnen aber jetzt noch anhaltender und mehr mit barocken Kuppen, isolirten, mit tafelförmigen Platten oder Kugeln bedeckten Säulen oder Pfeilern, gleich Bergschlössern, Festungen und dergleichen sich zu zeigen, und ihre Steilheit und Nacktheit nimmt mit jedem Schritte zu. Häufig bemerkt man deutlich niedergesunkene Hügel oder Berge, und man begreift recht deutlich, wie sie in das damalige Schlammthal versunken sind.

COLLINES SINGULIÈRES SUR LE HAUT MISSOURI

Dans les environs du Bighorn-Island, nous vîmes de nouveau les hauteurs couronnées de singuliers sommets. Des rangées de figures des plus extraordinaires se suivaient presque sans intervalle et les vallées latérales offraient de beaux points de vue vers cette nature remarquable ; car nous approchions alors des parties les plus intéressantes des Mauvaises-Terres. J'ai déjà décrit ces formes singulières dans les environs des Châteaux-Blancs ; mais où nous étions alors elles commencèrent à se montrer d'une façon bien plus continue : c'étaient alternativement des cimes baroques, isolées, des colonnes surmontées de tables ou de boules, des châteaux, des remparts, etc., tandis qu'ils augmentaient de plus en plus en escarpement et en nudité. On remarque souvent des collines ou des montagnes évidemment affaissées, et l'on comprend sans peine comment elles se sont enfoncées dans l'ancienne vallée marécageuse.

PAGE/SEITE 98/99

Remarkable hills on the upper Missouri
Merkwürdige Hügel am obern Missouri
Collines singulières sur le haut Missouri

THE WHITE CASTLES ON THE UPPER MISSOURI

On the mountain of the south bank, there was a thick, snow-white layer, a long extended stratum of white sandstone, which had been partly eroded by the river. At the end where it was exposed, being intersected by the valley, two high pieces in the shape of buildings had remained standing, and upon them lay remains of a more compact, yellowish-red, thinner stratum of sandstone, which formed the roof of the united edifice. Along the length of the whole edifice, there were small perpendicular slits, which appeared like so many windows. These singular natural formations, when seen from a distance, so perfectly resembled buildings raised by art that we were thoroughly deceived by them until assured of our error.

DIE WEISSEN SCHLÖSSER AM OBERN MISSOURI

An dem Berge des südlichen Ufers befand sich ein starkes schneeweisses Lager, eine weit fortstreichende Schicht von weissem Sandsteine, welche theilweise von den Gewässern bearbeitet war. An ihrem entblössten Ende, wo sie durch das Thal abgeschnitten ist, waren ein Paar erhöhte Stücke derselben in der Gestalt von Gebäuden stehen geblieben, und auf ihnen lagen Ueberreste einer compacteren, gelbröthlichen und weniger mächtigen Sandsteinschicht, welche täuschend die Dächer dieser vereinten Gebäude bildeten. An der Vorderseite der weissen Gebäude sah man kleine perpendiculäre Furchen, welche scheinbar eben so viele Fenster darstellten. Der Anblick dieser sonderbaren Naturgebilde hatte aus der Ferne eine solche Aehnlichkeit mit künstlich gemauerten Gebäuden, dass wir dadurch getäuscht wurden, bis man uns aus dem Irrthume zog.

LES CHATEAUX BLANCS MISSOURI SUPÉRIEUR

Contre les montagnes de la rive méridionale se trouvait une forte couche blanche comme de la neige ; c'était du grès qui s'étendait fort loin, et qui paraissait avoir été en partie façonné par les eaux. À son extrémité dénudée, où elle est coupée par la vallée, deux portions plus élevées étaient restées debout et figuraient des édifices, surmontés de débris d'une autre couche de grès, moins considérable, mais plus compacte et d'un jaune rougeâtre, qui représentaient, à s'y méprendre, les toits de ces deux édifices réunis. Sur le devant des bâtiments blancs, on voyait de petites fentes perpendiculaires que l'on pouvait prendre pour autant de fenêtres. L'aspect de cette singulière formation de la nature offrait de loin une si grande ressemblance avec des édifices élevés par l'art, que nous y fûmes trompés, jusqu'à ce que l'on nous eût démontré notre erreur.

PAGE/SEITE 104/105

Hunting of the Grizzly Bear
Jagd auf Grizzly Bären
Chasse au grizzly

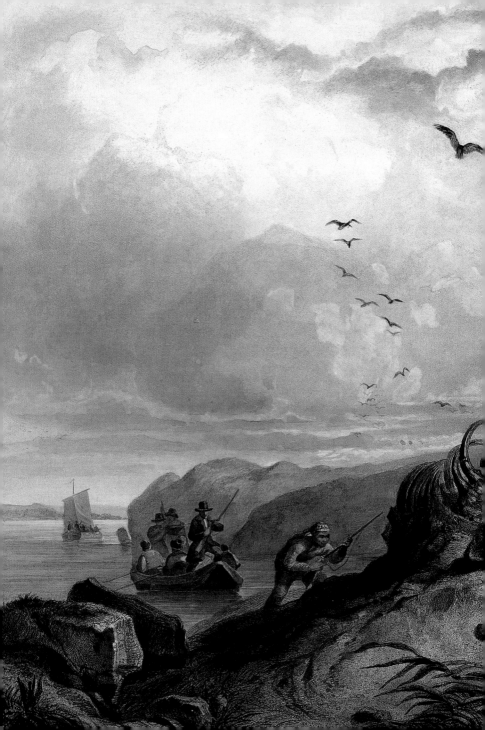

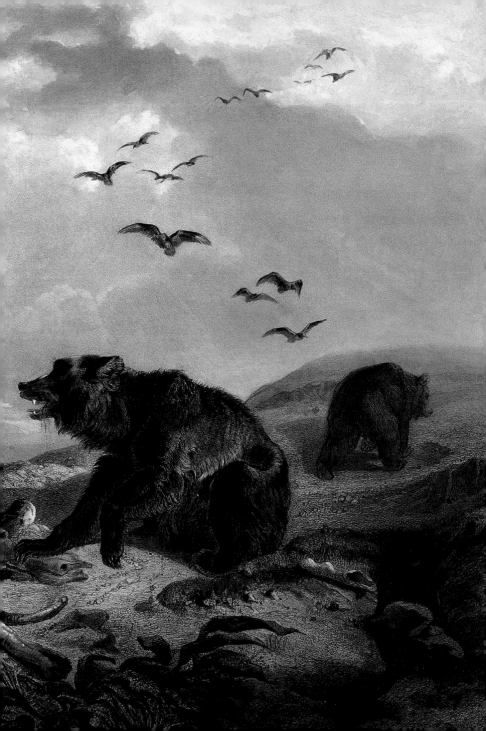

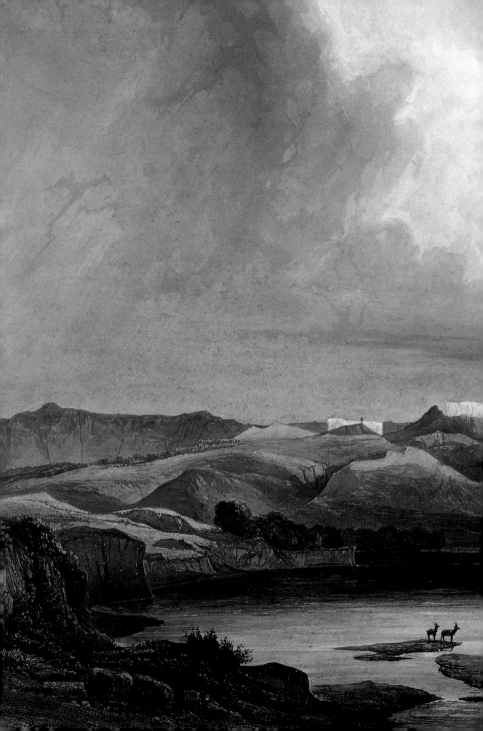

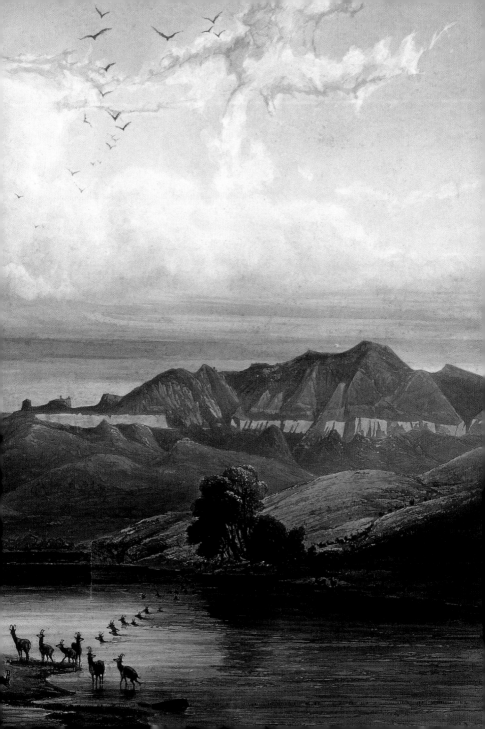

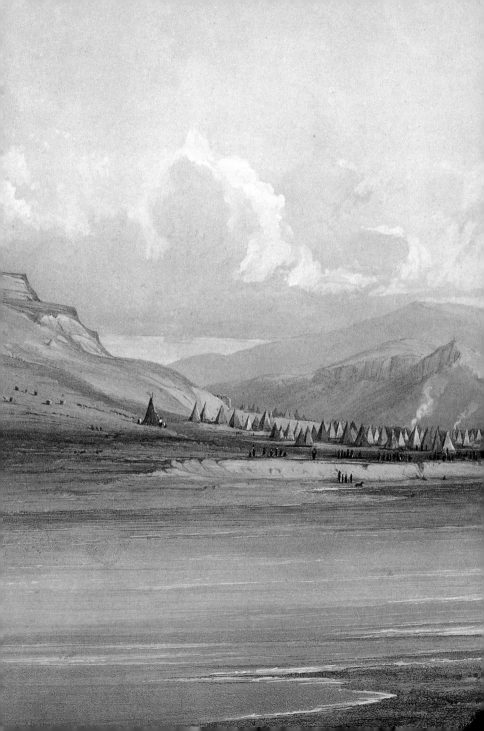

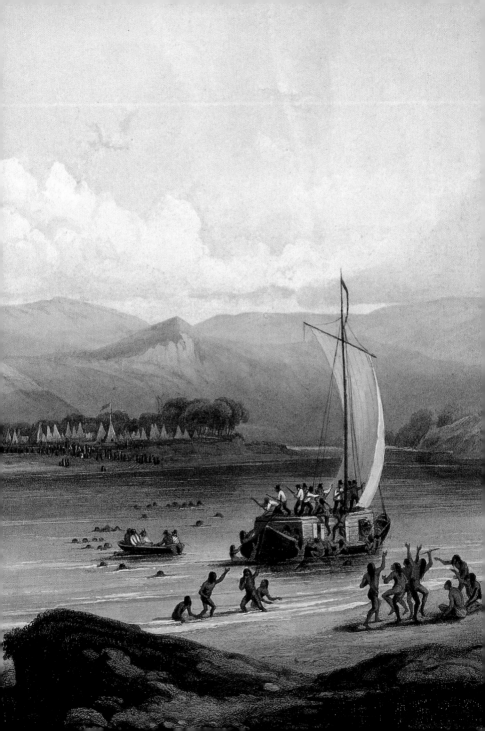

CAMP OF THE GROS VENTRES OF THE PRAIRIES ON THE UPPER MISSOURI

On the 5th of August [1833] we passed Bull Creek, the mouth of which is in pleasant country-side. At six o'clock, as we approached Judith River, a white sandstone hill, the first specimen of that formation, appeared before us on the north bank. On the left lay the mouth of Bighorn River, between considerable hills, on which numbers of Indians had collected. In front of the eminences the prairie declined gently towards the river, where about 260 leather tents of the Indians had been set up; the tent of the principal chief was in the foreground, and near it a high pole with the American flag. The whole prairie was covered with Indians, in various groupings, and with numerous dogs. Horses of every colour were grazing round, and horsemen galloped backwards and forwards, among them a celebrated chief who made a fine figure on his light bay.

LAGER DER GROS VENTRES DES PRAIRIES AM OBERN MISSOURI

Am 5. August [1833] früh schifften wir an Bull-Creek vorbei, und befanden uns gegen 6 Uhr in der ziemlich offenen Gegend des Judith-River. Ein weisser Sandsteinkopf zeigte sich hier vor uns am nördlichen Ufer, als erste Probe jener Formation, und zur Linken öffnete sich zwischen ansehnlichen, mit graugrünem Grase bewachsenen, und von kriechendem Wachholder schwärzlich gefleckten Höhen, der Bighorn-River, an dessen Ufern, so wie an den Bergen zahlreiche Indianer sich versammelt hatten. Vor den Bergköpfen, von welchen der eine etwas gabel-förmig gespalten ist, dehnte sich nach dem Flusse sanft abhängend die Prairie aus, auf welcher über 200 Lederzelte der Indianer [Gros Ventre] aufgeschlagen waren. Voran stand das Zelt des Hauptchefs, vor welchem auf einem Pfahle die americanische Flagge wehete. Die ganze Gegend war mit rothbraunen Menschen in mancherlei Gruppen und mit zahlreichen Hunden bedeckt, und Pferde von allen Farben graseten daselbst, Reiter sprengten hin und her, u. a. ein berühmter Chef, der sich sehr gut auf einem Falben ausnahm.

CAMP DES GROS VENTRES DES PRAIRIES SUR LE MISSOURI

Le 5 août, de grand matin, nous passâmes devant le Bull-Creek, et vers six heures nous nous trou-vâmes dans un pays assez découvert, où le Judith-River présente plusieurs bouches. Un sommet de grès blanc se fit voir sur la rive septentrionale, comme premier échantillon de cette formation, tandis que sur la gauche, entre des hauteurs assez considérables, couvertes d'une herbe vert grisâtre et de touffes noires de genévriers nains, s'ouvrait le Bighorn-River, sur les rives duquel, ainsi que sur les montagnes, de nombreux Indiens s'étaient rassemblés. Devant les sommets, l'un desquels est légèrement fourchu, s'étendait la prairie, qui descendait par une pente douce vers la rivière, et sur laquelle étaient dressées deux cents tentes indiennes en cuir. La campagne tout entière était couverte d'hommes cuivrés, rassemblés en groupes, et d'un grand nombre de chiens; des chevaux de toutes les couleurs y passaient; des cavaliers allaient et venaient au galop, et dans le nombre nous remarquâmes un chef célèbre qui avait très bonne mine à cheval.

NIAGARA FALLS

The roaring of the cataract is heard at a considerable distance, and lofty columns of mist and vapour ascend into the air. The stranger is conducted from the village to the above-mentioned rapids, and then proceeds, by a long, strongly-built wooden bridge over the end of the rapids to the small Bath Island. From the bridge leading to Goat Island there is a convenient path, to the right, which traces the shoreline through the wood. After proceeding along this path a short distance, the stranger suddenly finds himself on the rather steep declivity immediately above the fall of the right or southern arm of the river known as the American branch. The sight is striking, and much grander than any of the descriptions I had read had led me to conceive. The broad expanse of bright green water falls perpendicularly 144 to 150 feet into the abyss below, which is entirely concealed by the vapour, the whole torrent of falling water being completely dissolved into foam and mist in the midst of its descent.

NIAGARA FÄLLE

Schon aus der Ferne vernimmt man das Brausen und Toben der Fälle und hohe Säulen von Wasserdampf und Nebel steigen zum Himmel auf. Man tritt aus dem Dorfe an die beschriebene Stromschnelle (Rapid) und wandert auf einer langen, starken Holzbrücke über das Ende derselben nach der kleinen Badinsel (Bath-Island). Von der Brücke, auf welcher man Goat-Island (die Ziegeninsel) erreicht, führt ein bequemer gut gehaltener Weg rechts längs dem Ufer der Insel durch den Wald fort, und man tritt hier plötzlich, nachdem man eine kurze Entfernung zurückgelegt, an den etwas steilen Abhang, unmittelbar über dem Fall des rechten oder südlichen, sogenannten americanischen Flussarmes. Der Anblick ist imposant und weit grossartiger, als ich mir denselben nach den mancherlei davon gegebenen Beschreibungen dachte. Der breite stolze Fluss mit seinem lebhaft blau grünen, in weissen Schaum aufgelösten Wasser, fällt 144 bis 150 Fuss tief in die senkrechte, von Dampf gänzlich verhüllte Tiefe, und ist schon in der halben Fallhöhe gänzlich in Schaum und Nebel aufgelöst, indem er seine aufsteigenden Wolken den Winden Preis gibt.

LES CHÛTES DE NIAGARA

Le mugissement des chutes se fait entendre de fort loin, et des colonnes de vapeur et de brouillard s'élèvent jusqu'au ciel. En sortant du village près du rapide que je viens de décrire, on se rend par un long et solide pont de bois à la petite île souvent décrite, que l'on appelle l'île des Bains (Bath-Island). Du pont par lequel on arrive à Goat-Island, une route commode et bien entretenue conduit à droite, le long du rivage de l'île et à travers le bois, puis après avoir franchi une distance peu considérable on se trouve tout à coup près d'une pente assez rapide, immédiatement au-dessous du bras droit ou méridional, appelé le bras Américain de la rivière. L'aspect est imposant et beaucoup plus grandiose que je ne m'y étais attendu, d'après les diverses descriptions que j'en avais lues. La large et noble rivière, avec ses eaux bleu verdâtre transformées en écume blanche, tombe d'une hauteur de cent quarante-quatre à cent cinquante pieds dans un abîme perpendiculaire tout rempli de vapeur, et, avant d'arriver à moitié chemin, elle est déjà toute changée en écume et en brouillard, abandonnant aux vents les nuages qui s'en élèvent.

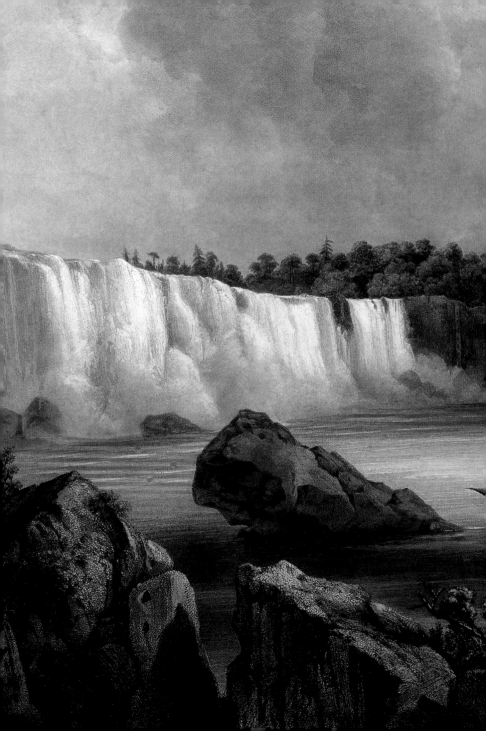

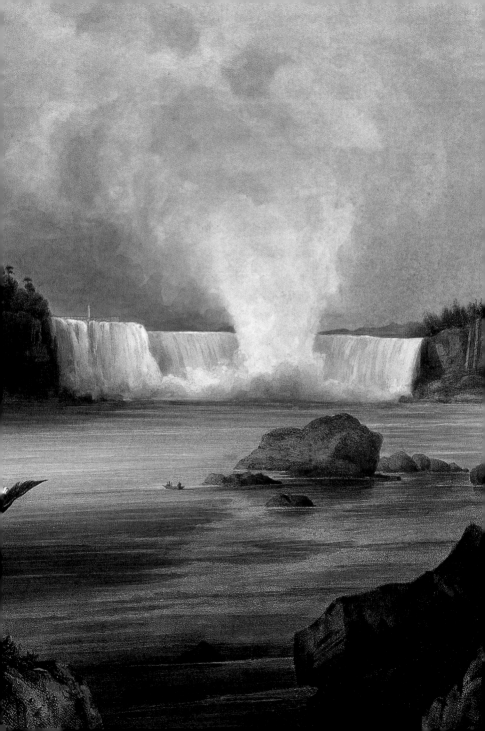

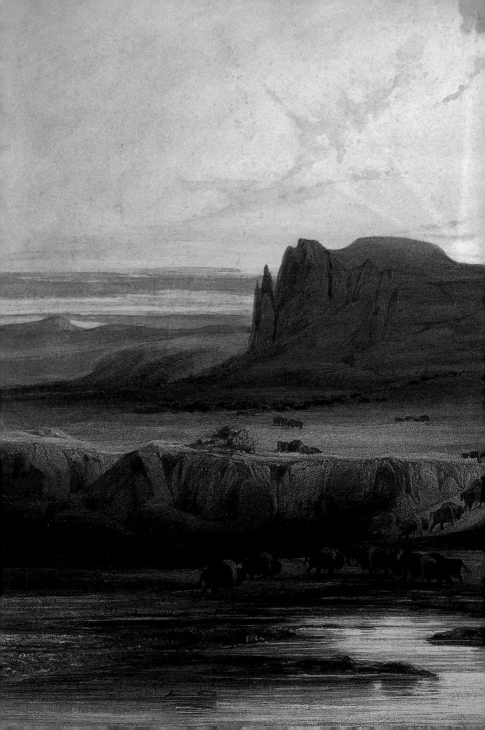

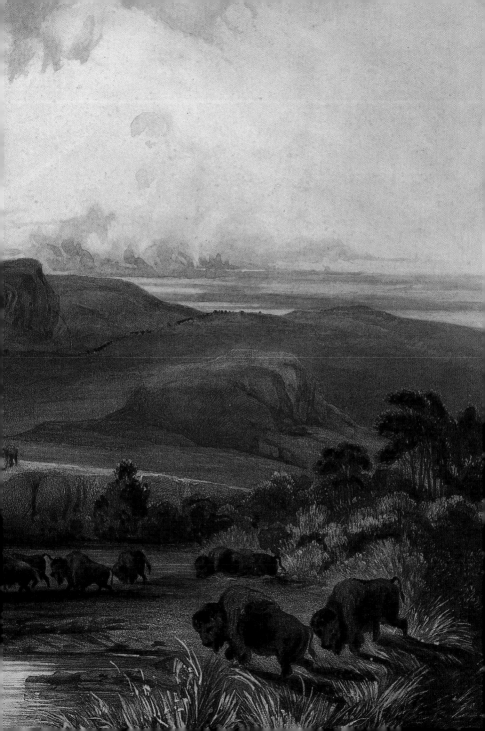

HERD OF BISON ON THE UPPER MISSOURI

The consumption of this animal is immense in North America. It has become as indispensable to the Indians as the reindeer is to the Laplanders, and the seal to the Esquimaux. It is difficult to obtain an exact estimate of the consumption of this species, numbers of which are decreasing annually as herds are decimated and driven further and further inland. Recently, the Fur Company sent 42,000 buffalo hides down the river in one year, to be sold in the United States at four dollars a-piece. Fort Union alone consumes about 600 to 800 buffalo annually, and the other forts in proportion. The numerous Indian tribes subsist almost entirely on buffalo, selling their skins after retaining a sufficient supply for their clothing, tents, etc., while the agents of the Company recklessly shoot down these noble animals for their own pleasure, often not making the least use of them and removing solely the tongue.

BISONHEERDE AM OBERN MISSOURI

Ungeheuer ist die Consumtion dieser im inneren Nord-America so höchst unentbehrlichen Thierart, welche dem Indianer das ist, was dem Lappen das Rennthier und dem Eskimaux der Seehund. Schwer ist eine richtige Schätzung der Consumtion dieser jährlich mehr verminderten und immermehr zurück getriebenen Thierart. Die Fur-Company hat in einem der letzteren Jahre allein 42000 Kuhfelle den Fluss hinabgesendet, wovon man in den Vereinten Staaten das Stück zu 4 Dollars verkauft. Allein Fort Union consumiert zu seiner Nahrung in einem Jahre 6[00] bis 800 Stück Bisonten, alle übrigen Forts thun ebenfalls das ihrige; die zahlreichen Indianer leben beinahe ausschliesslich von diesen Thieren, verkaufen ihre Felle, nachdem sie den nöthigen Bedarf für ihre Kleidung, Zelte und Lederwerk davon zurück behalten haben, und dabei schiessen die Angestellten der Compagnie auf ihren Excursionen rücksichtslos zu ihrem Vergnügen diese edlen Thiere nieder, ohne oft den mindesten Gebrauch davon zu machen, zuweilen bloss, um ein Paar Zungen davon zu benutzen.

TROUPEAU DE BISONS SUR LE HAUT MISSOURI

La consommation qui se fait de ces animaux si indispensables, dans l'intérieur de l'Amérique septentrionale, est immense. Ils sont pour les Indiens ce que le renne est pour les Lapons, et le phoque pour les Esquimaux. Il serait difficile d'évaluer la consommation de cette espèce d'animal qui diminue tous les ans, et que l'on repousse toujours plus en arrière. La Compagnie des Pelleteries, à elle seule, a expédié, en une seule année, 42000 peaux de bison femelle, qui se vendent aux États-Unis à raison de quatre dollars pièce. Le Fort-Union consomme annuellement, pour sa subsistance, de 6[00] à 800 bisons, et tous les autres forts en proportion ; les nombreux Indiens vivent presque exclusivement de la chair de cet animal, dont ils vendent les peaux, après s'en être réservé la quantité nécessaire pour leurs vêtements, leurs tentes et leurs objets de cuir. Il faut remarquer, en outre, que les employés de la Compagnie, dans leurs excursions, tuent souvent ces précieux animaux, seulement pour se divertir, et sans avoir la moindre intention d'en faire usage, ou, tout au plus, pour en manger la langue.

VIEW OF THE STONE WALLS
ON THE UPPER MISSOURI

Being detained by a violent thunderstorm, it was one o'clock (on the 5th of August 1833) before we reached the place where the Missouri flows through a rather narrow gorge, from the remarkable sandstone valley, called the Stone Walls; a white sandstone hill appeared before us on the north bank, the first specimen of this formation; to the left, the mouth of Bighorn River appeared from between grey-green grassy hills speckled black with juniper.

ANSICHT DER STONE-WALLS
AM OBERN MISSOURI

Durch ein heftiges Gewitter aufgehalten, erreichten wir erst um 1 Uhr eine Stelle, wo der Missouri durch eine etwas enge Kehle aus dem merkwürdigen Sandsteinthale hervortritt, welches den Namen der Stone-Walls (Steinmauern) trägt. Ein weisser Sandsteinkopf zeigte sich hier vor uns am nördlichen Ufer, als erste Probe jener Formation, und zur Linken öffnete sich zwischen ansehnlichen, mit graugrünem Grase bewachsenen, und von kriechendem Wachholder schwärzlich gefleckten Höhen, der Bighorn-River.

VUE DES STONE-WALLS
SUR LE HAUT MISSOURI

Retenus par un violent orage, nous n'arrivâmes qu'à une heure à un endroit où le Missouri sort, par une gorge un peu étroite, de la singulière vallée de grès qui porte le nom de Stone-Walls (Murailles-de-Pierre). Un sommet de grès blanc se fit voir sur la rive septentrionale, comme premier échantillon de cette formation, tandis que sur la gauche, entre des hauteurs assez considérables, couvertes d'une herbe vert grisâtre et de touffes noires de genévriers nains, s'ouvrait le Bighorn-River.

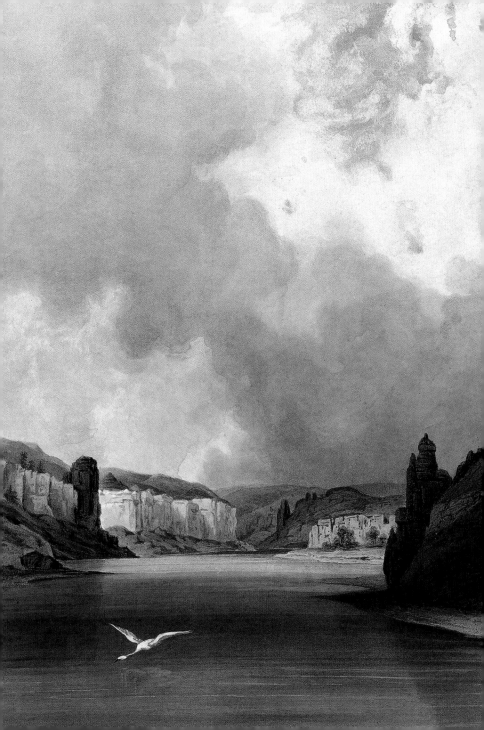

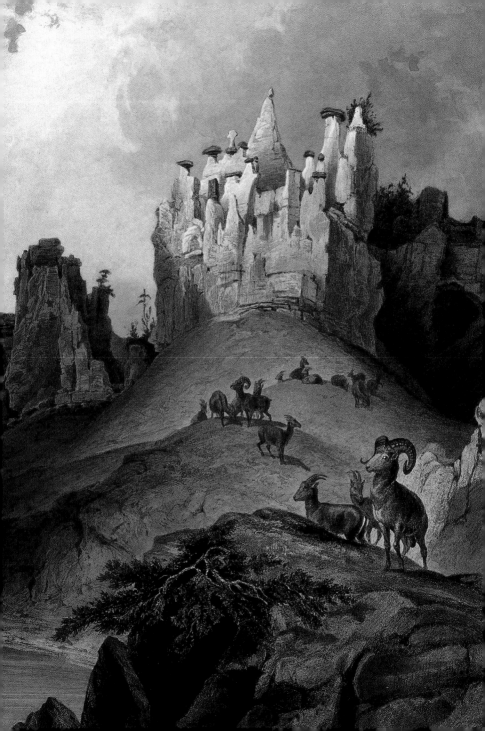

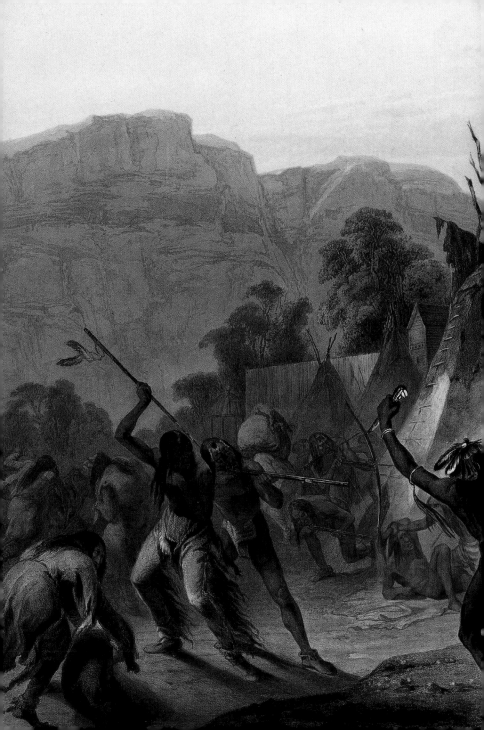

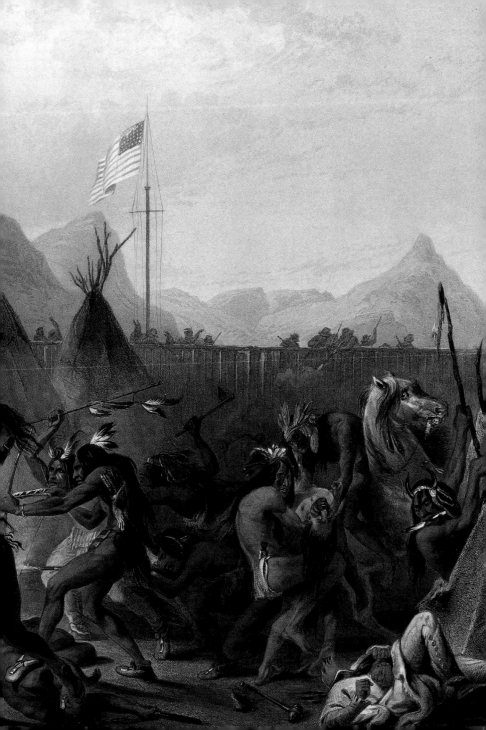

FORT MACKENZIE, 28TH AUGUST 1833

On the 28th of August, at break of day, we were awakened by musket-shot, and Doucette entered our room, crying, "Levez-vous, il faut nous battre," on which we arose in haste, dressed ourselves, and loaded our fowling-pieces with ball. When we entered the courtyard of the fort, all our people were in motion, and some were firing from the roof. On ascending to it, we saw the whole prairie covered with Indians on foot and on horseback, who were firing on the fort, while several detached bodies were arrayed along the horizon … When the first news of the proximity of the enemies was received from a Blackfoot, who had escaped, the engagés immediately repaired to their posts on the roof of the buildings, and the fort was seen to be surrounded on every side by the enemy, who had approached very near. They had cut up the tents of the Blackfoot with knives, discharged their guns and arrows at them, and killed or wounded many of the inmates, roused from their sleep by the unexpected attack.

FORT MACKENZIE DEN 28TEN AUGUST 1833

Am 28. August, als der Tag anbrach, wurden wir durch Flintenschüsse geweckt, und Doucette trat mit dem Ausruf in unser Zimmer »Levez vous! il faut nous battre!« worauf wir schnell aufsprangen, uns in die Kleider warfen, und unsere Jagdgewehre mit Kugeln luden. Bei dem Eintritte in den Hofraum des Fortes war die ganze Besatzung schon in Bewegung und von den Dächern fielen Schüsse. Dort oben angekommen, sahen wir die ganze Prairie mit Indianern zu Pferd und zu Fusse bedeckt, welche nach dem Forte schossen; auf den Höhen befanden sich geschlossene Trupps … Als man durch einen entflohenen Piëkann die erste Nachricht von der Nähe der Feinde erhielt, hatten sich die Engagés sogleich auf ihren Posten, auf die Dächer der Gebäude begeben, und man sah nun das Fort von allen Seiten in ganz geringer Entfernung von dem Feinde umringt. Sie hatten die Zelte der Piëkanns mit Messern zerfetzt, ihre Gewehre und Pfeile in dieselben abgeschossen, und die aus dem Schlafe geschreckten Bewohner zum Theil nieder geschossen oder verwundet.

FORT MACKENZIE, LE 28 AOÛT 1833

Le 28 août, au point du jour, nous fûmes éveillés par des coups de fusil, et Doucette entra dans notre chambre, en criant : «Levez-vous! Il faut nous battre!» Nous sautâmes à bas du lit, nous nous habillâmes à la hâte et nous chargeâmes nos fusils de chasse. Quand nous arrivâmes sur la place du fort, nous trouvâmes toute la garnison sur pied, et des coups de fusil partaient des toits. Y étant montés, nous vîmes toute la prairie couverte d'Indiens à pied et à cheval, qui tiraient sur le fort. Des troupes étaient rangées en lignes serrées sur les hauteurs … Un fuyard Piegan ayant donné le premier avis de l'approche de l'ennemi, les engagés s'étaient immédiatement postés sur les toits des maisons, d'où l'on voyait le fort entouré d'ennemis de tous les côtés et à fort peu de distance. Ils avaient coupé à coups de couteau les tentes des Piegans ; puis ils y avaient envoyé des coups de fusil et des flèches, tuant ou blessant les habitants subitement éveillés.

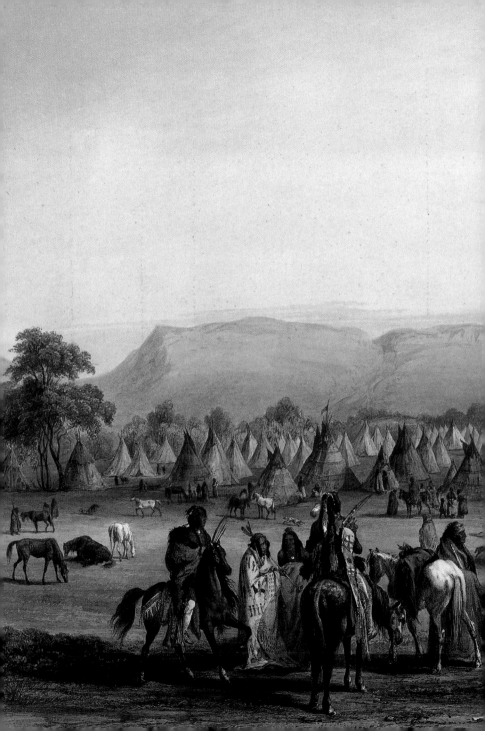

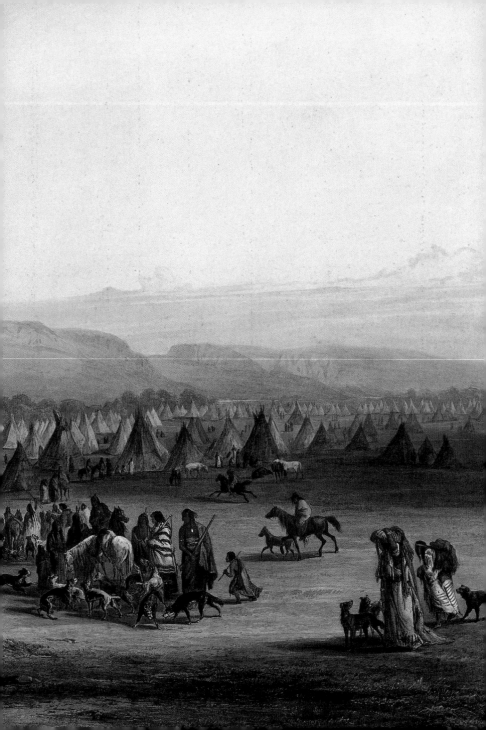

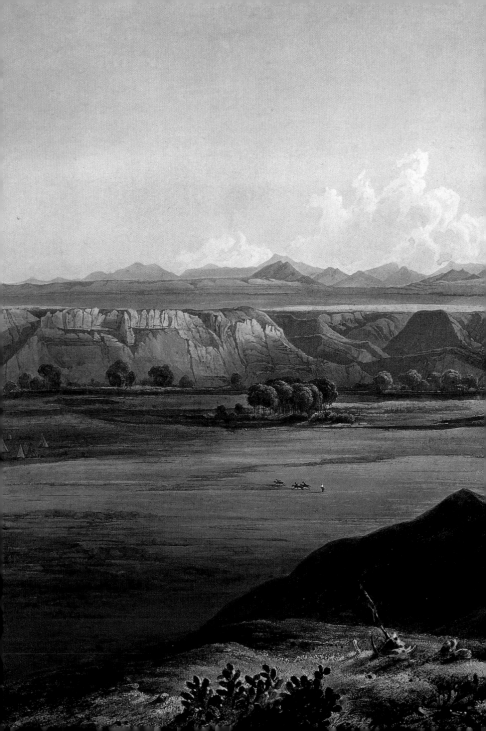

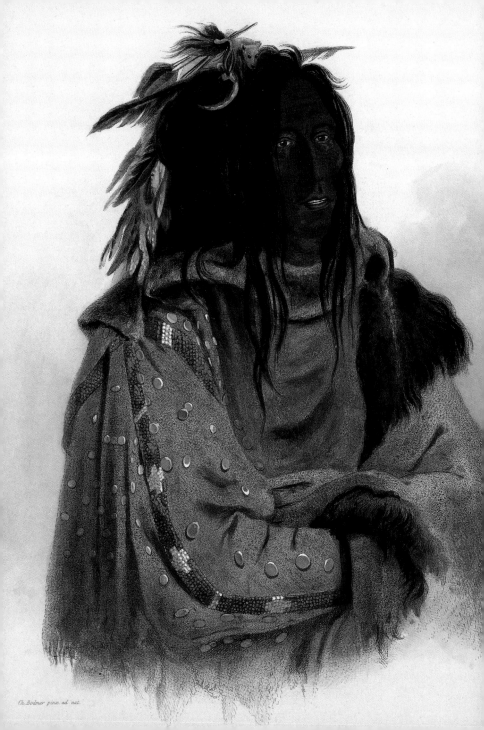

Ch. Bodmer pinx. ad. nat.

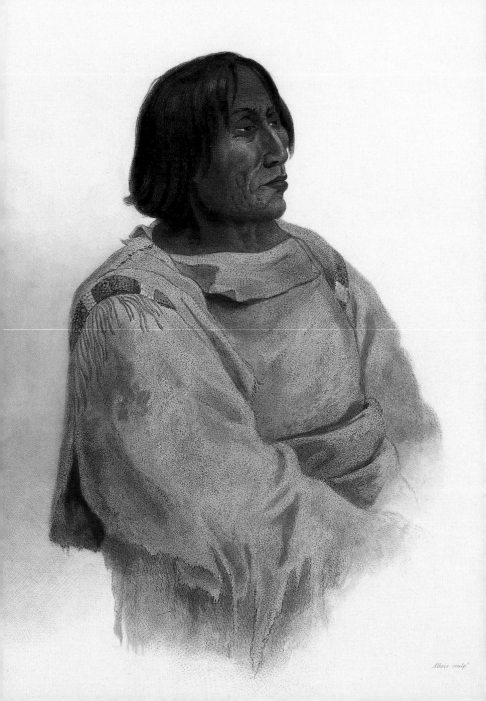

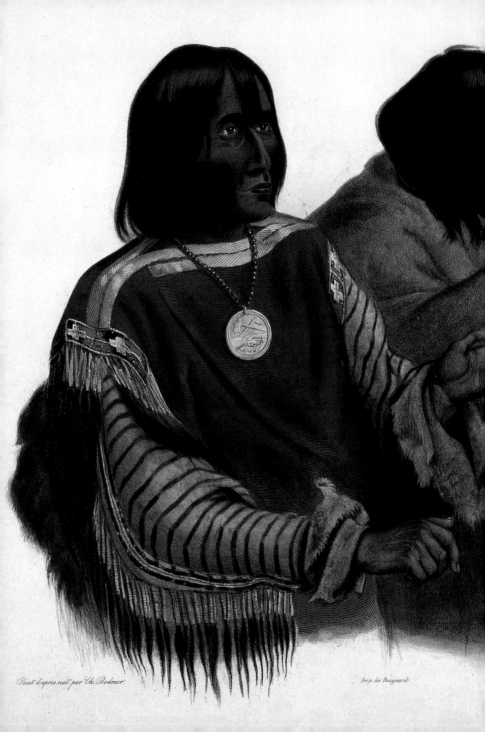

Peint d'après nat par Ch. Bodmer. Imp. de Bougeard.

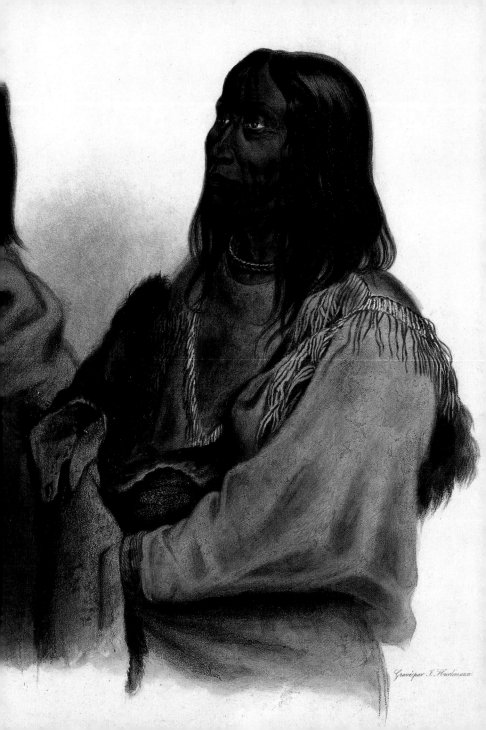

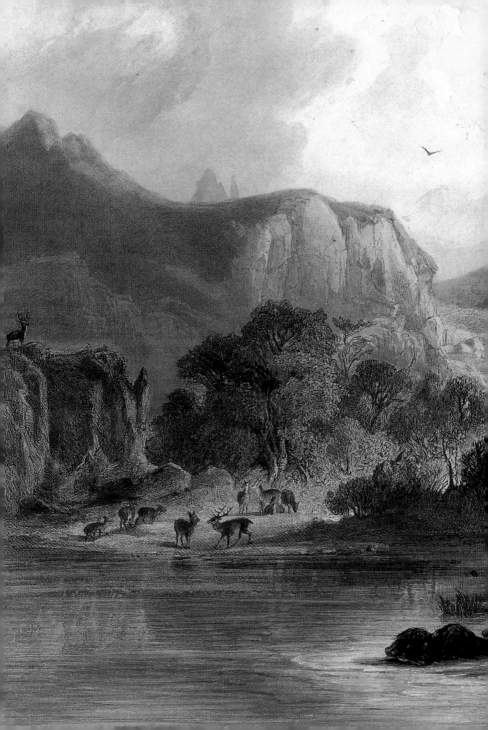

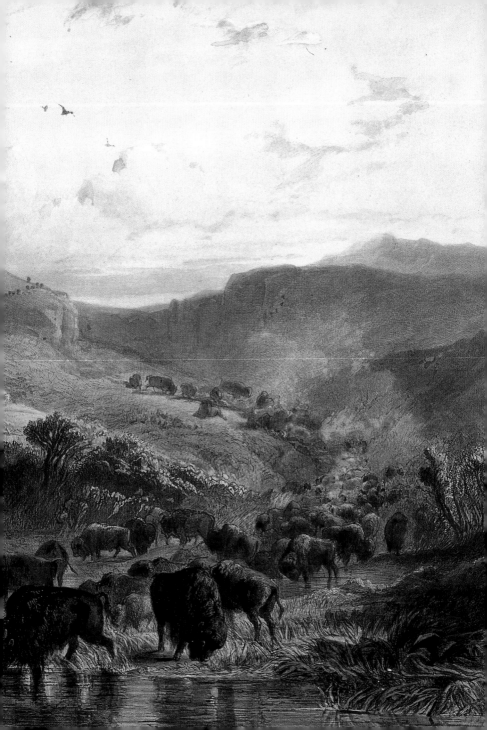

INDIAN UTENSILS AND ARMS

1 Stone knife, which Prince Maximilian of Wied found close to New Harmony.
2 Stone knife from Mexico, depicted by way of comparison.
3 Lance, Sauk and Fox, consisting of a sword blade attached to a pole covered with cloth and feathers.
4 Gunstock club with steel blade, Sauk and Fox. Original: National Museum of Man, Ottawa
5 Headdress similar to that owned by Mató-Tópe, which is in the keeping of the Prince Maximilian Collection. This form of headdress with vertically arranged eagle feathers was very widespread among the Blackfoot. The bonnet consists of eagle feathers, ermine and dyed chicken feathers, attached to a band of rawhide covered with red trade cloth.
6 Shield of the Crow, painted and adorned with eagle feathers.
7 Roach, Fox, made from a stag's tail dyed with vermilion, decorated with eagle feathers and the rattle of a rattlesnake.
8 Folding storage container (parflèche), Dakota, made of rawhide painted with geometrical patterns. Original: Ethnologisches Museum, Berlin
9a Moccasin, Dakota, embroidered with a bear-track pattern. The prince bought these moccasins on his travels. Original: Linden-Museum, Stuttgart
9b Iroquois moccasin, which the Prince probably acquired during his visit to the "village of the Seneca Indians". Original: Linden-Museum, Stuttgart
10 Quiver with bow and arrows, Crow.
11 Pipe tamper and cleaner, Assiniboin. Decorated with porcupine and bird quills.
12 Dakota pipe: The pipe bowl is made of red pipestone (catlinite) with lead inlay; the stem is wood with an openwork pattern, decorated with porcupine quills and dyed horsehair. Original: Linden-Museum, Stuttgart
13 Ceremonial pipe, Blackfoot (Piegan).
14 Mih-Ptott-Kä leather ball, Mandan and Hidatsa (Minitari), embroidered with porcupine quills. It was used for the women's ball games.
15 Hoop and pole game, Mandan. Original: Linden-Museum, Stuttgart
16 Double whistle of a men's ceremonial society, such as the Mandan age-group the "Ravens", who wore a double goose bone whistle of this kind as one of their insignia.
17 Ceremonial or medicine drum formerly owned by Mató-Tópe.
18 Moccasin with porcupine quill embroidery.
19 Stone knife

INDIANISCHE GERÄTHSCHAFTEN UND WAFFEN

1 Steinmesser, das Prinz Maximilian zu Wied in der Nähe von New Harmony fand.
2 Steinmesser aus Mexiko, das als Vergleichsstück abgebildet ist.
3 Lanze, Sauk und Fox. Die Schwertklinge ist an einem mit Stoff und Federn besetzten Stab befestigt.
4 Gewehrkolbenkeule mit Stahlklinge, Sauk und Fox. Original: National Museum of Man, Ottawa
5 Federhaube ähnlich derjenigen aus dem Besitz Mató-Tópes, die sich in der Sammlung von Prinz Maximilian befindet. Der Kopfschmuck mit den gerade aufgerichteten Adlerfedern war bei den Blackfoot sehr verbreitet. Die Haube besteht aus Adlerfedern, Hermelinfellen und gefärbten Hahnenfedern mit einem Ring aus Rohhaut, der mit rotem Wollstoff überzogen ist.
6 Schild der Crow mit Adlerfedern verziert und bemalt.
7 Kopfschmuck der Fox aus rot gefärbtem Hirschschwanzhaar mit Adlerfeder und Schwanzrassel der Klapperschlange.
8 Falttasche der Dakota aus Rohleder (Parflèche), mit geometrischen Mustern bemalt. Original: Ethnologisches Museum Berlin

9a Mokkasin der Dakota mit dem Ornament einer Bärenfährte. Der Prinz kaufte diese Mokkasins auf seiner Reise. Original: Linden-Museum Stuttgart

9b Irokesen-Mokkasin, die der Prinz wahrscheinlich während seines Besuchs im »Seneca-Dorf« erworben hat. Original: Linden-Museum Stuttgart

10 Köcher mit Bogen und Pfeilen, Crows

11 Stock zum Reinigen der Pfeife, Assiniboin. Mit Stachelschweinborsten und Federkielen verziert.

12 Dakota-Pfeife, Pfeifenkopf aus rotem Pfeifenstein (Catlinit) mit Bleieinlagen als Dekor. Pfeifenstiel aus Holz mit durchbrochenem Muster und Verzierung aus Stachelschweinborsten und gefärbtem Pferdehaar. Originale: Linden-Museum Stuttgart

13 Zeremonialpfeife der Blackfoot (Piegan)

14 Mih-Ptott-Kä-Lederball der Mandan und Hidatsa (Mönnitarris), den die Frauen für Ballspiele verwendeten.

15 Reifen- und Stabspiel der Mandan. Original: Linden-Museum Stuttgart

16 Doppelpfeife einer Männer-Zeremonialgesellschaft, wie etwa der Mandan-Altersgruppe der »Raben«, die eine solche Doppelpfeife aus zwei Gansflügelknochen als Abzeichen trugen.

17 Zeremonial- oder medizintrommel aus dem Besitz von Mató-Tópe

18 Mokkasin mit Stachelschweinborstenstickerei

19 Steinmesser

USTENSILES ET ARMES INDIENS

1 Couteau de pierre trouvé par le prince Maximilien de Wied-Neuwied dans les environs de New Harmony.

2 Couteau de pierre du Mexique représenté pour comparaison.

3 Lance, Sauks et Fox. La lame est accrochée à une hampe garnie de morceaux de tissu et de plumes.

4 Crosse de fusil avec lame en acier, Sauks et Fox; Original: National Museum of Man, Ottawa

5 Parure de plumes semblable à celle de Mató-Tópe, qui se trouve dans la collection du prince Maximilien. La parure aux plumes d'aigles dressées était très répandue chez les Pieds-Noirs. Elle se compose de plumes d'aigles, de fourrure d'hermine et de plumes de coq peintes avec un anneau en cuir recouvert de laine rouge.

6 Bouclier des Crows orné de plumes d'aigles et peint.

7 Parure des Fox en poils de queue de cerf teints en rouge garnie de plumes d'aigles et d'écailles de la queue d'un crotale.

8 Sac pliant (pare-flèche) des Dakotas en cuir brut et peint avec motifs géométriques; Original: Ethnologisches Museum Berlin

9a Mocassin des dakotas avec pour ornement l'empreinte d'une patte d'ours. Le prince acheta ces mocassins lors de son voyage. Original: Linden-Museum Stuttgart

9b Mocassin des iroquois, que le prince acheta probablement durant sa visite au «village Seneca». Original: Linden-Museum Stuttgart

10 Carquois avec arc et flèches, Crows

11 Tige pour nettoyer les pipes, Assiniboins. Ornée de piquants de porc-épic et de tuyaux de plumes.

12 Pipe dakota: fourneau en pierre rouge décoré de morceaux de plomb inséré. Tuyau en bois au motif ajouré et orné de piquants de porc-épic et de crinière de cheval teinte. Originaux: Linden-Museum Stuttgart

13 Pipe de cérémonie des Pieds-Noirs (Piegan)

14 Balle de cuir Mih-Ptott-Kä des Mandans et des Hidatsas (Meunitarris), utilisée par les femmes pour jouer au ballon.

15 Disque et tige de jeu des Mandans; Original: Linden-Museum Stuttgart

16 Double-pipe d'une société masculine, comme la classe des «Corbeaux» des Mandans, dont le signe distinctif était cette double-pipe faite à partir des os d'une aile d'oie.

17 Tambour de cérémonie ou de sorcier ayant appartenu à Mató-Tópe.

18 Mocassin avec des broderies en piquants de porc-épic.

19 Couteau de pierre

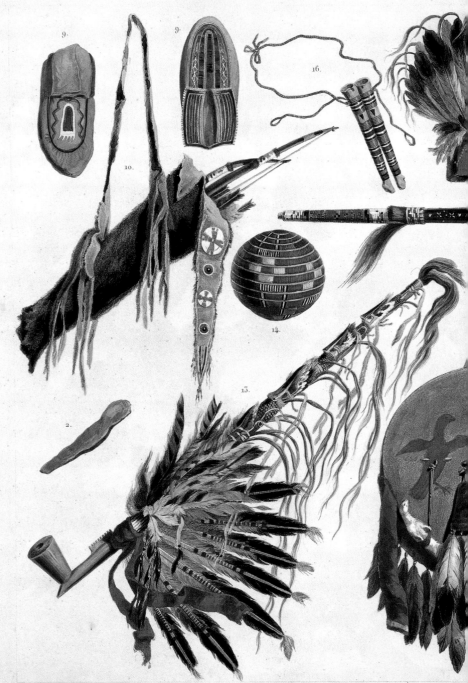

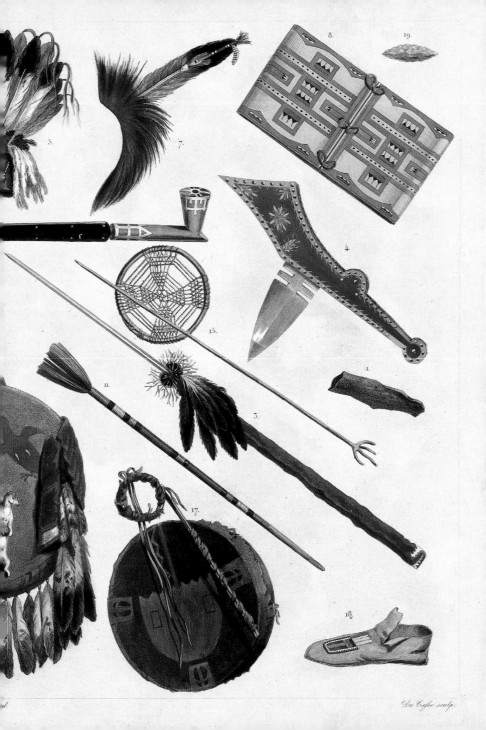

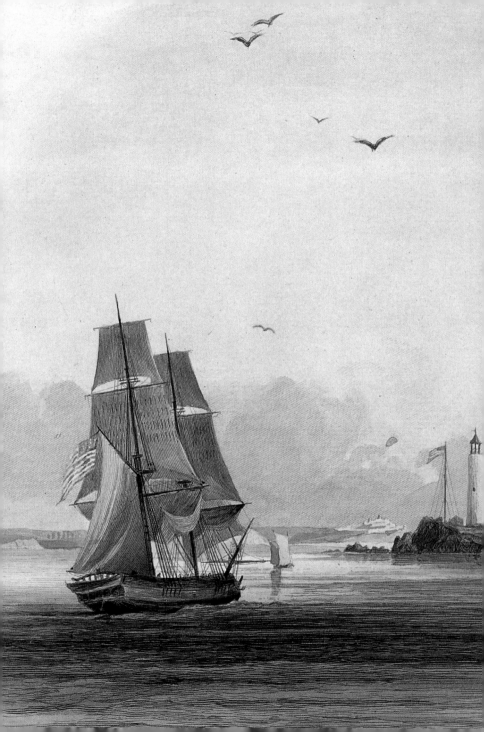

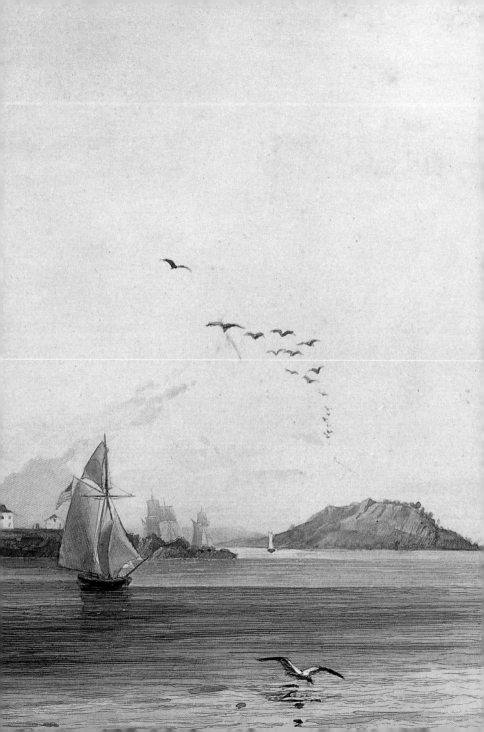

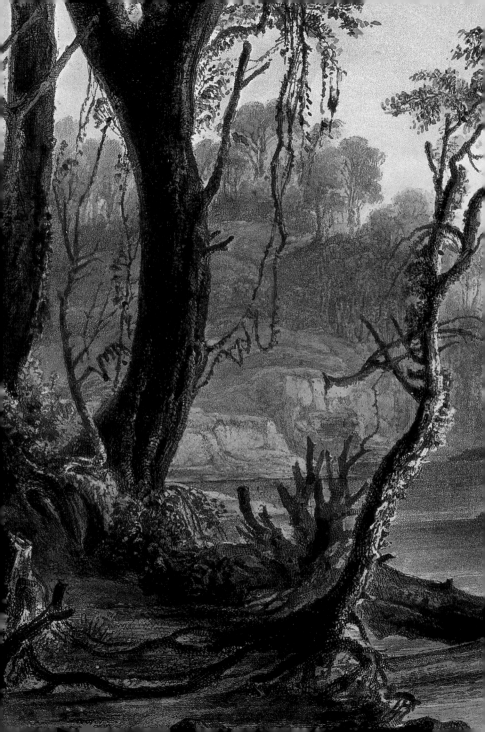

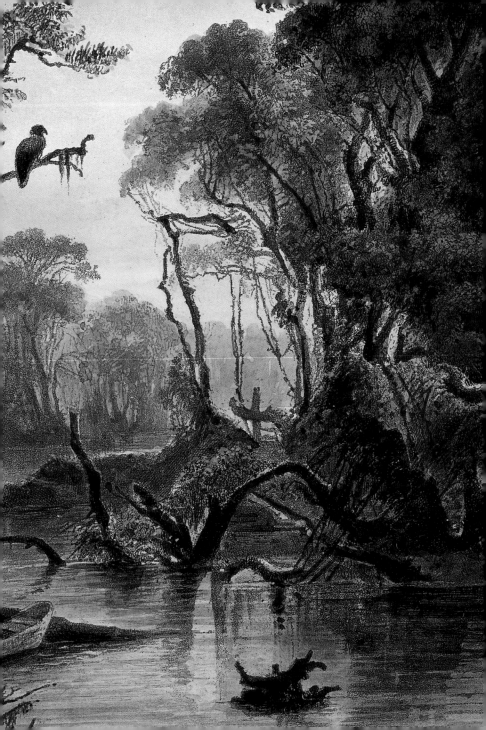

BOSTON LIGHTHOUSE

In the centre, in the direction of the city of Boston, was the white lighthouse with its black roof on a small rocky island, and around it several little picturesque islands, some of white sand with patches of grass on top, some of rock, which adorn the beautiful bay. In the distance we saw some low mountains. The coast studded with villages was obscured by the smoke of the gunpowder, while numerous ships and boats were sailing in every direction, all adorned with gay flags in honour of the day.

LEUCHTTHURM VON BOSTON

Im Mittelpunkte, in der Richtung der Stadt Boston, stand auf einer kleinen Felseninsel der weisse Leuchtthurm mit seinem schwärzlichen Dache, in der Umgebung mehrere kleine malerische Inseln, theils von weissem Sande, oben mit Grasboden, theils Felsen, welche den schönen Meerbusen zieren. In der Entfernung erblickte man einige niedrige Berge, die Küste mit vielen in Pulverdampf gehüllten Ortschaften bedeckt, eine Menge von Schiffen und Barken, heute sämmtlich mit bunten Flaggen geziert, welche hin und her segelten.

PHARE DE BOSTON

Au centre, et dans la direction de la ville de Boston, on voyait, sur une petite île de rochers, le phare blanc avec son toit noirâtre, entouré de plusieurs petites îles pittoresques, ornements de cette baie déjà si belle ; les unes ont pour sol un sable blanc recouvert de gazon, et les autres ne présentent que des rocs nus. Dans l'éloignement, on distinguait quelques collines, des villages qu'enveloppait la fumée de la poudre, et un grand nombre de petits bâtiments et de barques, tous pavoisés pour la fête, et qui sillonnaient les flots en tous sens.

CUT-OFF RIVER BRANCH OF THE WABASH

The Wabash, a fine river, as broad as the Moselle, winds between banks which are now culti-vated, but were lately covered with thick forests. A hilly tract, covered with woods, bounds the valley of the Wabash, which is frequently flooded by the river, and thereby gains in fertility.

The Wabash divides at Harmony, the easterly arm becoming Cut-off River, while further down it splits into several branches, forming many wooded islands, the largest of which are in-habited.

CUTOFF-RIVER ARM DES WABASH

Der Wabash, ein schöner Fluss von der Stärke der Mosel, häufig noch breiter, schlängelt sich durch die zum Theil bebauten, vor kurzem aber noch überall mit grossen Waldungen bedeckten Ufer dahin. Eine hügelige, mit Wald bedeckte Gegend schliesst sich an die Wabash-Niederung an, welche letztere in manchen Jahren grösstentheils vom Flusse überschwemmt wird und da-durch an Fruchtbarkeit gewinnt.

Der Wabash theilt sich bei New Harmony in zwei Arme, wovon man den östlichen Cu-toff-River nennt, weiter hin aber in mehre, und bildet viele waldige Inseln, von welchen die grösseren bewohnt sind.

CUTOFF-RIVER BRAS DE WABASH

Le Wabash, belle rivière, large comme la Moselle et souvent plus large encore, serpente entre des bords en partie cultivés, mais qui naguère encore étaient partout couverts de bois épais. Une campagne ondulée et boisée vient se joindre à la vallée du Wabash, qui est souvent inondée dans toute son étendue, ce qui ne fait du reste qu'en augmenter la fertilité.

Le Wabash se divise, auprès d'Harmony, en deux bras, dont le plus oriental s'appelle Cu-toff-River. Plus loin ces deux bras se subdivisent en plusieurs autres et forment un grand nombre d'îles boisées dont les plus considérables sont habitées.

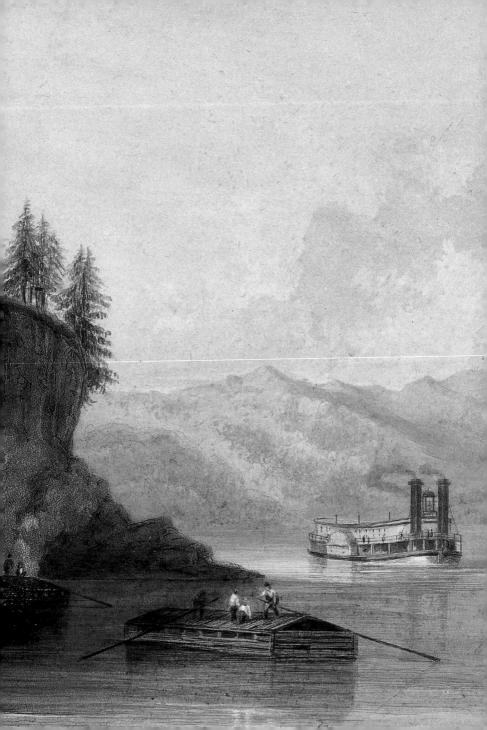

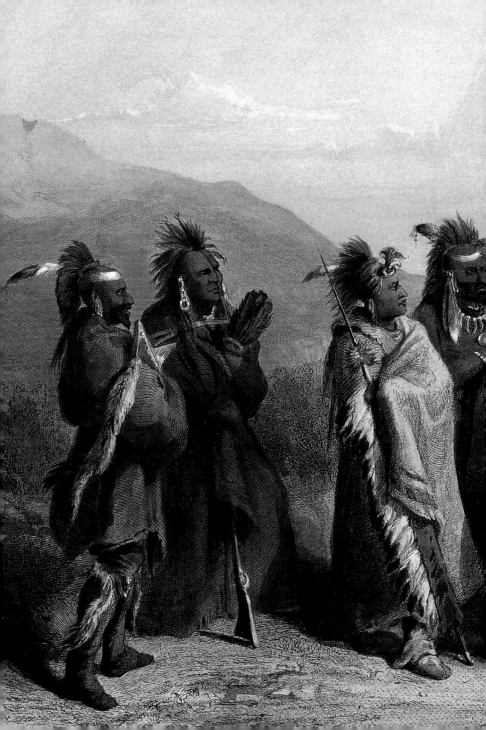

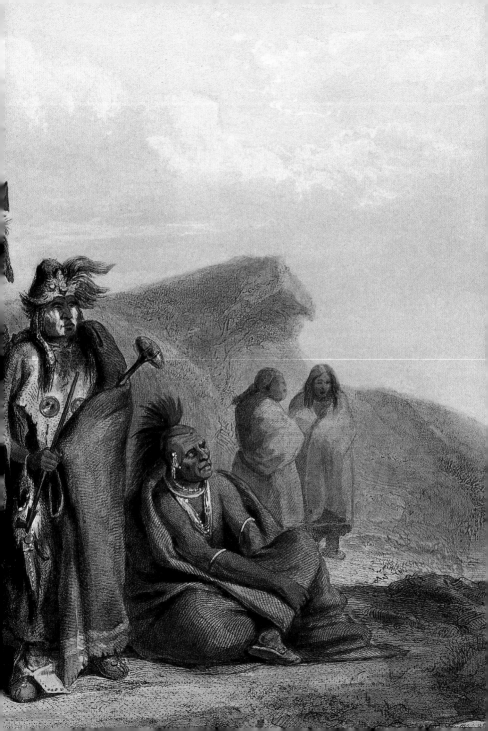

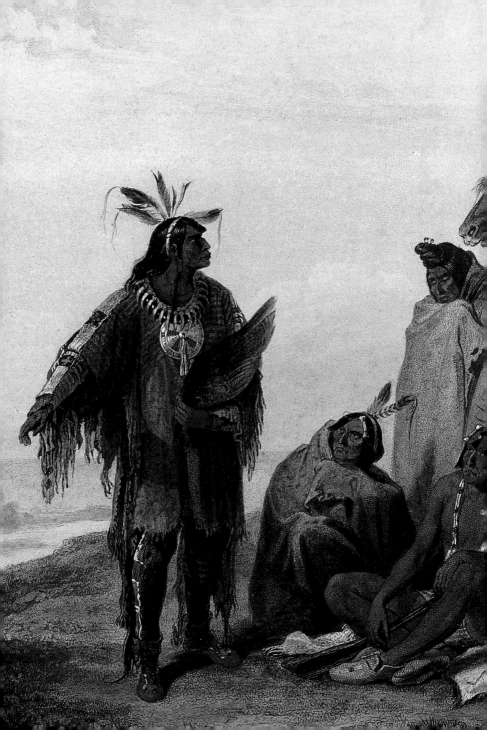

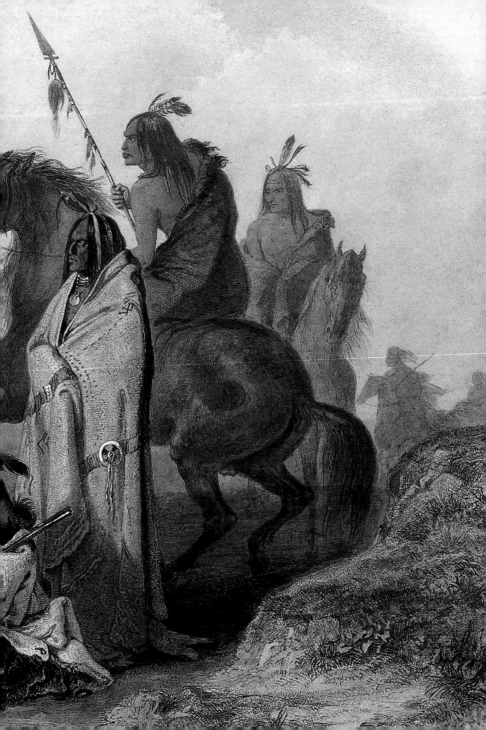

TOWER-ROCK VIEW ON THE MISSISSIPPI

The calcareous rocks, grey, bright yellow, bright blue, or yellowish-red, were often most singularly formed, especially a little further up. One, known as the Grand Tower, an isolated, cylindrical rock, from 60 to 80 feet in height, was splendidly illuminated by the setting sun as we approached it.

The Grand Tower stands quite isolated on the left bank, its summit crowned with red cedars. Behind it there is another large rock, split into several perpendicular divisions, like towers, and the whole group forms, as it were, a most original portico.

TOWER-ROCK ANSICHT VOM MISSISSIPPI

Die Kalkwände, grau, hellgelb, hellblau oder gelblich-roth, waren häufig sehr sonderbar gebildet, besonders etwas weiter aufwärts der interessante Grand-Tower, eine isolirte, rundliche Trommelgestalt von 60 bis 80 Fuss Höhe, welchen wir in der schönsten Abendbeleuchtung erreichten.

Der Grand Tower steht gänzlich isolirt am linken Ufer und trägt ebenfalls rothe Cedern auf seiner Höhe. Hinter denselben befindet sich ebenfalls wieder ein grosser in mehre senkrechte Thurmabtheilungen gespaltener Felsen, und diese ganze Gruppe bildet gleichsam eine höchst originelle Flusspforte.

TOWER-ROCK VUE SUR LE MISSISSIPPI

Les parois calcaires grises, jaune clair, bleu clair et rouge jaunâtre, présentent souvent des formes singulières: je citerai entre autres celle que l'on appelle the Grand Tower, qui est une masse isolée, à peu près cylindrique, de 60 à 80 pieds de haut; quand nous la vîmes, elle était admirablement éclairée par les rayons du soleil couchant.

The grand Tower est absolument isolée sur la rive gauche; elle est couronnée de cèdres rouges. Par derrière il y a encore un grand rocher qui est aussi partagé par des fentes en plusieurs tours perpendiculaires, tandis que le groupe tout entier forme sur la rivière une porte d'un genre fort original.

SAUKIE AND FOX INDIANS

It happened that, during our stay at St. Louis, a deputation from two tribes, the Sauk and Fox Indians or Ootagami came down the Mississippi to intercede for Black Hawk who was a prisoner in Jefferson barracks.

They are stout, well formed men, many of them tall, broad shouldered, muscular and brawny. The features of the men are expressive, and strongly marked: the cheek bones prominent, the lower jaw broad and angular, and the dark brown eyes animated and fiery.

SAKI UND MUSQUAKE INDIANER

Es fügte sich, dass zur Zeit unserer Anwesenheit zu St. Louis eine Deputation zweier indianischer Stämme, der Sakis oder Saukis und der Foxes oder Utagámis den Mississippi herab kam, um sich für den in den Jefferson-Barracks gefangen gehaltenen Black-Hawk zu verwenden.

Sie sind starke wohlgebildete Männer, viele von mehr als Mittelgrösse, breit, muskulös und fleischig. Die Gesichtszüge der Männer sind ausdrucksvoll, stark ausgewirkt, die Backenknochen vortretend, die Flügel des Unterkiefers breit und eckig, die schwarzbraunen Augen lebhaft und feurig.

INDIENS SÂKIS ET RENARDS

Il arriva que pendant notre séjour à Saint-Louis, une députation de deux tribus indiennes, celle des Sâkis ou Saukis (Sacs des Français) et celle des Fox ou Utagamis (Renards des Français), avait descendu le Mississippi pour intercéder en faveur de Faucon Noir (Black Hawk) détenu prisonnier dans les casernes de Jefferson.

Ce sont des hommes forts, bien faits, d'une taille généralement au-dessus de la moyenne, musculeux et charnus. Leur physionomie est expressive ; ils ont les traits fortement marqués, les pommettes saillantes, les côtés de la mâchoire inférieure larges et anguleux, les yeux noirs, vifs, plein de feu et l'angle intérieur un peu rabaissé.

Crow Indians · Crow Indianer · Indiens Corbeaux

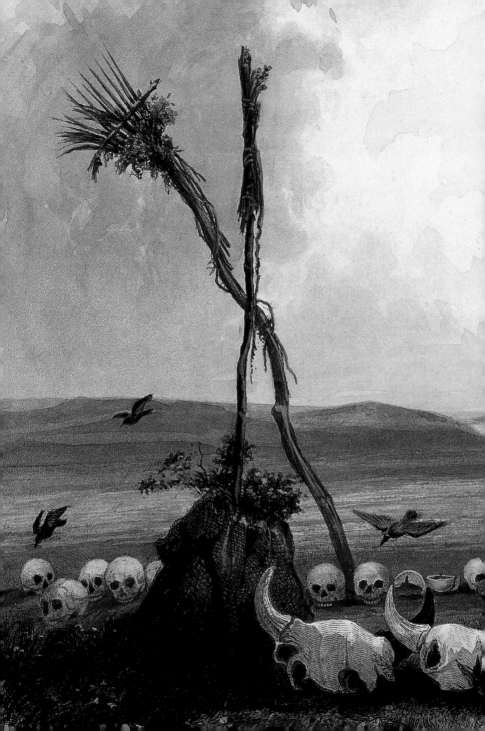

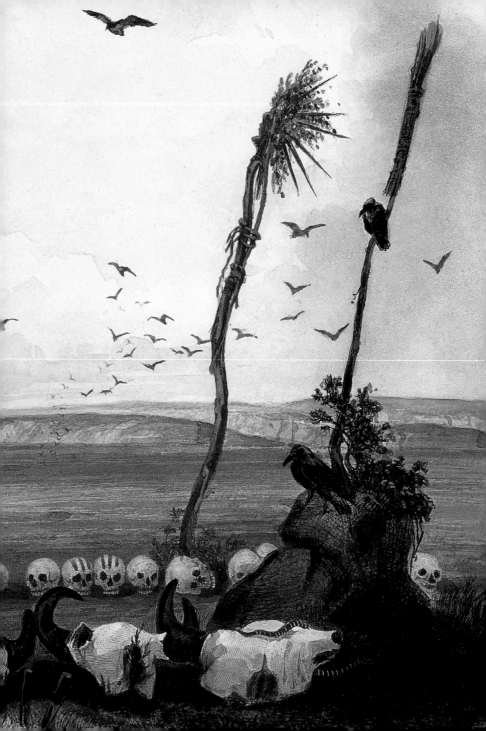

OFFERING OF THE MANDAN INDIANS

The Mandans have many other medicine establishments in the vicinity of their villages, all of which are dedicated to the superior powers. Mr. Bodmer had made a very accurate drawing of those near Mih-Tutta-Hang-Kusch, one of which consists of four poles placed in the form of a square; the two foremost have a heap of earth and green turf thrown up around them, and four buffalo skulls laid in a line between them, while twenty-six human skulls are placed in a row from one of the stakes at the back to the other; some of these skulls are painted with a red stripe. Behind the whole a couple of knives are stuck into the ground, and a bundle of twigs is fastened at the top of the poles with a kind of comb, or the teeth of a rake, painted red.

The Indians repair to such places when they desire to make offerings or put up petitions; they howl, lament, and make loud entreaties, often for many days together, to the lord of life.

OPFER DER MANDAN INDIANER

Die Mandans haben ausserdem noch mancherlei Medecine-Anstalten in der Nähe ihrer Dörfer. Die bei Mih-Tutta-Hangkusch befindlichen hat Herr Bodmer mit grosser Treue abgebildet, und sie sind sämmtlich den überirdischen Mächten dargebrachte Opfer. Die eine von ihnen z.B. besteht in vier im Quadrate aufgestellten Stangen, von welchen die beiden vorderen mit einem Haufen von Erde und Rasenstücken an ihrer Wurzel umgeben sind. Zwischen den beiden vorderen Stangen sind vier Bisonschädel in einer Reihe niedergelegt, und in der Linie der beiden hinteren 26 Menschköpfe, die zum Theil mit rothen Streifen bemalt sind. Hinter der ganzen Vorrichtung waren ein Paar Messer (Manhi) in die Erde gesteckt. Die Stangen haben oben Bündel von Reisern mit einer Art von Kamm oder Rechen von zugespitzten, roth angemalten Hölzern.

Die Indianer gehen an solche Orte, wenn sie Opfer bringen oder Wünsche thun wollen, heulen, bitten und klagen daselbst oft mehre Tage lang zu dem Herrn des Lebens.

OFFRANDE DES INDIENS MANDANS

Les Mandans ont outre cela plusieurs médecines dans les environs de leurs villages. Celle qui se trouve près de Mih-Tutta-Hangkusch a été très exactement dessinée par M. Bodmer; elles se composent toutes d'offrandes faites aux puissances surhumaines. L'une d'elles, par exemple, consiste en quatre perches posées en carré, dont les deux de devant sont garnies au pied d'un amas de terre et de gazon. Entre les deux perches de devant, il y a quatre crânes de bison rangés par terre en ligne droite; et entre celles de derrière, vingt-six têtes d'homme, peintes en partie avec des raies rouges. Derrière l'édifice, il y a deux couteaux (Manhi) fichés en terre. Les perches sont surmontées de faisceaux de branches avec une espèce de crête faite de morceaux de bois pointus par le bout et peints en rouge.

Les Indiens se rendent dans ces endroits quand ils veulent y porter des offrandes ou faire des souhaits; alors ils crient, gémissent et adressent des prières au seigneur de la Vie.

MAGIC PILE ERECTED BY
THE ASSINIBOIN INDIANS

The neighbourhood around Fort Union is a wide, extended prairie, intersected in a northerly direction by a chain of rather high, round, clay-slate and sandstone hills.

We observed on the highest points, and at certain intervals of this mountain chain, singular stone markers, set up by the Assiniboins, and consisting of blocks of granite, or other large stones, on the top of which is placed a buffalo skull. The purpose of these, we were told, is to attract the herds of buffalo, and thereby ensure a successful hunt.

ZAUBER MAAL BEI DEN
ASSINIBOIN INDIANERN

Die nächste Umgebung von Fort Union ist eine weit ausgedehnte Prairie, in nördlicher Richtung von einer Kette mässig hoher, abgerundeter Thonschiefer- und Sandsteinhügel durchschnitten.

Auf den höchsten Puncten dieser Hügelkette bemerkt man in gewissen Entfernungen sonderbare von den Assiniboins aufgesetzte Steinsignale von Granitblöcken u. a. grossen Steinen, auf deren Spitze ein Bisonschädel thront und welche die Indianer, wie man uns versicherte, in der Absicht errichten, um die Bisonheerden herbei zu ziehen und eine glückliche Jagd zu haben.

MONUMENT MAGIQUE
DES INDIENS ASSINIBOINS

Les environs immédiats du Fort-Union sont une vaste prairie, coupée, dans la direction du nord, par une chaîne de collines d'argile et de grès arénacé, de hauteur médiocre et à sommets arrondis.

Sur les points les plus élevés de cette chaîne de collines, on découvre à de certaines distances de singuliers signaux de pierres placés par les Assiniboins, et qui consistent en blocs de granit et d'autres grosses pierres, au haut desquels est placé un crâne de bison. Le but en est, nous a-t-on dit, d'attirer de ce côté les bisons et de se procurer une heureuse chasse.

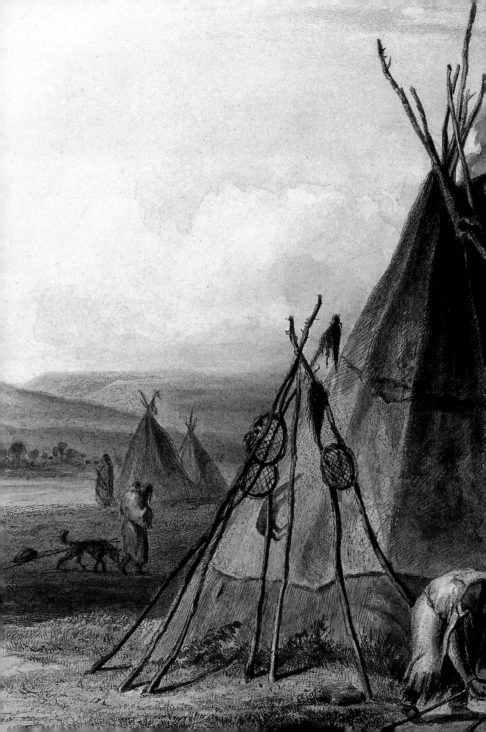

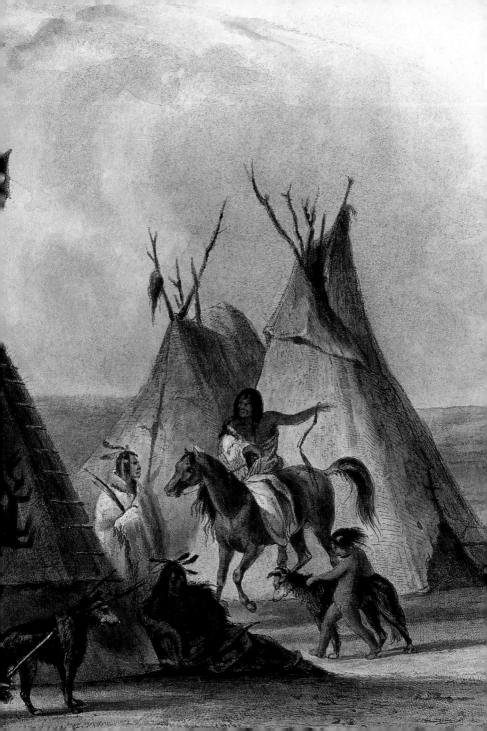

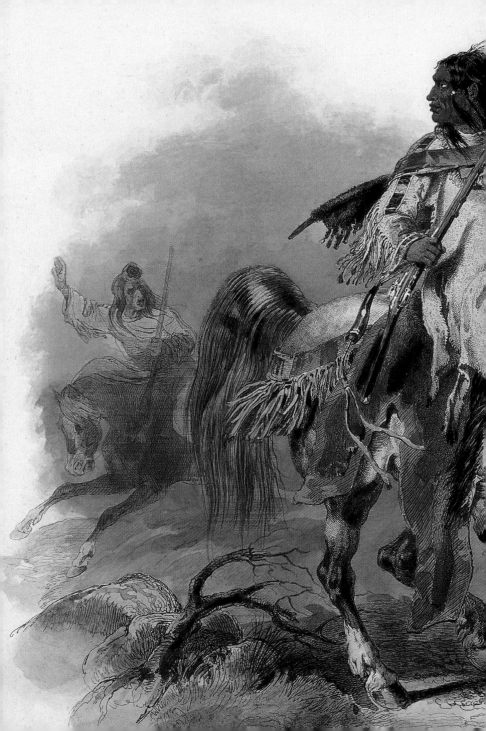

A SKIN LODGE OF AN ASSINIBOIN CHIEF

On the 30th of June [1833], at noon, a band of Indians arrived, and 25 tents were set up near the fort [Fort Union]. One of these tents, the dwelling of a chief, was distinguished from the rest by being painted the colour of yellow ochre with a broad reddish-brown border below. On each of its sides a large black bear was painted (something of a caricature it must be confessed). To the head of this, just above the nose, a piece of red cloth was fastened, which fluttered in the wind, acting no doubt as a medicine.

LEDERZELT EINES ASSINIBOIN CHEFS

Am Mittage des 30. Juni [1833] hatte sich eine Bande von Indianern eingefunden, und 25 Zelte waren neben dem Forte [Union] aufgeschlagen worden. Eines dieser Zelte, die Wohnung eines Chefs, zeichnete sich aus. Es war ockergelb angestrichen, hatte unten einen breiten rothbraunen Saum, und an einer jeden seiner Seiten war ein grosser Bär etwas verzerrt in schwarzer Farbe angemalt, an dessen Kopf über der Nase man jedesmal ein scharlachrothes, im Winde flatterndes Tuchläppchen befestigt hatte, ohne Zweifel eine Medecine.

TENTE EN CUIR D'UN CHEF ASSINIBOIN

Le 30 juin [1833], vers midi, une troupe d'Indiens arriva et vingt-cinq tentes se trouvèrent dressées près du fort [Union]. Une de ces tentes, l'habitation d'un chef, se distinguait des autres. Elle était peinte en ocre; au bas régnait une large raie rouge brun, et de chaque côté on voyait la figure d'un grand ours, assez mal peinte en noir, et sur la tête duquel, au-dessous des naseaux, on avait attaché un morceau de drap écarlate qui flottait au vent. C'était sans doute une médecine.

A BLACKFOOT INDIAN ON HORSE-BACK

The Blackfoot are fond of handsome housing, made of a large panther's skin, which they generally obtain from the Rocky Mountains. As these animals have now become more scarce, a high price is often given for the skin; sometimes a good horse, or even several, seldom less than sixty dollars in value. The panther's skin is so laid across the horse that the long tail hangs down on one side, and has scarlet cloth laid under it, which forms all round a broad border, to the four legs as well as to the head and tail.

BLACKFOOT INDIANER ZU PFERD

Die Blackfeet lieben als Luxusartikel schöne Schabracken von einem grossen Pantherfelle, die sie meist aus den Rocky-Mountains erhalten. Da solche Thiere jetzt schon seltener werden, so bezahlt man die Felle oft theuer, oft mit einem guten Pferde, oder sogar mit mehren, und selten unter 50 Dollars an Werth. Das Pantherfell wird quer übergelegt, so dass der lange Schwanz an einer Seite herabhängt, und ist mit Scharlachtuch unterlegt, welches rundum, an den vier Beinen sowohl, als an dem Kopfe und Schwanze einen breiten Saum bildet.

INDIEN PIEDS NOIR À CHEVAL

Les Pieds-Noirs aiment comme objets de luxe, de belles housses, faites de peaux de panthère qu'ils tirent principalement des montagnes Rocheuses. Ces animaux commençant à devenir rares, les peaux reviennent assez cher ; on donne souvent pour en avoir une un bon cheval, quelquefois plusieurs chevaux, et sa valeur, estimée en argent, est rarement au-dessous de 50 dollars. La peau de panthère est placée en travers, de façon que la longue queue retombe d'un côté ; elle est doublée de drap écarlate qui forme une large bordure tout autour.

CHIEF OF THE GROS-VENTRES DES PRAIRIES

Among them were several men of a good and open character, but one was a very bad man. This Mexkemahuastan (the iron which moves) Mr. Mitchell had turned out of Fort McKenzie the year before, on account of his bad conduct. We were now entirely at the mercy of these people, and had every reason to fear the vengeance of this man. Prompted, doubtless, by his own interests, he behaved, to our astonishment, in a most friendly manner; shook hands with us, and, like his comrades, gratefully accepted the presents which were offered to him. He wore his hair in a thick knot on his forehead, and had a deceitful, fawning countenance.

CHEF DER GROS-VENTRES DES PRAIRIES

Unter diesen Chefs befanden sich mehre Männer von gutem offenem Character, aber auch ein sehr schlimmer Mensch, Mexkemáuastan (das Eisen, welches sich bewegt), welchen Herr Mitchill im vergangenen Jahre zu Fort McKenzie, wegen seiner Umtriebe vor die Thür geworfen hatte. Jetzt befanden wir uns gänzlich in der Gewalt dieser Leute, und man hatte allen Grund, die Rache dieses Mannes zu fürchten. Ohne Zweifel von Interesse geleitet, war er zu unserm Befremden höchst freundlich, drückte uns die Hand und nahm wie seine Collegen die Geschenke dankbar an, welche ihm gemacht wurden. Er trug seine Haare vorn in einen dicken Knoten zusammen gebunden und hatte ein einschmeichelndes falsches Gesicht.

CHEF DES GROS-VENTRES DES PRAIRIES

Parmi ces chefs se trouvaient plusieurs hommes d'un caractère franc et ouvert; mais il y en avait aussi un fort méchant, Mexkemahuastan (le fer qui se remue): M. Mitchill s'était vu forcé l'année précédente de le renvoyer du fort Mackenzie pour sa mauvaise conduite. Nous étions alors complètement au pouvoir de ces gens, et nous avions tout à craindre de la vengeance de cet homme. Guidé sans doute par son intérêt, il se montra, à notre grand étonnement, fort amical, nous serra la main, et accepta, comme ses collègues, avec reconnaissance, les présents qui lui furent offerts. Il portait les cheveux rassemblés sur le devant de la tête en une forte touffe, et avait la physionomie flatteuse et fausse.

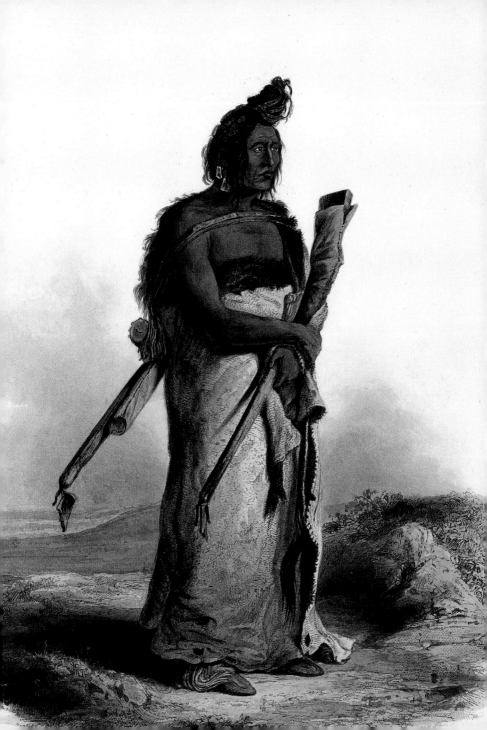

THE ELKHORN PYRAMID
ON THE UPPER MISSOURI

The prairie extended, without interruption, as far as the eye could see; it is called Prairie à la Corne de Cerf, because the wandering Indians have here erected a pyramid of elks' horns.

About 800 paces from the river, hunting or war parties of the Blackfoot Indians have gradually piled up a quantity of horns (elk mixed with a few buffalo), some still attached to part of the skull and some free, to form a pyramid 16 to 18 feet high, and 12 to 15 feet in diameter.

DIE ELKHORN-PYRAMIDE
AM OBERN MISSOURI

Die Prairie dehnte sich ununterbrochen aus, so weit das Auge reichte, sie trägt den Namen der Prairie à la corne de cerf, weil hier die durchstreifenden Indianer eine Pyramide von Hirschgeweihen erbaut haben.

Etwa 800 Schritte vom Flusse entfernt haben die Jagd- oder Kriegspartheien der Blackfoot Indianer nach und nach eine Menge von Elkhirschgeweihen aufgehäuft, wodurch eine Pyramide von 16 bis 18 Fuss Höhe und 12 bis 15 Fuss im Durchmesser entstanden ist.

LA PYRAMIDE DES CORNES D'ELK
SUR LE HAUT MISSOURI

La prairie s'étendait sans interruption aussi loin que la vue pouvait porter. On l'appelle la prairie à la Corne de Cerf, à cause d'une pyramide de bois de cerfs que les Indiens chasseurs y ont construite.

À huit cents pas environ du bord de l'eau, les détachements de chasse ou de guerre des Indiens Pieds-Noirs ont successivement accumulé un tas de bois d'élans, au point d'en avoir formé une pyramide de seize à dix-huit pieds de haut et de douze à quinze pieds de diamètre.

ENCAMPMENT OF THE TRAVELLERS
ON THE MISSOURI

The morning of the 14th of September was fine and bright, and promised us a pleasant voyage. By noon all our effects had been put on board the new boat, and it became more and more evident that we did not have sufficient room in this vessel. The great cages, with the live bears, were placed upon the cargo in the centre, and prevented us from passing from one end of the boat to the other; besides this, there was not room for us to sleep on board; this was a most unfavourable circumstance, because it obliged us always to lie to for the night.

BIVOUAC DER REISENDEN
AM MISSOURI

Der Morgen des 14. Septembers brach heiter und schön an, und versprach uns eine angenehme Reise. Man belud das neue Boot, womit man gegen Mittag zu Stande kam, und es bestätigte sich die Bemerkung nun immer mehr, dass wir nicht hinlänglich Raum in diesem Fahrzeuge hatten. Die grossen Kasten mit den lebenden Bären wurden oben auf die Mitte der Ladung gesetzt und benahmen uns die freie Communikation; auch fand sich nicht so viel Raum, dass man an Bord hätte schlafen können.

HALTE DES VOYAGEURS
SUR LE MISSOURI

La journée du 14 septembre se présenta belle et sereine, et sembla nous présager un voyage agréable. On chargea le nouveau bateau, ce qui fut achevé vers midi, et nous acquîmes de plus en plus la conviction que nous n'y aurions pas assez de place. Les grandes caisses avec les ours vivants furent placées en haut, au milieu du chargement, et nous ôtèrent toute libre communication. Nous reconnûmes encore que l'emplacement ne suffirait pas pour pouvoir coucher à bord.

CHIEF OF THE CREE INDIANS

Several Cree Indians arrived at Fort Union, among them the celebrated medicine man, or conjurer, Mähsette-Kuiuab (le sonnant), whose portrait Mr. Bodmer had great difficulty in taking, because he could not get him to sit still. He was suffering severely from an affection of the eyes; complained of his poverty, and wanted to borrow a horse, promising to pay for it at a future date. This man is highly respected among his countrymen, because his incantations are said to be most efficacious; and even the engagés of the Company firmly believe in such mummeries.

CHEF DER CRIH INDIANER

Mehre Crih Indianer trafen zu Fort Union ein, und unter ihnen der berühmte Medecine-Mann oder Beschwörer Mähsette-Kuiuab (Le Sonnant), welchen Herr Bodmer mit grosser Mühe zeichnete, da er durchaus nicht stille sitzen konnte. Er litt sehr an den Augen, klagte über seine Armuth, wollte ein Pferd geborgt haben, und dasselbe erst später bezahlen. Dieser Mann steht in Ansehn bei seinen Landsleuten, weil er stark in Beschwörungen seyn soll, und selbst die Engagés der Compagnie glauben fest an dergleichen Gaukeleien.

CHEF DES INDIENS CRIH

Plusieurs Indiens Crihs arrivèrent au Fort-Union, et parmi eux, le fameux homme de médecine ou exorciste Mähsette-Kuiuab (le Sonnant), que M. Bodmer dessina avec beaucoup de peine, attendu qu'il ne voulait absolument pas se tenir tranquille. Il souffrait beaucoup des yeux et se plaignait de sa misère ; il demanda à acheter un cheval à crédit. Cet homme jouit d'une grande considération parmi ses compatriotes, parce qu'il passe pour être fort habile dans les conjurations ; les engagés de la compagnie eux-mêmes croient à de semblables jongleries.

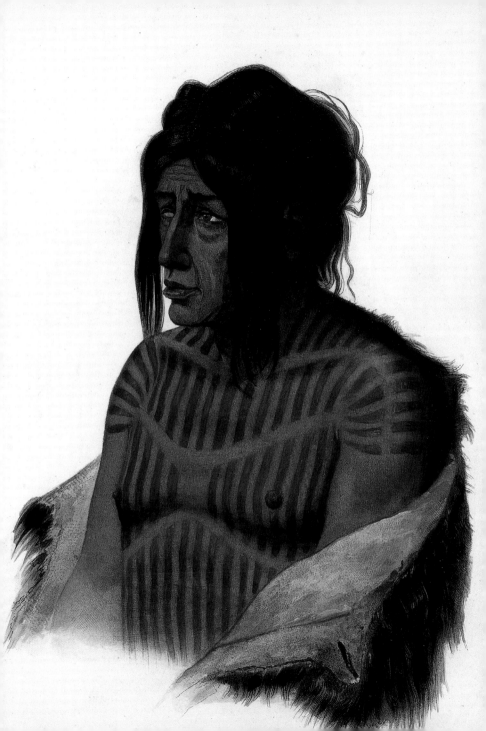

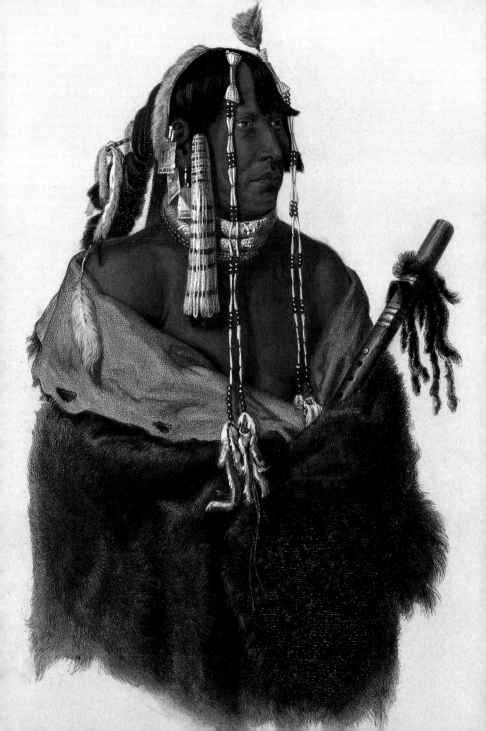

Mándeh-Páhchu, a young Mandan Indian · Mándeh-Páhchu, junger Mandan Indianer ·
Mándeh-Páhchu, jeune Indien Mandan

ISCHOHÄ-KAKOSCHÓCHATÄ –
DANCE OF THE MANDAN INDIANS

... The whole company, very gaily and handsomely dressed, soon afterwards entered the fort, followed by a crowd of spectators. About 20 vigorous young men, with naked torsos (having thrown off their robes which they wore for their entrance), painted and ornamented in the most gaudy manner, formed a circle in the courtyard of the fort.

As soon as the drum started beating, the dancers bent their bodies forward, leaped up with both feet together, holding their guns in their hands, and the finger on the trigger, as if about to fire. In this manner they danced for about a minute in a circle, then gave a loud shout, and, having rested a little, began the dance again, and so on alternately.

ISCHOHÄ-KAKOSCHÓCHATÄ –
TANZ DER MANDAN INDIANER

... Bald nachher zog, von einer Menge von Zuschauern begleitet, die ganze Gesellschaft, höchst bunt und schön gekleidet in das Fort ein. Etwa 20 kräftige, schlanke, junge Manner, den Oberleib nackt (als sie kamen, hatten sie ihre Roben umgehängt, die sie aber abwarfen), auf das bunteste gemalt und geschmückt, schlossen im Hofraume des Fortes den Kreis.

Sobald die Trommel geschlagen wurde, legten die Tänzer den Oberleib vor, und sprangen mit gleichen Füssen in die Höhe, während sie ihre Gewehre gleichsam zum Schusse bereit und den Finger am Abzuge hielten. Auf diese Art tanzten sie etwa eine Minute im Kreis herum, jauchzten dann, und ruheten ein wenig, worauf der Tanz wieder seinen Anfang nahm und auf diese Art abwechselte.

ISCHOHÄ-KAKOSCHÓCHATÄ –
DANSE DES INDIENS MANDANS

... Bientôt après, toute la compagnie, très-richement vêtue, entra dans le fort, accompagnée d'une foule de spectateurs. Une vingtaine de jeunes hommes vigoureux et élancés, nus jusqu'à la ceinture, portant leurs arcs en sautoir, mais qu'ils déposèrent plus tard, parés et peints de différentes couleurs, formèrent un cercle dans la cour du fort.

Aussitôt que l'on commença à battre le tambour, les danseurs penchèrent le haut du corps en avant et sautèrent en l'air les deux pieds à la fois, pendant qu'ils tenaient leurs fusils, comme pour tirer, avec le doigt sur le chien. Ils dansèrent ainsi en rond pendant près d'une minute, après quoi ils jetèrent un cri de joie, se reposèrent pendant quelques instants, puis recommencèrent à danser, ce qu'ils répétèrent plusieurs fois.

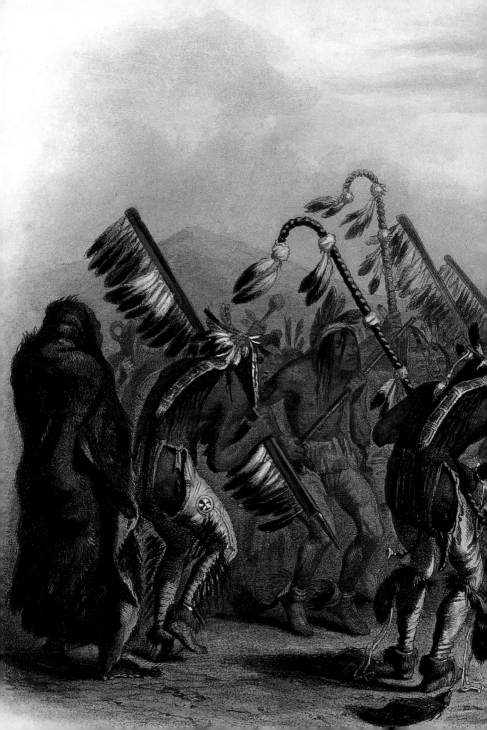

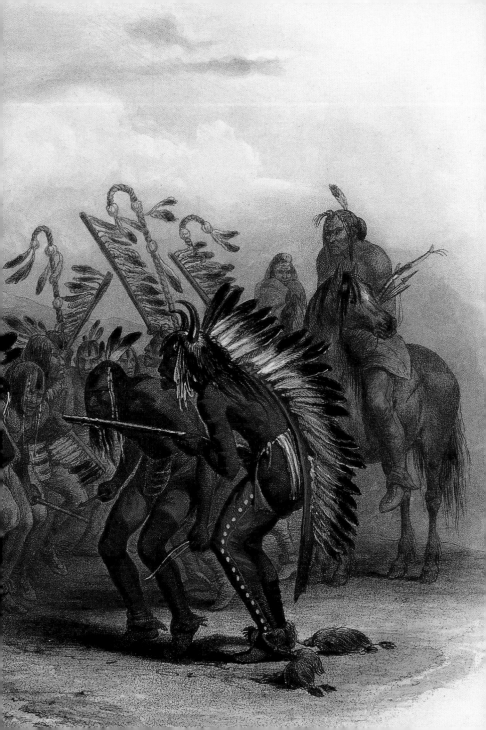

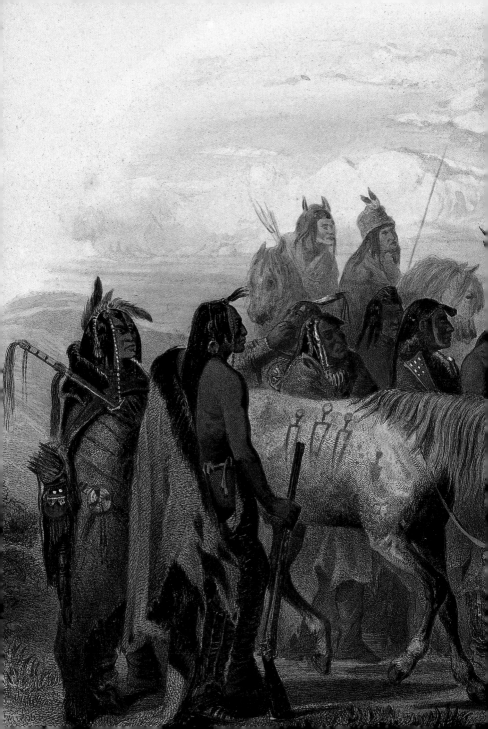

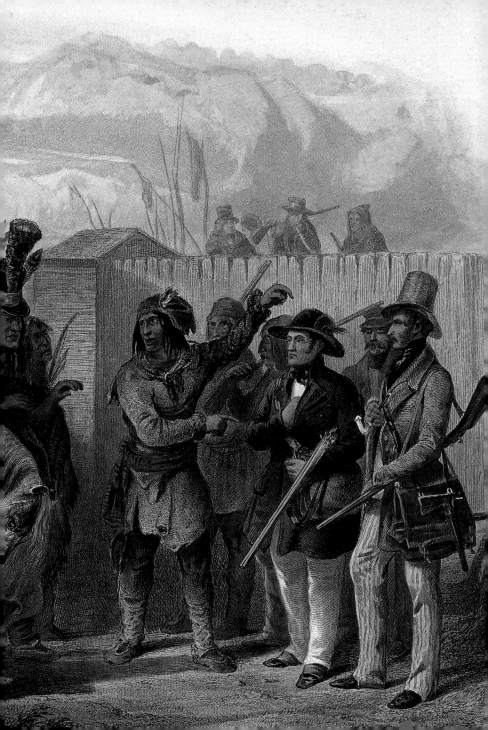

AN ARRIKKARA WARRIOR

On the following day [6th of March 1834], Mató-Tópe introduced to us a tall, robust Arikara, named Pachtüwa-Chtä, who lived peaceably among the Mandan. He was a handsome man, but not to be depended on, and was said to have killed many white men.

ARRIKKARA KRIEGER

Am folgenden Tage [6.3.1834] führte Mató-Tópe einen grossen, starken Arikara bei uns ein, der friedlich unter den Mandans lebt und dessen Name Pachtüwa-Chtä war. Er war ein schöner kräftiger Mann übrigens aber ein schlimmer Mensch, der schon viele Weisse umgebracht haben sollte.

GUERRIER ARRIKKARA

Le lendemain [6.3.1834], Mató-Tópe nous amena un grand et vigoureux Arikara, qui vit paisiblement parmi les Mandans, et qui s'appelle Pachtüwa-Chtä. C'était un très bel homme. Du reste, il était méchant et avait déjà tué plusieurs blancs.

The travellers meeting with Minaterre Indians near Fort Clark
Zusammenkunft der Reisenden mit Monnitarri Indianern bei Fort Clark
Rencontre des voyageurs avec des indiens Meunitarri près du Fort Clark

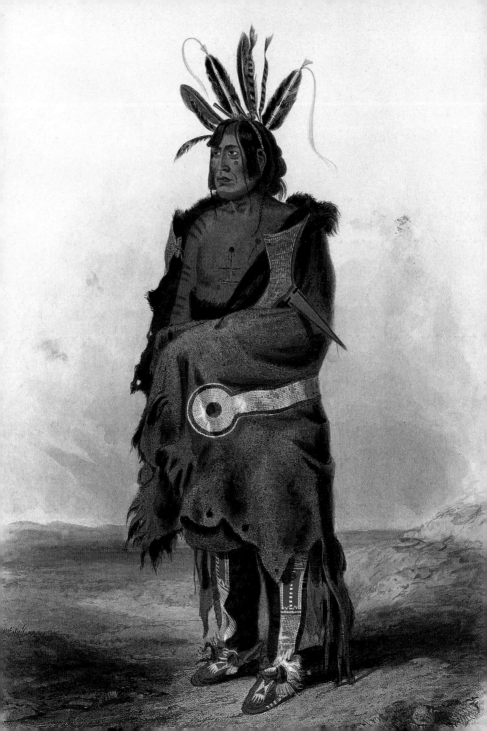

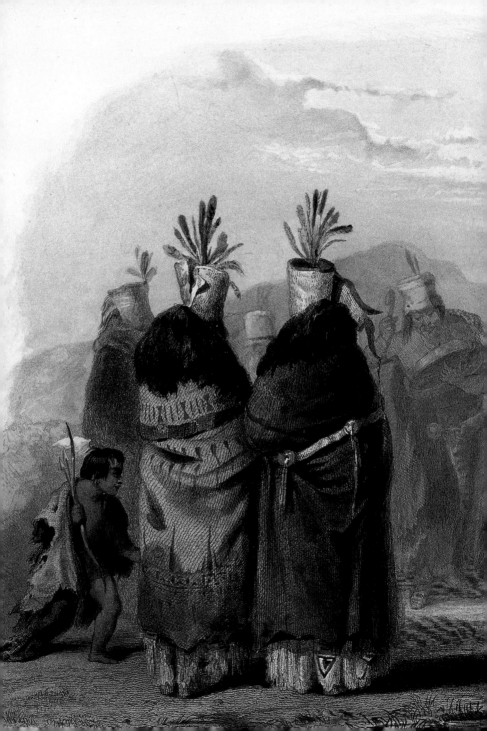

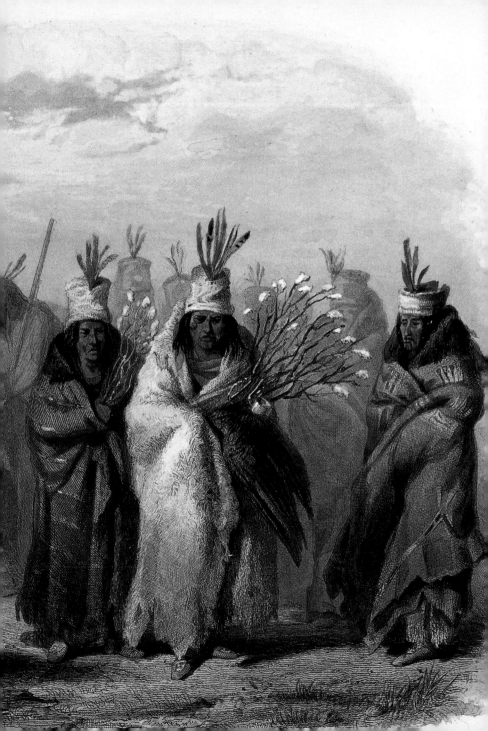

DANCE OF THE MANDAN WOMEN

At noon [25th of December 1834] there was a concourse of Indians in the fort: the woman's band of the "White Buffalo Cow" had come to perform their dance. The company consisted of 17, mostly older women, and two men, with the drum and the schischikué; the first of these two men carried a gun in his hand. A stout elderly woman went first; she was wrapped in the hide of a white buffalo cow, and held, in her right arm, a bundle of twigs in the form of a cornucopia, with down feathers at the top, and at the lower end an eagle's wing, and a tin drinking vessel. Another woman carried a similar bundle. All these women wore round their heads a piece of buffalo hide in the form of a hussar's cap, with a plume of owl or raven feathers in front, some of which were dyed red; only two of them wore the pelt of a polecat; all the men were bareheaded.

TANZ DER MANDAN WEIBER

Um Mittag [25. December 1834] gab es einen Auflauf der Indianer im Forte, die Bande der Weiber von der weissen Bisonkuh, Ptihn-Tack-Ochatä, zog ein, um ihren Tanz aufzuführen. Diese Gesellschaft bestand in 17 meist ältlichen Weibern und zwei Männern, welche das Schischikué und die Trommel hören liessen, der erstere mit seiner Flinte in der Hand. Voran zog eine ältliche, dicke Frau in die Haut einer weissen Bisonkuh gehüllt, welche im rechten Arme in der Stellung eines Füllhorns einen Bündel Reiser trug, an dessen Spitze Flaumfedern, unten am Handgriffe ein Adlerflügel und ein Trinkgefäß von Blech befestigt waren. Noch eine zweite Frau trug einen ähnlichen Bündel. Die Köpfe aller dieser Weiber waren mit einem hohen, hinten vereinigten Stücke von weisser Bisonhaut gleich einer Husarenmütze geziert, an welchem vorn ein Busch von Uhu- oder Rabenfedern stand, der zum Theil roth gefärbt war; nur zwei von ihnen trugen das Fell eines Stinkthiers um den Kopf, die Männer diesen Theil gänzlich unbedeckt.

DANSE DES FEMMES MANDANS

Vers midi [25 décembre 1834] il y eut une grande affluence d'Indiens dans le fort; la bande des femmes de la Vache-Blanche, Ptihou-Tack-Ochaté, y fit son entrée pour y exécuter sa danse. Cette compagnie se composait de dix-sept femmes, la plupart déjà sur le retour, et de deux hommes qui jouaient du chichikoué et battaient du tambour, le premier tenant son fusil à la main. La marche était ouverte par une grosse femme d'un certain âge, couverte de la peau d'une vache blanche, et qui portait sur le bras droit un faisceau de branches, dans la position d'une corne d'abondance; aux extrémités des branches était attaché du duvet, et près de la poignée une aile d'aigle et un vase à boire en fer-blanc. La coiffure de toutes les femmes était une grande pièce de peau de bison, se rejoignant par derrière comme un bonnet de hussard, ornée sur le devant d'une touffe de plumes de chat-huant ou de corbeau, en partie peintes en rouge; deux d'entre elles seulement portaient sur la tête une peau de putois; les hommes avaient la tête tout à fait découverte.

DOG-SLEDGES OF THE MANDAN INDIANS

When they quit their huts for a longer period than usual, they load their dogs with the baggage, which is drawn in small sledges made of a couple of thin, narrow boards, 9 or 10 feet in length, fastened together with leather straps, and with four cross-pieces to give them firmness. Leather straps are attached in front, and drawn either by men or dogs. The load is fastened to the sledge by straps.

HUNDESCHLITTEN DER MANDAN INDIANER

Sobald man die Hütten auf längere Zeit verlässt, werden die Hunde mit dem Gepäcke beladen, welches sie auf Schleifen, Menissischan und im Winter auf kleinen Schlitten, Mánna-Jürutáhne, ziehen. Diese Schlitten bestehen aus zwei schmalen, mit ledernen Riemen neben einander befestigten, vorn in die Höhe gewölbten dünnen Brettern, etwa 9 bis 10 Fuss lang; vier Querleisten vereinigen diese beiden Bretter, um ihren Halt zu verstärken, und vorn sind an dieser einfachen Anstalt lederne Stränge angebracht, an welchen Menschen und Hunde ziehen. Die Last wird mit Riemen auf den Schlitten befestigt.

TRAINEAUX À CHIENS DES INDIENS MANDANS

On voit souvent les Indiens se rendre de leurs villages d'hiver à ceux d'été, pour y chercher divers objets dont ils ont besoin, car ils y laissent toujours une partie de leurs effets. Dès qu'ils quittent leurs cabanes pour un temps un peu long, les chiens sont chargés de leurs bagages, qu'ils traînent sur des claies (Menissichan), et en hiver, sur de petits traîneaux (Manna-Jirutahne). Ces traîneaux se composent de deux planches étroites et minces attachées ensemble par des courroies, recourbées par devant, et d'une longueur de 9 à 10 pieds ; ces planches sont unies par quatre traverses, qui servent à les renforcer, et par devant il y a des lanières de cuir auxquelles les hommes ou les chiens sont attelés. La charge de ces traîneaux y est fixée par des courroies.

PAGE/SEITE 188/189

Horse racing of Sioux Indians near Fort Pierre
Pferderennen der Sioux Indianer bei Fort Pierre
Course aux chevaux des Indiens Sioux près du Fort Pierre

PAGE/SEITE 190/191

Entry to the bay of New York taken from Staten Island
Einfahrt des Hafens von New York von Staten Island aus
Entrée du port de New York prise de Staten Island

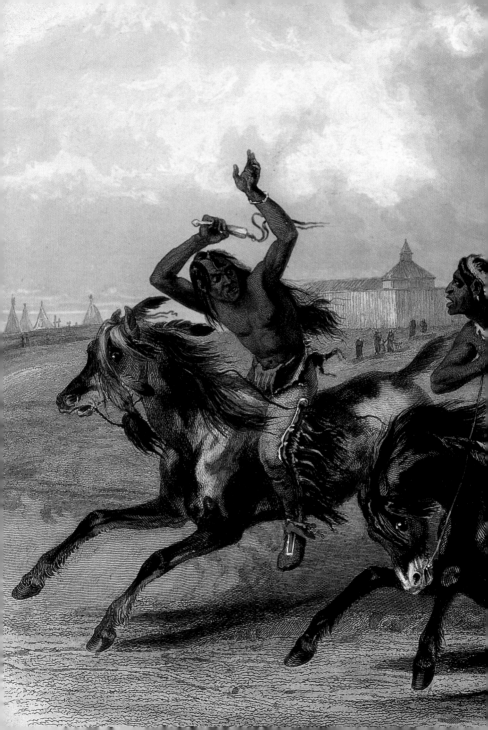

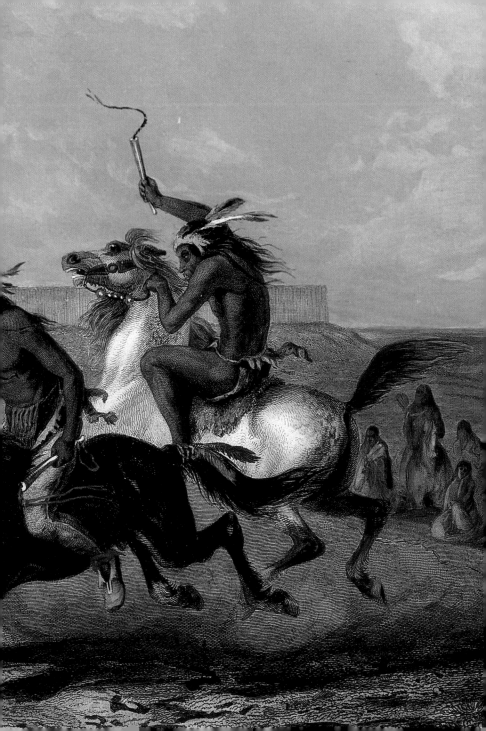

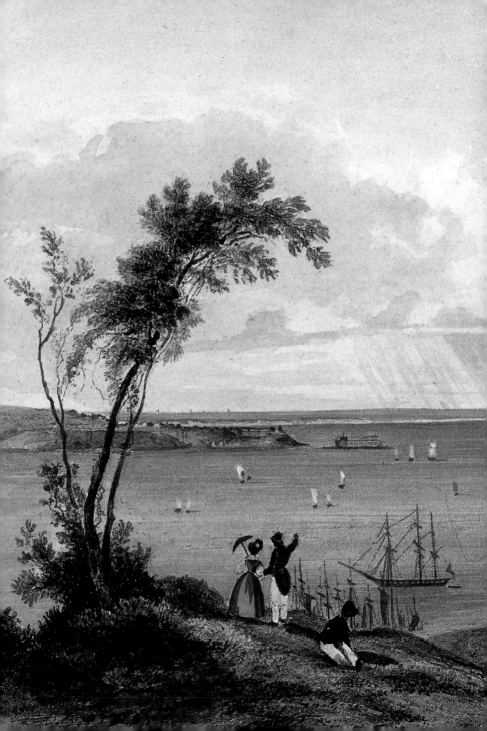

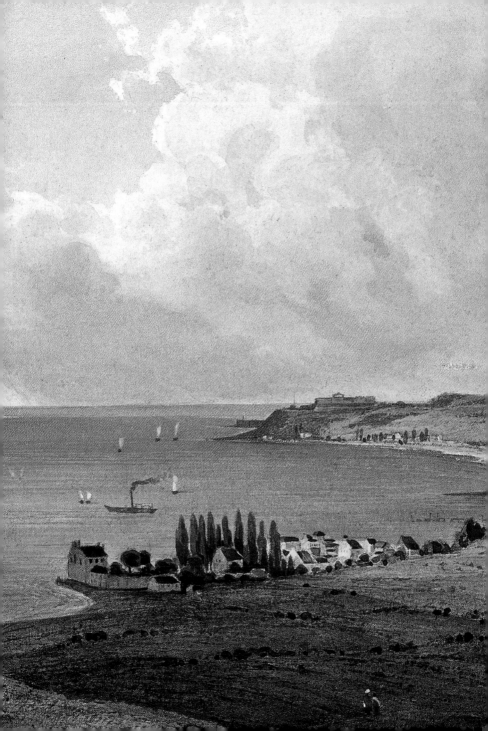

To stay informed about upcoming TASCHEN titles, please
request our magazine at www.taschen.com or write to
TASCHEN, Hohenzollernring 53, D–50672 Cologne, Germany,
Fax: +49-221-254919. We will be happy to send you a free
copy of our magazine which is filled with information
about all of our books.

EDITORIAL COORDINATION
Petra Lamers-Schütze, Cologne

DESIGN AND LAYOUT
Claudia Frey, Cologne

ENGLISH TRANSLATION
Malcolm Green, Heidelberg (Essay by Sonja Schierle)

TRADUCTION FRANÇAISE
Catherine Henry, Nancy
Frances Wharton, Cologne
(Editing and translation of the quotes from Maximilian Prince of Wied)

PRODUCTION
Thomas Grell, Cologne

Printed in Italy
ISBN 3-8228-4738-0

ICONS